GEORGE BELLOWS

The Artist and His Lithographs *1916 – 1924*

JANE MYERS *and* LINDA AYRES

With an Introduction by JEAN BELLOWS BOOTH

AMON CARTER MUSEUM FORT WORTH, TEXAS 1988

iv

The Amon Carter Museum was established in 1961
under the will of Fort Worth publisher and philan-
thropist Amon G. Carter (1879–1955). Initially com-
prised of Carter's collection of paintings and sculpture
by Frederic Remington and Charles M. Russell, the
Museum has since broadened the scope of its collection
to include American paintings, prints, drawings, and
sculpture of the nineteenth and early twentieth cen-
turies, and American photography from its beginnings
to the present day. Through its collections, special
exhibitions, public programs, and publications, the
Museum serves as a center for the study and apprecia-
tion of American art.

Copyright © 1988
Amon Carter Museum of Western Art
Fort Worth, Texas

Design by George Lenox
Printed in the United States of America
by Meriden-Stinehour Press, Inc.

ISBN 0-88360-059-5
Library of Congress
Catalog Card Number 88-70703

Contents

For Jean Bellows Booth

Foreword

George Bellows began making lithographs in 1916, having already made a name for himself in New York as a painter. Between that year and his death in 1925, at age forty-two, he devoted much of his energy to lithography as well as painting. In the history of American printmaking, Bellows stands out as one of the great masters in the field and as one responsible, in large part, for the growth of lithography as a fine art in the early twentieth century. The Amon Carter Museum, a center for the study of the American print, is one of the three major repositories for Bellows' lithographs, along with the Boston Public Library and the Cleveland Museum of Art. We are privileged to have the largest holdings of the prints of George Bellows, a collection of 220 prints acquired in 1985 from the artist's estate, having been compiled by Bellows' widow, Emma, and, after her death in 1959, by his daughter, Jean Bellows Booth. The Bellows lithographs in the collection represent the full range of Bellows' print oeuvre, including unique images and previously unrecorded states, published for the first time in this catalogue.

The seventy-five lithographs chosen for the present exhibition span the wide range of Bellows' subject matter, from the popular depictions of boxing matches and gently satirical views of everyday life to the more intimate nude studies and portrait renderings. Together they illustrate the artist's stylistic and technical evolution.

Linda Ayres, curator of paintings and sculpture, began her research on George Bellows in the early 1980s in preparation for an exhibition at the National Gallery of Art in 1982. Soon after her move to the Amon Carter Museum in the summer of 1984, her interest in the artist was heightened by the news of the availability of the estate's print collection. Jane Myers, associate curator and the Museum's print specialist, enthusiastically joined in the pursuit and ultimate acquisition of the prints, and plans for an exhibition and publication quickly followed.

Their long and devoted work is evidenced in this volume. They would like to thank their colleagues at the Amon Carter Museum, most especially Milan Hughston, who offered invaluable reference assistance and expeditiously assembled a wide range of research materials, Matthew Abbate, for his careful and expert editing of the manuscript, and Linda Lorenz, for photographing variant states of lithographs for the catalogue. The authors are also grateful to Kathie Bennewitz, Sandy Scheibe, and Marla Mosley, for the kind assistance given them in the course of this project.

We have been extremely fortunate to have the encouragement and counsel of Jean Bellows Booth from the beginning of this project, and in our dedication of this publication to her we extend our deep gratitude for her many kindnesses. She not only gave us access to the artist's record and account books, but shared with us, in conversation and in the written account that serves as this catalogue's introduction, her memories of her father, his studio, and his fellow artists and other acquaintances. To her and her husband, Earl, go our warmest thanks for their unwavering support.

Glenn Peck of H. V. Allison Galleries (long the representative of Bellows' estate) freely gave of his extensive knowledge of Bellows and his work. The expertise he shared with us was of invaluable assistance in cataloguing the prints and preparing the technical section of the catalogue. Clinton Adams, director emeritus of the Tamarind Institute and the leading authority on Bolton Brown (the printer of Bellows' lithographs in the last four years of his life), offered helpful comments on the catalogue manuscript and assisted the staff in sorting out some of the technical questions that came up in the course of this study. Thanks also go to Marjorie Cohn, head conservator of the Harvard University Art Museums, for undertaking an examination of two Bellows drawings at the Boston Public Library that shed light on some of the early

lithographs. We would like to thank the Trustees of Amherst College and Jean Bellows Booth for their kind permission to quote from the George Wesley Bellows Papers in the Amherst College Library, and the Trustees of Amherst College for permission to quote from the Charles Morgan Papers in the Amherst College Archives.

We are pleased to be able to share this exhibition with a wide audience and are grateful for the cooperation of J. Richard Gruber, John Dobkin, and Peter Bermingham and their staffs at the Memphis Brooks Museum of Art, National Academy of Design, and University of Arizona Museum of Art, respectively, to which the exhibition will travel.

Finally, our sincere gratitude goes to the Union Pacific Foundation, which supported this project with a generous grant on behalf of Union Pacific Corporation and its operating companies—Union Pacific Railroad Company, Union Pacific Resources Company, and Union Pacific Realty Company.

JAN KEENE MUHLERT

Director

Acknowledgments

In addition to those mentioned in the director's foreword, the authors would like to thank the following for their assistance to this project:

Garo Antreasian

Archives of American Art
(Smithsonian Institution)

Will Barnet

Judith Barter,
Mead Art Museum

David Brewster

Cheryl A. Brutvan,
Albright-Knox Art Gallery

Carolyn Carr,
National Portrait Gallery

Allison Cywin,
Newport Art Museum and Art Association

Daria D'Arienzo,
Amherst College Library

Richard Field,
Yale University Art Gallery

Jim Fisher

Linda Fisher,
Columbus Museum of Art

Henry S. Francis

Jane Glaubinger and the staff
of the Prints and Drawings Department,
Cleveland Museum of Art

Linda Guy,
Texas Christian University

Historical Society of Pennsylvania

Sinclair Hitchings,
Boston Public Library

Ann Hopkins,
Amherst College Library

David Kiehl,
Metropolitan Museum of Art

John Lancaster,
Amherst College Library

Colles and John Larkin

Nannette Maciejunes,
Columbus Museum of Art

Burr Miller

Prints and Photographs Division,
The New York Public Library

Carlotta Owens,
National Gallery of Art

Deborah Pelletier,
Amherst College Library

Albert Reese

Dr. and Mrs. Harold Rifkin

Dorothy Schneiderman,
Harbor Gallery

Karen Shafts,
Boston Public Library

Ann Shuster,
Print Club of Philadelphia

Linda Simmons,
Corcoran Gallery of Art

Clyde Singer,
The Butler Institute of American Art

Al Slader

Miriam Stewart,
Harvard University Art Museums

Woodman Taylor,
Art Institute of Chicago

Martha Tedeschi,
Art Institute of Chicago

Spencer Tucker,
Texas Christian University

Judy Weinland,
Boston Public Library

Rebecca Zurier

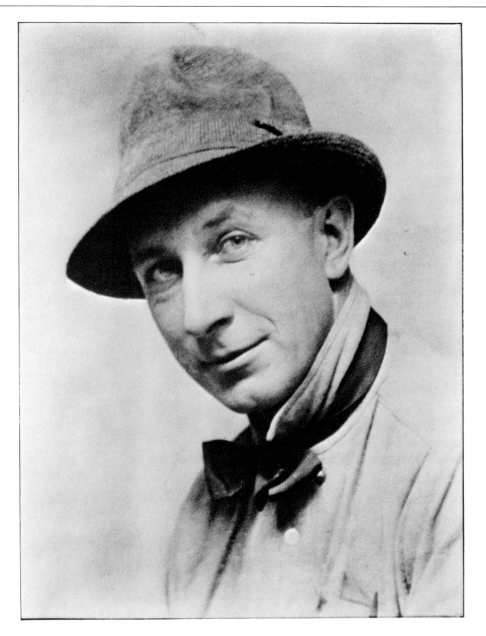

George Bellows, not dated
Courtesy of
H.V. Allison Galleries, Inc.,
New York

Introduction: A Daughter Remembers George Bellows

Over the years, people have asked me if I remember my father, a question I always found a little ridiculous, as he was not the kind of person one could easily forget—least of all his daughters!

Physically, he towered over us all. Vocally, his booming voice out-decibeled ours, but one had only to look in his eyes or notice his long, slender fingers to realize that here was a person of unusual sensitivity. He seemed to be able to relate to all kinds and classes of people—young, old, rich, poor, black, white—but could not tolerate pretensions of any kind. Bald by the age of twenty-seven, we nevertheless thought he was very handsome, especially when he appeared dressed for some formal occasion in his white tie and tails. Usually, though, his dress was quite informal—sporting a bow tie (when he wore a tie) and, during the winter, a heavy tweed jacket that held a wonderful masculine aroma of bay rum, Corona-Corona cigars, and, probably, oil paint. I loved to bury my nose in it!

My sister and I were often asked if we'd inherited any of his characteristics, and, of course, we did have some of them. Anne was always terribly proud that she had inherited the dimple in his chin—a little less proud of her 5′ 10½″ height and quite distraught that she, too, was left-handed. On the other hand, the fact that he was a southpaw never impeded George in any way. As for me, Elsie Speicher always said I had George's eyes, Lucie Bayard (like George, a pupil of Robert Henri) maintained I had a natural flair for drawing, and I have been accused of being too outspoken and frank, taking center stage whenever possible, and lacking in the social graces. George liked to say "I've got manners, but they're bad." Both he and Emma (my mother), apparently, rebelled against their "Victorian" upbringings to the extent that we were never taught to say "please" or "thank you"— and interrupting someone in the middle of a conversation was considered perfectly normal and acceptable.

George had an enormous appetite, but learned not to expect steaks for breakfast, when Emma flatly refused to cater to *that* whim.

Mother told us that at one dinner party, he started to remove the entire dessert from the serving platter, until he received a nudge or a kick from her, alerting him to the fact that he was only supposed to take *some* of it!

He was an absolutely wonderful father, who tried to include us in his activities, whenever he could. This was not often, as he was a very busy man—but I remember being taken to sit in the bleachers by Fifth Avenue, when the World War I army was marching in their victory parade, and holding oranges for George to throw to the wounded men riding in open touring cars. Even at that tender age (I must have been three), I was impressed by his accurate pitching! Another time, when New York City had been hit by a blizzard, he got out our sled and pulled us all over town, much to our delight. He often walked us to parties or school, or when we dined out, but his giant strides were almost too much for me to keep up with, with my short, chubby legs.

During the summer months, wherever we happened to be, there were picnics—on the beach, if one was nearby, or by a babbling brook or lake, always with a group of friends or family. Anne and I were never excluded from these outings.

When he and Emma were gone for some months during the winter of 1919, while he was teaching at the Art Institute of Chicago, he sent us a series of letters in the form of drawings. My favorite was one picturing George and Emma standing in a bathtub overflowing with tears. "I want to see Anne and Jean," sobs George. "I want to see Jean and Anne," cries Emma.

Because Emma couldn't abide the production-line faces on the dolls sold at that time, she persuaded George to paint "real" faces on our dolls (Anne and I each had only one). In addition, he also made furniture for our dolls, as well as a dressing table for Anne. After he finished building our summer house in Woodstock, in the Catskills, he made all sorts of furniture to install in it: a double bed, a huge chest for

storing blankets (and costumes), a hutch—all painted a bright orange. He also constructed all his model stands, some of which were as large as a small stage, and innumerable chests for storing paintings and lithographs, besides putting together his canvases.

Ours was a pretty hectic household, with a constant stream of people coming and going. In the city, George was kept busy teaching at the Art Students League, organizing exhibitions with Robert Henri, giving occasional lectures, and, of course, painting in his studio. None of us ever dared interrupt him while he was working, the studio being off limits to all but himself and his model (when there was a model). Having a fantastic, photographic memory, many of his paintings were executed in solitude.

He often worked on his lithographs until one or two o'clock in the morning and consequently liked to sleep late. As a result, Anne and I were conditioned to make as little noise as possible when we got up to go to school in the morning. This was not always easy, but I think we managed pretty well.

Except for those early mornings in the city, however, or when he was working in his Woodstock studio, it was never necessary for us to be the least bit quiet. Every member of the Bellows family had an opinion to express, especially at mealtimes, when it became merely a matter of the survival of the loudest.

Mealtimes were when the family got together, with George sitting at the head of the table, Emma on his left, Anne on his right, and Jean at the other end. He rather enjoyed having the family cat jump on his right shoulder and sit there, while he ate—that is, until the night the cat jumped up when he wasn't wearing his jacket! That produced one of his louder yells. In that basement dining room on East 19th Street, besides the table and chairs, was an old Mission sofa in one corner. Here George would stretch out and read the newspaper, while awaiting the next course.

When we finally settled in our house in the art colony of Woodstock during the summer, he always took us to the Sunday baseball games.

He was the captain of a team that consisted of fellow artists as well as local talent. Sitting in the bleachers, Anne and I had as much fun listening to the comments of the viewers, most of whom were also artists, as we did watching our father play. Charlie Rosen, Henry Lee McFee, Hughes Mearns, J. P. McEvoy, John Carroll, Konrad Cramer, Gene Speicher, Henry Mattson, the De Liagres, John Carlson, Norbert Heermann, Edward Chase, Mischka Petersham, and Earl Winflow are some of the Woodstockers who come to mind.

The studio in Woodstock, which was in a separate building from the house, was as sacrosanct as the one in New York. We were not supposed to be too noisy while he was painting. There were occasions when Anne and I would be having too much hysterical fun in the swimming pool and he would come storming out, to tell us to be quiet—in no uncertain terms! Once, I was overcome with curiosity about what went on in that studio. So I tiptoed up to one of the windows (covered inside by louvered blinds) for a peek. He was in the process of painting *Nude with Hexagonal Quilt*, which might have proved a shock to a nine-year-old girl who had never seen a "live" nude woman. However, I was quite overwhelmed by the beauty of her body, which glowed, as if covered with oil. That was the first and last time I ever attempted that though. The highlight of each summer was the annual Maverick Festival, held in August at the Maverick, an art colony founded by Hervey White on his farm near Woodstock. This was an occasion when all the artists and their families dressed in costume and arrived with their picnic baskets to enjoy an outdoor supper, followed by a lavish outdoor spectacle. One year George appeared in this show as a Nubian slave, helping to carry the Queen of Sheba in on a litter. He really enjoyed dressing up for these occasions, once arriving as a woman with balloon-like breasts and a frumpy blonde wig—a sight to behold! Another year, he made up his face to look like an aging sailor, with bulbous red nose, long sideburns, and a handlebar moustache. To top it off was one of our sailor hats.

One of his favorite parlor tricks was to put Anne up on his shoulders, with her legs dangling astride his neck; then I would get on Anne's shoulders in a similar position and he would walk this tower-of-children around the room. I was ecstatic, being so close to the ceiling, although I'm not so sure how Anne felt about it.

There were also quiet evenings, when we would be joined by Grandma and Grandpa Story and Emma would play the piano and George would treat us to a concert of songs sung in his rich baritone voice: "Danny Boy," "On the Road to Mandalay," or "Water Boy." Some evenings Anne and I would be encouraged to put on a performance. We took ourselves very seriously and once, when the performance was a dance, George roared with laughter and his daughters dissolved in tears.

All during those years when George was alive, and for many years thereafter, we were surrounded by his marvelous friends. The Eugene Speichers, the Robert Henris, Leon Kroll, and William and Edith Glackens were some of the most frequent visitors, but there were many others: John and Dolly Sloan, Randall and Florence Davey, Jonas Lie, Frank Crowninshield, Carmel White, the Albert Sterners, various art collectors, publishers, writers, sculptors, and all those Woodstock residents. Every now and then, Anne and I were allowed to join the group and pose for their impromptu sketches.

We were also surrounded, generally in the summer months, by our Grandma Bellows and Aunt Fanny, as well as Aunt Laura, her son, Howard Monnett and, of course, the Storys. George painted portraits of all of them—two of Grandpa Story, one of which he destroyed and another that was never finished—but he never painted our Grandma Story. I have often wondered why—perhaps she didn't want to pose—but he did manage to include her at the telephone on the landing in the lithograph and painting entitled *The Studio*, and he also copied a tintype photograph of her from her childhood, as the model for the child in the striped dress in his lithograph *The Irish Fair*. (Robert Henri also served as the model for the central figure in that print.)

The studio, which occupied the third and fourth floors of the house on East 19th Street, was built by George shortly after he acquired the building, with funds given him by his father, in 1910. He added the fourth story, with a series of windows across the top, facing 19th Street, which admitted the all-important north light. In the back was a staircase leading up to a large balcony with a southern exposure, which also served as George's workshop and later housed the large lithograph press. The studio walls were lined, not surprisingly, with large canvases and lit with shaded lights hanging from the ceiling. On the east side of the room was a brick fireplace, bordered on its left with a series of irregular bookshelves and drawers reaching to the ceiling. (The drawers were fashioned from used cigar boxes, of which there were many, left over from the weekly poker parties.) The studio was furnished with sofas, chairs, several tables, and a large Governor Winthrop desk, as well as a big wooden easel, paintstand with removable marble top, and two huge screens, behind which was a large sink (with ample space to hold the tray of oil paints under water overnight) and a storage area.

At one time, the leopard skin (which in *The Studio* hangs on the balcony balustrade) was used as a rug on the studio floor and served as an endless source of fascination to me, as a child, with its open mouth and bared teeth.

This room served many functions—not only as a studio and office for George but as the living room for the family and the place where all guests were entertained, poker games played, and paintings displayed for critique and discussion by his friends. The cigar smoke was thick and the discussions often ran late into the night. Then there were the Christmases—always held in the studio, at Emma's insistence, on Christmas Eve. She used real candles on the tree and felt they showed off to their best advantage at night. Oh! the excitement of climbing the stairs and witnessing that tree, straight out of fairyland! (George was always careful to have a large bucket of water nearby, in case there was a fire—but there never was.)

The entrance to the studio was through bifold doors, from a small landing by the stairs. This held the only telephone in the house and, when the call was for Grandma Story, entailed her climbing up two flights of stairs from her ground-floor apartment to answer it.

My father had a marvelous sense of humor, a great feeling for the ridiculous, and a sharp wit. He could have been a stand-up comedian, or a singer, or an actor, or a cabinet-maker, or a baseball or basketball pro, but his passion was art. He didn't want to be just a good artist, either; he wanted to be a great one.

There are quite a few people who believe he achieved that goal, but there are also those who criticize his absorption with dynamic symmetry and use of the Maratta colors. I believe he was impressed with the miraculous symmetry in nature—so why not in art? And color? He must have tried them all—but I don't recall his ever having a palette with paints neatly laid out in sequences of color, as Gene Speicher did. He would mix them as he worked. And how he worked! Painting was almost an athletic exercise for him—a few strokes on the canvas, then back at least six feet to survey the result, perhaps a few seconds of furious rocking in his Mission rocking chair to evaluate what he'd done, then back to the canvas. His paintings were never executed to be viewed with myopic eyes.

The lithographs were something else. Most of them were done on the upstairs balcony, which overlooked his studio. Here, during the winter months, he had a southern exposure—completely wrong for painting, of course, but perfect for black and white drawing. This "balcony" was, in fact, a good-sized room—with ample space for his lithograph press, an area at least eight feet wide that held a large assortment of tools (used for his carpentry), a small storage room, a series of casement windows overlooking the back yard, a table large enough to hold the lithograph stones on which he drew, and chairs for his models and himself to sit on. He only had a few stones, some large, some small, with a smooth surface on both sides, enabling him to draw on both. Once the prints were

made, he had the stones re-ground for a new series of drawings. Although I was much too young to remember George Miller, the master printer with whom he first worked, it is easy to recall Bolton Brown, the printer who collaborated with Bellows from 1919 to 1925. Brown was almost a permanent fixture, working that press. He was quiet and serious and, to me, looked like a college professor. The floor of the balcony was usually covered with discarded lithographs—prints that were too dark or too light or whatever—which provided a marvelous source of paper for Anne and me to draw on the reverse sides of, with our crayons. George sometimes aided us with our compositions, adding a horse here or a few dramatic clouds there.

Because there was so much more light during the summer, I think my father eventually executed most of his paintings in the Woodstock studio, reserving his quarters in New York City for the drawings and lithographs. He had no printing press in Woodstock, although Brown maintained a studio there and perhaps made some prints during the summer. Whether George brought any of his stones with him from the city or not I don't know.

I don't remember posing for most of his lithographs of me but I do recall sitting for *Jean in a Black Hat*. I was wearing the black velvet dress, cape, and hat that Emma provided for us to wear to Sunday School and Miss Robinson's Dancing Class (a weekly event held at the Plaza Hotel). Posing for my father was never an ordeal—in fact, it was fun—and by the time I was seven or eight years old, sitting still had become routine. He paid us regular hourly model's rates, too, so naturally we never objected when asked to pose.

To store all his lithographic prints, he built a tall series of shelves in his studio in New York, which accommodated stacks of boxes—about $26'' \times 33'' \times 2\frac{1}{2}''$ deep—that could be pulled out and opened up in front. Each box was labeled with the names of the prints inside.

After he died, early in 1925, Emma began gradually removing everything he used on that upstairs balcony: the printing press, the work bench, the stones—everything. She had the balcony completely remodeled into a bedroom, which she and Anne and I shared for several years, while she rented the second-floor "apartment." Consequently it was many years before I ever got a whiff of a lithography press again. Some years ago, when my daughter and I were visiting the art department at Michigan State University, we wound up on the floor where they were printing lithographs. Suddenly there it was, that overpoweringly familiar smell! Who would have thought that, after nearly fifty years, it would affect me so? It was all I could do to hold back the tears.

My mother wanted to have a permanent, public record made of all his lithographs. Toward this end, she probably removed the complete set of lithographs from the wooden box that George had fashioned to house his collection, and, with the aid of Alfred A. Knopf, the publisher and family friend, the first catalogue of Bellows lithographs was published in 1927. She insisted that each print occupy a full page of the book—with *no* printing to distract the viewer. It was a very handsome edition indeed and sold out before the end of the year. Consequently, she had a second edition published in 1928, with a few corrections made regarding the first and second states of various prints. However, she made no attempt to list the edition size of each print as she felt this was not important and, possibly, because she knew my father's accounts of the edition sizes were not entirely accurate.

After Knopf had finished photographing the lithographs, they were returned to the wooden box and remained there during Emma's lifetime. When she died in 1959, this box became part of the Trust she set up of all the works of art in her possession, and it remained intact and unopened in a New York City storage house until September of 1982, when Gordon Allison and I (as the last remaining trustees) decided it was time we opened it up and checked on the lithographs. We were both delighted and relieved to discover they were all in perfect condition!

As the exclusive dealer for the art works in the Trust, Gordon asked me a few times how I felt about breaking up the complete collection, especially as so many of the prints had been sold out for a number of years. However, I felt it should be kept intact, and so it was.

In the summer of 1984, Gordon Allison suggested I come to New York to meet with Glenn Peck, who was planning to join with Gordon in running the H. V. Allison Galleries. I went with great pleasure, as I had been concerned, for some time, over Gordon's failing health and had wondered how much longer he would be able to continue as the Bellows dealer. It was a fortunate decision for all concerned, as Gordon died only a few months later, leaving the gallery in the very capable hands of Mr. Peck.

At this time, and during the succeeding months, it was necessary for us to make a complete inventory of all the paintings, drawings, and lithographs that were contained in the Trust. We also went over all the lithographs Emma set aside after Knopf was finished with them. This set, we discovered, was not entirely complete after all. Emma had not been aware that there were several different states of some of the prints—indeed, neither Gordon Allison nor I was aware of this fact either. It was Glenn Peck, with his practiced eye, who suddenly began to discover two or more states of many of the lithographs, most notably *Murder of Edith Cavell*. As a result, it was not until January of 1985 that we both felt we had finally assembled as complete a set as possible of the prints, having added 24 additional states to George and Emma's original 196. It is this collection, then, that was acquired by the Amon Carter Museum.

JEAN BELLOWS BOOTH

August 1987

NOTE

Titles for Bellows' prints, with some exceptions, are those given in Lauris Mason and Joan Ludman's *The Lithographs of George Bellows: A Catalogue Raisonné* (Millwood, N.Y.: KTO Press, 1977), hereafter referred to as Mason. In cases where Mason's titles differ from the titles assigned by Bellows himself, either in his record books or on the prints themselves, Bellows' own titles have been used. Since Bellows did not use the term "stones" to refer to variations of the same image produced on different stones, Mason's designations "First Stone" and "Second Stone" have been replaced by "No. 1" and "No. 2," indicating the sequence in which the prints were produced. Bellows in his record books used a similar system to describe the different versions of an image, employing Roman numerals to distinguish between the prints.

The lithographs of George Bellows (1882–1925) were a pivotal achievement in the history of American printmaking. From 1916 until shortly before his death in January 1925, Bellows produced over 170 lithographic images. These he reworked in numerous states and variations, printing thousands of impressions. Lithography played a significant role in his development as an artist, providing a vehicle well suited to his spirited curiosity and creative enterprise. The medium proved to be a sympathetic one for the expression of his skillful draftsmanship and for his sensitive portrayals of the human condition. Through his development of an individual style Bellows laid the foundation for the growth of lithography as an artistic medium in the United States.

Born and raised in Columbus, Ohio, Bellows attended Ohio State University for three years before moving to New York in 1904. First an art student, then a professional illustrator and painter, he quickly established himself in New York's art community. Years before he made his first lithograph, a potent combination of talent, ambition, and an outgoing personality had fueled his meteoric rise to prominence. An outspoken partisan of the artist's right to express himself freely, Bellows made a strong impression: "He hardly stopped to learn how to paint before he began to make himself heard," remarked one critic.[1]

Arriving in New York as an eager amateur, Bellows enrolled in the New York School of Art, popularly known as the Chase School after William Merritt Chase, the school's founder and its leading instructor. Under the tutelage of Robert Henri (1865–1929), a member of the faculty and the spiritual leader of the group of progressive artists known as The Eight, Bellows devoted his artistic energies to subjects drawn from his urban environs. He met and befriended others of Henri's generation who sought artistic inspiration from the everyday life of the streets. John Sloan, William Glackens,

Everett Shinn, and George Luks had begun their careers as newspaper illustrators in Philadelphia, and, like Henri, relocated in New York around the turn of the century. There the members of the Henri circle worked in a realist style, providing a graphic appraisal of the city and its people.

The newcomer Bellows progressed quickly in his art studies, grasping the essentials of painting and drawing and assimilating Henri's precepts as a member of his class. Guy Pène du Bois, another student of Henri, described his class as "the seat of sedition among the young." Henri emphasized the appropriateness of technique to subject rather than the actual mechanics of painting, and he encouraged his students to follow his lead in expressing their own ideas in their art.[2] Bellows became a similarly independent spirit and, like Henri, undertook the role of teacher. He supplemented what was initially a modest income from his paintings by taking teaching positions at the Art Students League and, in the summer of 1908, at the University of Virginia. In 1909 Henri, having broken ties with the New York School of Art, set up his own school in the Lincoln Arcade Building at 66th and Broadway, where Bellows also maintained a studio and residence. Here Bellows continued to drop in for art lessons, now offering counsel himself to the junior students.[3]

Henri, whose magnetic personality and persuasive teachings were to shape the goals and outlook of many young artists, became a close ally for whom Bellows maintained deep respect. Some years later, writing to their mutual friend, the artist Leon Kroll, Bellows spoke of Henri's culminating statement on art and life, *The Art*

1. Forbes Watson, "George Bellows," *Evening Post Illustrated Magazine*, c. November 1913, p. 9 (clipping in Forbes Watson Papers, Archives of American Art, Smithsonian Institution, Washington, D. C., roll D48, frame 7).

2. Guy Pène du Bois, *Artists Say the Silliest Things* (New York: American Artists Group, Inc., 1940), p. 84; William Innes Homer, *Robert Henri and His Circle* (Ithaca: Cornell University Press, 1969), pp. 158–159. Bellows recalled the convivial, raucous atmosphere of Henri's night class in three prints depicting a group of male students drawing from a nude female model: his only etching (illustrated in Mason, pp. 22–23) and two lithographs entitled *The Life Class* (Mason numbers 8 and 43).

3. Homer, *Henri and His Circle*, p. 282, n. 50, and Charles Morgan, *George Bellows, Painter of America* (New York: Reynal & Company, 1965), p. 95.

Spirit: "[Henri's] new book is a peach. Consisting of notes letters and sayings. Really a classic, and nothing like it in literature unless the notes of Butler be thought of." Bellows enjoyed an intellectually challenging relationship with Henri, entering into his mentor's intimate circle of friends and associates from the art and literary fields who socialized at Henri's home on a weekly basis.[4] There, conversation frequently revolved around such topical issues as the controversial Armory Show, an exhibition of modern American and European painting and sculpture that Bellows, who numbered among its exhibitors, helped to install in 1913. The Armory Show signaled the arrival of modernism to a broad spectrum of the American public and was perhaps the most far-reaching of the revolutionary events taking place in the art world of the time.

It was Bellows' particular fortune to achieve popular and financial success in this lively and polemical milieu. Accepted within the ranks of the conservative National Academy of Design, where, in 1909, he was voted an associate member,[5] he simultaneously acted as a daily participant in the more radical Henri group. Bellows managed to bridge traditional and modern viewpoints, his realist approach appealing to the old school critical of the intrusion of European modernism while his choice of commonplace subject matter and his bold, expressive brushwork allied him with a more contemporary outlook. By 1916, the year Bellows added printmaking to his list of accomplishments, he had already earned numerous prizes and accolades for his painting.

When Bellows established himself as an artist in the first two decades of the twentieth century, the potential for lithography as an artist's medium in the United States remained largely unexplored. Despite tentative interest on both sides, a wide gulf existed between the technically proficient commercial lithographers working in the large printing firms and artists seeking to explore the lithographic medium. Few opportunities were presented for collaborative efforts whereby the commercial printer could lend his technical expertise to the artist. Joseph Pennell, an etcher and lithographer and perhaps the best-known printmaker in the United States during the period, was able to find only in Philadelphia a printing firm, Ketterlinus Lithographic Company, where his lithographs could be printed.[6] When Bellows died in 1925, the prospects for the artist-cum-printmaker had broadened significantly. Numerous artists had undertaken lithography—a dramatic development over a relatively short time, due, in no small part, to Bellows' abiding commitment to promoting the medium and to his own spectacular series of lithographic prints.

Bellows initially encountered the medium of lithography through his association with Albert Sterner (1863–1946), an artist, printmaker, and the husband of Marie Sterner who represented Bellows in her New York art gallery. The Sterners' Gramercy Park home was located near Bellows' East 19th Street residence and studio, where he and his bride Emma Story of Upper Montclair, New Jersey, lived following their marriage in 1910. According to Marie Sterner, her husband offered to instruct Bellows in the

4. *The Art Spirit* was published in 1923, the year of George Bellows' letter to Kroll. The letter is quoted in Frank Seiberling, Jr., "George Bellows, 1882–1925: His Life and Development as an Artist" (Ph.D. diss., University of Chicago, 1948), p. 52. The weekly gatherings at Henri's home are described in Homer, *Henri and His Circle*, pp. 150–151.

5. Eliot Clark, *History of the National Academy of Design, 1825–1953* (New York: Columbia University Press, 1954), p. 247.

6. The technical printer's journals of the period often made note of print exhibitions and occasionally ran articles on artist-printmakers. See, for example, *National Lithographer* 25 (August 1918): 42, which reprinted an article by the New York Public Library curator of prints, Frank Weitenkampf, from the *American Magazine of Art* 9 (July 1918): 352–355. The article described a lithography exhibition at the New York Public Library in which Bellows was represented. Also, *The Printing Art, An Illustrated Monthly Magazine Devoted to the Graphic Arts*, a journal for commercial printers emphasizing typography and layout, ran short articles, largely taken from other periodicals, on modern lithography as an artist's medium. See, for example, J. Albert Heppes, "Department of Offset and Lithography," *Printing Art* 31 (August 1918): 453, and Heppes, "Department of Offset and Lithography," *Printing Art* 32 (January 1919): 357.

On Pennell's search for a printer, see Clinton Adams, *American Lithographers, 1900–1960* (Albuquerque: University of New Mexico Press, 1983), p. 20. As Adams describes, Childe Hassam, Albert Sterner, and John Sloan were among other artists of the period seeking printers for their lithographs (pp. 24–25).

intricacies of lithography.[7] Born in London, Albert Sterner was a cosmopolitan figure who had spent long periods working in Europe. He owned his own lithographic press, and his knowledge of lithography surpassed that of most other American artists. His training in printmaking included employment as a young man at the Chicago lithography firm of Shober and Carqueville and an acquaintance not only with the German and French printers who pulled lithographs for him, but also with the leading Parisian illustrator-lithographers of the day, including Théophile Steinlen and Jean-Louis Forain. Like Pennell, Sterner had also made lithographs at Ketterlinus in Philadelphia.[8] Bellows never was to travel abroad; Sterner could offer him firsthand knowledge of contemporary European illustration, and could share with him expertise drawn from his work with American and European printers. In 1911 and again in 1915, Sterner's lithographs were featured in one-man exhibitions organized by Martin Birnbaum, owner of the Berlin Photographic Company Gallery in New York City.

It was Sterner who introduced Bellows to a talented young commercial lithographer, George Miller (1894–1965). Miller and Bellows' association proved to be a felicitous one that enabled Bellows to augment his rudimentary knowledge of lithography with the expertise of a professional. From a family of professional printers, Miller was an employee of the American Lithographic Company, where he had risen from a position as apprentice to foreman of the stone proofing department. His acquaintance with Albert Sterner dated to 1914 when Sterner, in printing his own lithographs, encountered technical problems he could not resolve. Lithography posed technical challenges not present in the related discipline of drawing. Since the lithographer makes an image consisting simply of grease pencil drawn on stone, keeping the image intact through repeated runs of the stone through the press was an important and difficult skill. When Sterner ran into trouble on one stone Miller salvaged the image for him, further impressing him with his ability to produce prints that precisely reflected the artist's conception. After Miller came to his rescue, Sterner invited the printer to work with him on other lithographs and introduced him to Bellows.[9]

Undaunted by his lack of technical expertise and the relatively difficult task of obtaining information on the intricacies of lithographic printing, Bellows had already experimented with the medium and had pulled some lithographs himself on a press he had acquired in the winter of 1915–16.[10] Bellows' introduction to Miller provided him with a colleague whose technical skill matched his own boundless enthusiasm. From this time his commitment to lithography was assured.

Many details of Miller and Bellows' collaboration remain unknown. Through early 1917, Miller printed for Bellows on the press installed on the balcony of the artist's studio, as portrayed in Bellows' print *The Studio* (fig. 119). After April 1917, when Miller opened his own lithographic printing studio (the first establishment for the production of artists' prints in the United States), he may have printed Bellows' stones at his own facility. Their working relationship set a valuable precedent for the association of artist and printer. With Miller's assistance Bellows refined his lithographic technique, and together they produced large, uni-

7. Seiberling, "George Bellows," p. 98, n. 1.

8. Adams, *American Lithographers*, p. 20. Information on Sterner's life and prints may be found in Ralph Flint, *Albert Sterner: His Life and His Art* (New York: Payson & Clarke Ltd., 1927); Martin Birnbaum, "Albert Sterner's Lithographs," *Print Collector's Quarterly* 6 (1916): 213–224; Edward Alden Jewell, "Albert Sterner's Prints," *Print Collector's Quarterly* 19 (1932):253–266; and Harry A. Broadd, "Albert Sterner: Printmaker with Ideas," *Print Review* 14 (1981): 26–40.

9. Information on George Miller is drawn from Ernest W. Watson, "George Miller, Godfather to Lithography," *American Artist* 7 (June 1943): 13–15; George Miller, "The Craft of Lithography," *American Artist* 7 (September 1943): 21–23, 28; Stow Wengenroth and Lynd Ward, "George C. Miller, Master Printer," *American Artist* 30 (May 1966): 12–13, 63; Janet A. Flint, *George Miller and American Lithography* (Washington, D. C.: National Collection of Fine Arts, 1976); Alfred P. Maurice, "George C. Miller and Son, Lithographic Printers to Artists Since 1917," *American Art Review* 3 (March–April 1976): 133–144; "Interview with Gerald K. Geerlings," in Joseph S. Czestochowski, *Gerald K. Geerlings* (Cedar Rapids, Iowa: Cedar Rapids Museum of Art, 1984), pp. 21–22; and author's interview with George Miller's son, Burr Miller, October 20, 1987.

10. Morgan, *George Bellows*, pp. 197–198.

form editions of prints. By temperament a self-effacing man who strove to accommodate the artist's desire to achieve a particular effect, Miller would become the primary printer for leading lithographers of the first half of the twentieth century, including Grant Wood, Thomas Hart Benton, and Rockwell Kent.

Although the precise sequence in which Bellows produced his first lithographs is not known, by April of 1916 he had completed a number of accomplished prints. In that month seven of his prints, including *Artists' Evening, In the Park, Splinter Beach*, and *Prayer Meeting*, were exhibited at Frederick Keppel and Company alongside those of such well-known European lithographers as Paul Gavarni (1804–1866), Henri Fantin-Latour (1836–1904), and Auguste Raffet (1804–1860). Bolton Brown, the lithographer-artist who, in the 1920s, would print over one hundred lithographs for Bellows, was one of the few other Americans to be represented in the exhibition. Bellows' lithographs were also published upon completion in popular periodicals. The May 1916 issue of *Arts & Decoration* contained illustrations of *Artists' Evening* and *Benediction in Georgia* with the caption ". . . of the first essays in lithography done by George Bellows. Neither has been shown or published before."[11]

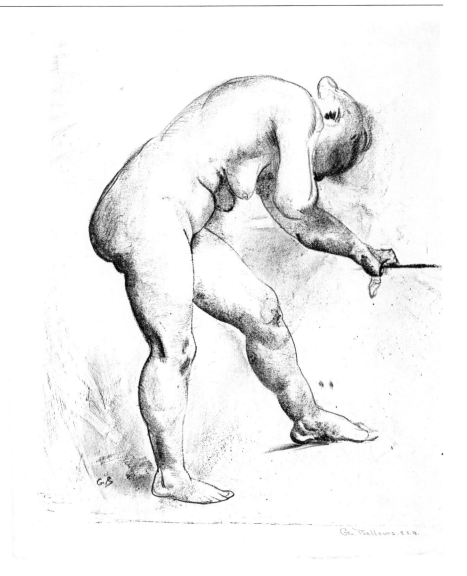

1.
Standing Nude Bending Forward, 1916
Lithograph
11⁷⁄₁₆ × 10¹¹⁄₁₆ in. (irreg.).
Amon Carter Museum
ALSO FIG. 152

11. *Arts & Decoration* 7 (May 1916): 348. For the Keppel exhibition, see *Catalogue of an Exhibition of Lithographs* (Archives of American Art, roll N439, frames 653–665). The other Bellows prints in the exhibition were *Between Rounds No. 1, Business-Men's Class*, and *Introducing the Champion*. The exhibition catalogue contained an introduction by Carl Zigrosser.

In Bellows' "Book B Record of Pictures" (manuscript in possession of Jean Bellows Booth; hereafter referred to as Record Book B), which includes a listing by year of his paintings, drawings, and prints, *Prayer Meeting* is the first lithograph appearing under "1916," and Emma Bellows in the two editions of her catalogue raisonné of Bellows' prints, *George W. Bellows: His Lithographs* (New York: Alfred A. Knopf, 1927, 1928), p. 239, also cites *Prayer Meeting* as Bellows' first print. However, in the 1919 exhibition of Bellows' lithographs at Roullier Art Galleries, Chicago, the accompanying brochure (which includes commentary by the artist) cites *Hungry Dogs* as "the first lithograph made by George Bellows." (*Catalogue of an Exhibition of Original Lithographs by George Bellows, N. A.* [Chicago: Albert Roullier Art Galleries, 1919], n.p.) It is difficult to determine the precise order of production since no records were kept of the printing process. However, the order of the prints listed in the artist's Record Book B does suggest

2.
Nude Woman Standing,
Side View, 1916
Lithograph
19¹/₁₆ × 9¼ in.
Amon Carter Museum
ALSO FIG. 148

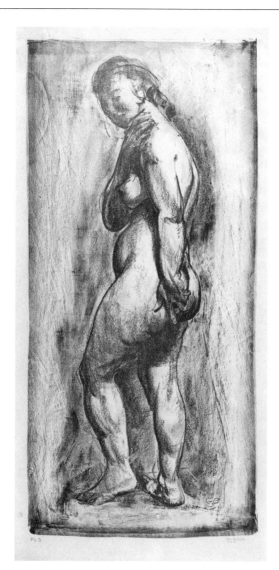

In his record book Bellows wrote on January 1, 1917, "During the past year I have made 28 lithographs of aproximately [*sic*] 50 proofs each. Titles as follows." A series of nude figures were not listed in the record book (suggesting that they were technical exercises rather than finished lithographs); these may well have been his first lithographic efforts: *Standing Nude Bending Forward* (fig. 1); *Nude Woman Standing, Side View* (fig. 2); *Nude Woman Seated* (fig. 3); and *Man on His Back, Nude* (fig. 4).[12] In these prints Bellows was primarily concerned with technical considerations rather than with the subjects themselves. The majority of prints in the series were unsigned, the editions were small, and the prints were reworked in multiple states, all suggesting that Bellows was experimenting with the various effects he could achieve with lithographic crayon and tusche (like lithographic crayon, a grease-based material). Tusche, in its liquid form, was freely applied to many of these prints as background shading and to impart a three-dimensional quality to the figures. Bellows' generously proportioned, unidealized female nudes are academic studies of the human figure, their forms defined by simple outlines enhanced by the fluid, gestural strokes of the lithographic crayon. In prints such as *Nude Woman Seated*, Bellows explores the repertoire of lithographic effects by painting varying amounts of liquid tusche onto the states. (See Appendix A for a detailed discussion of the differences among the states of various Bellows prints.) He also experimented with colored inks

a logical sequence, corresponding to the prints' appearance in various exhibitions—those prints listed first appear in earlier exhibitions. One can surmise, for example, that *A Stag at Sharkey's* was printed in March or April of 1917 since it was not included in the March 1917 Milch exhibition of Bellows' paintings, drawings, and prints, but did appear in the Rochester exhibition of April 1917. See Appendix B for a full list of exhibitions through 1925 containing Bellows' lithographs.

12. *Male Torso* (Mason 2) and *Nude, Woman Kneeling* (Mason 5) may also be considered part of Bellows' initial series of nudes. In his Record Book B, p. 106, Bellows actually recorded twenty-six prints, to which Emma Bellows added four additional titles. *Man on His Back, Nude* (Mason 3) and *Standing Nude Bending Forward* (Mason 4) were excluded from the list as were the second versions of *Prayer Meeting* and *Reducing*, bringing the total print production for 1916 to thirty-four.

in this series—one impression of *Nude Woman Seated* is printed in black, for example, while another is printed in brown ink—and with the use of the transfer process. Bellows' commitment to mastering the technical aspects of printmaking was unswerving and a cornerstone of his artistic philosophy: ". . . if a thing is made easier by technical understanding, then by so much is it true that having this particular phase made easier, your strength is conserved for the struggle with difficulties which must always remain immense."[13] Despite the experimental nature of these early nudes, the prints anticipate Bellows' mature lithographic style in their expressive and varied use of lithographic crayon and tusche.

Although Bellows made at least one etching, it was lithography that captured his imagination, and his searching approach to the medium solidified quickly as his adroitly rendered prints of 1916–17 demonstrate.[14] His increasingly facile handling of the medium is evident in such

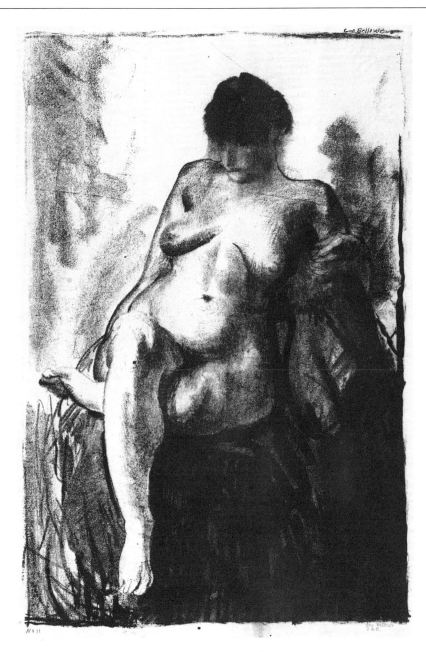

3.
Nude Woman Seated, 1916
Lithograph
15 1/16 × 10 1/8 in.
Amon Carter Museum
ALSO FIG. 144

13. Estelle H. Ries, "The Relation of Art to Every-day Things: An Interview with George Bellows, on How Art Affects the General Wayfarer," *Arts & Decoration* 15 (July 1921): 202.

Emma Bellows identified *Man on His Back, Nude* as a transfer lithograph: "This method of transference was used only in the artist's earliest essays. All subsequent works were drawn directly on the stone" (*Bellows: His Lithographs*, p. 247). In fact, all of the prints in this series show evidence of the transfer process. In such prints, the design is transferred to the stone from a drawing placed against the stone, rather than drawn directly on the stone. It was a common practice at the time; both Pennell and Sterner employed the transfer process.

Two small lithographs, *Fantasy* (Mason 9) and *Family* (Mason 10), were also early prints in which Bellows worked out details of the lithographic process. *Fantasy*, printed in a small edition, includes a sampler of lithographic techniques—liquid tusche, lithographic crayon, and scratching into the ink to produce narrow white lines.

14. In 1906 Bellows recorded in his "List of the Works Painted and Drawn by Geo Bellows from 1905, After Coming to New York" (manuscript in possession of Jean Bellows Booth; hereafter referred to as Record Book A), p. 16: "Nude Woman Entering a Bed, etching in Ink, Property Rex Slinkard, Los Angeles, Ca." If this does refer to an actual print rather than a drawing, the work has not been located. The etching *The Life Class* (Mason, pp. 22–23) is likely the one to which Bellows refers in a letter of March 15, 1917, to his former Ohio State University English professor Joseph Taylor: "I have made one successful etching also and may take it up sometime." (George Wesley Bellows Papers, Amherst College Library, box I, folder 13.)

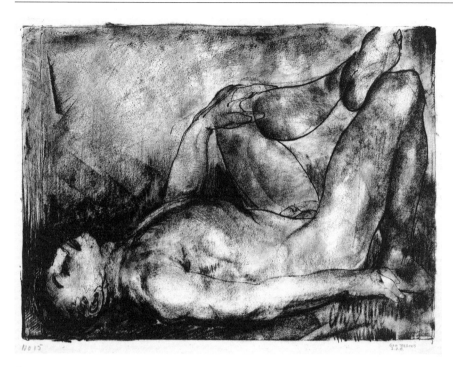

4.
Man on His Back, Nude, 1916
Lithograph
8⁷⁄₁₆ × 11⁵⁄₈ in.
Amon Carter Museum

lithographs as *The Old Rascal* (fig. 5), *Two Girls* (fig. 7), and *Reducing* (figs. 16, 17), in which he placed nude or partially clothed figures in interior settings. In recent paintings such as *Nude with Parrot* (1915, private collection) and *Torso of Girl with Flowers* (1915, unlocated), Bellows had portrayed single nude figures within naturalistic but sparely delineated settings. In the lithographs, multiple figures and accentuation of light and dark contrasts lend dramatic dimension to his subjects.

The Old Rascal recalls Sterner's lithograph *The Abduction* (fig. 6), printed a few years earlier. The subject is an unusual one for Bellows but not for Sterner. Though Sterner's illustrations for popular periodicals featured the attenuated and gracefully beautiful American woman, his lithographs often treated emotionally charged, symbolic subjects. Both Sterner's and Bellows' lithographs depict an encounter between male and female figures—the male rendered in dark tonalities, against whom the flesh of a female nude is contrasted. The curvilinear outlines of Sterner's figures lend a decorative aspect to the print, while Bellows' figures are more three-dimensionally realized. Although Sterner's ambiguous setting and generalized figures suggest an allegorical content, Bellows conceived his subject in the comic, farcical style of the French satirist François Rabelais, whom the artist cited when exhibiting the print.[15]

A print with less dramatic content, *Two Girls* (fig. 7), a study of two nudes on a bed, is probably based on a small pencil drawing (fig. 8).[16] In the print, Bellows adjusted the image to render a unified pictorial whole; he eliminates two figures and deemphasizes the linearity of the drawing, setting the figures against a richly shaded

In undertaking etching, Bellows may have been influenced by John Sloan, who had begun his career as a printmaker in the 1880s. The influence was apparently reciprocal, for two Sloan lithographs from 1923, both in a private collection, *Sunday, Drying Their Hair on the Roof* and *Shine, Washington Square* (Peter Morse, *John Sloan's Prints* [New Haven: Yale University Press, 1969], nos. 209 and 210), are inscribed by Bellows: "Original Proof Pulled On My Press."

15. In the 1919 Roullier exhibition catalogue (n.p.), the entry for the print bears the caption "A Rabelaisian study."

16. There is also a drawing of the standing figure in the collection of The Snite Museum of Art, University of Notre Dame.

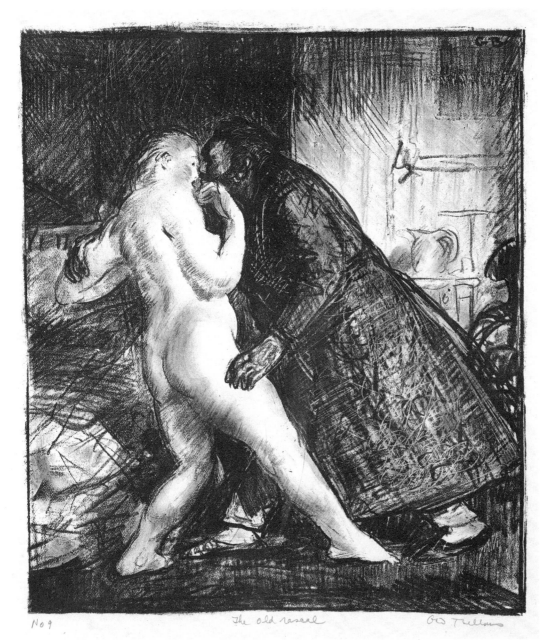

No 9 *The Old rascal* Geo Bellows

5.
The Old Rascal, 1916
Lithograph
10⅛ × 8¹⁵⁄₁₆ in.
Amon Carter Museum

6.
Albert Sterner
The Abduction, 1913
Lithograph
14¾ × 10¹¹⁄₁₆ in.
Tamarind Institute,
Albuquerque, New Mexico

background. The arcing forms of the nudes and basin in the foreground become the compositional focal points. Bellows translated a number of his drawings to prints by this method of simplifying the composition and amplifying the tonal contrasts.

Bellows worked diligently, and by the end of 1917 he had executed a total of forty-nine prints.[17] In a letter to his friend Joseph Taylor, Bellows described the production of his early lithographs, an enterprise that had become for Bellows sufficiently important to expound on at length. As his letter makes clear, Bellows was fascinated by all phases of lithographic production. He employed a stone grainer to prepare the stones to receive a new design, as well as the printer George Miller, who came to the studio three nights a week when the absence of daylight led Bellows to put aside painting.

I draw direct on giant stones which I have invented ways and means of handling . . . I print ap[p]roximately 50 proofs of each stone and while the stone is easy to spoil and change, by expert handling the proofs can be made to vary or not and the limit is only that of practicality or desire. The great disadvantage is that all the editions must be pulled of course before a new drawing can be made on the stone. I have six stones and can draw on both sides. The process is chemical and not mechanical as in etching and engraving. The principle being the opposition of grease and water. We draw with sticks of grease loaded with lamp black with greasy ink or wash in a special and rare limestone. The white parts are kept wet when inking for printing. And the stone is treated with slight etch and gum arabic to reduce the grease and keep it in place. . . . This is great work for night and dark days of which there are too many here in New York in winter, and I am busy as the proverbial bee.[18]

17. In addition to the thirty-four prints produced in 1916, Bellows listed fourteen for 1917 in his Record Book B, p. 139. He did not record his 1917 Christmas card, a lithograph (Mason 50) made after his oil painting of 1914, *Love of Winter* (Art Institute of Chicago).

18. Bellows to Taylor, March 15, 1917, Bellows Papers, Amherst College, box I, folder 13. This letter is Bellows' most revealing statement concerning lithography. Toward the end of his life, Bellows also prepared an article on lithography for the *American Art Student and Commercial Artist*. The article is referred to in two issues of the magazine, September 1925, p. 11 and November 1925, p. 56. However, a review of the periodical reveals that the article was apparently never published.

On Bellows printing at night, see Rollo Walter Brown, *Lonely Americans* (New York: Coward-McCann, 1929), p. 160.

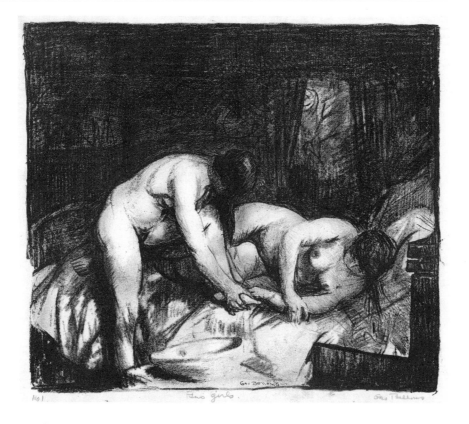

7.
Two Girls, 1917
Lithograph
7⅝ × 8¹³⁄₁₆ in.
Amon Carter Museum

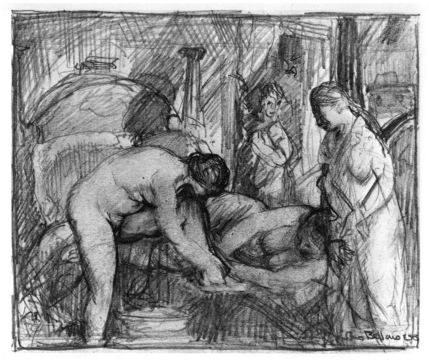

8.
Two Girls, c. 1916
Graphite on paper
5⁷⁄₁₆ × 7¹⁄₁₆ in.
Boston Public Library,
Print Department;
Gift of Emma Story Bellows

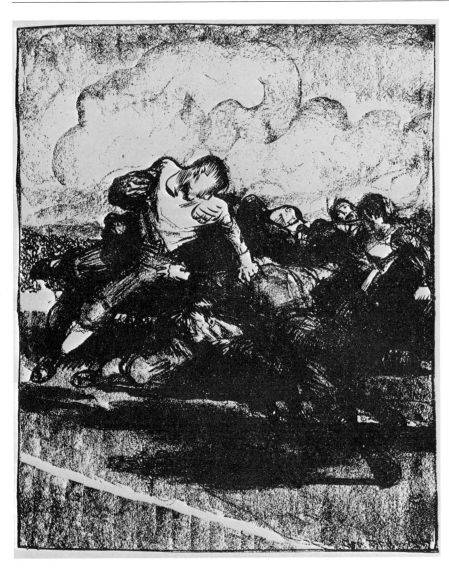

9.
*"Weekes Began a Spectacular
Hurdling of Their Line and
Backs...."*
Everybody's Magazine 27
(November 1912): 639
Mary Couts Burnett Library,
Texas Christian University,
Fort Worth, Texas

An essential property of lithography for Bellows was its ability to reproduce the autographic quality of drawing, and his prints were in part an outgrowth of his remarkable skill as a draftsman. Drawing had fascinated him as a child and he produced many sketches during his student years at Central High School in Columbus, Ohio, and at Ohio State University. The drawings from this early period include copies of historical prints and humorous caricatures for the school yearbook characterized by the tight, controlled style of the leading turn-of-the-century illustrators and cartoonists.[19] Once in New York, Bellows parlayed his background as an amateur draftsman into a career as a professional magazine illustrator. For many in the Henri circle, Sloan and Glackens among them, such commissions provided both a livelihood and a popular forum for artistic expression. Their illustrations, sometimes political or satirical in nature, were executed in a simplified realistic manner, expressing themes that were readily comprehensible to a wide audience. Many of the pictorial ideas first essayed by Bellows in his magazine illustrations of 1913 to 1915 became the basis for his earliest ventures in lithography.

Illustrations executed for some of the major periodicals of the day, including *American Magazine, Harper's Weekly*, and *The Masses*, proved a rich source of material. In these illustrations, which often accompanied stories about sporting events, Bellows provided spirited interpretations of the narrative, often electing to describe the climactic moment. Typical are the illustrations he made for the short story "Hold 'Em," a fictionalized account of an Ivy League football game by Edward Lyell Fox, in the November 1912 issue of *Everybody's Magazine* (fig. 9). As early as 1909 Bellows was commended along with Jerome Myers, Maurice Prendergast, William Glackens, John Sloan, and others for his skill as both artist and illustrator—

19. A number of these drawings are in the collection of the Mead Art Museum, Amherst College. See the exhibition catalogue *George Wesley Bellows* (Amherst, Mass.: [Amherst College], 1972).

an ability to give a convincing semblance of reality based on intimate familiarity with his subject.[20] Bellows and his compatriots in the Henri circle helped to usher in a distinctive style that ran counter to the prevailing delicate pen and ink style of much contemporary illustration. Some periodicals provided a generous amount of space for artists, often allowing two full pages per illustration. Like some of the French illustrators including Steinlen and Gavarni, to whom he was often compared, Bellows employed a lively, expressive style. He shared their humanitarian themes, even when portraying the anecdotal moment as in his 1914 illustration for the *Masses*, "Dey's Worms in It!" (fig. 10).

Some of his drawings depicting street life, first used as magazine illustrations, Bellows later turned into prints. *The Street* (fig. 11), a lithograph executed in 1917, is set beneath the elevated tracks and filled with characters from the immigrant families of the Lower East Side that held a particular fascination for him. In 1913 he had treated this subject in a drawing titled *"I Was Beatin' 'is Face"* for a *Harper's Weekly* story, a morality tale of religious and racial prejudice that told of a fight between a Jewish and a Christian boy.[21] In the *Harper's* drawing (fig. 12), one of the boys is apprehended by a policeman following the altercation. In another version of the

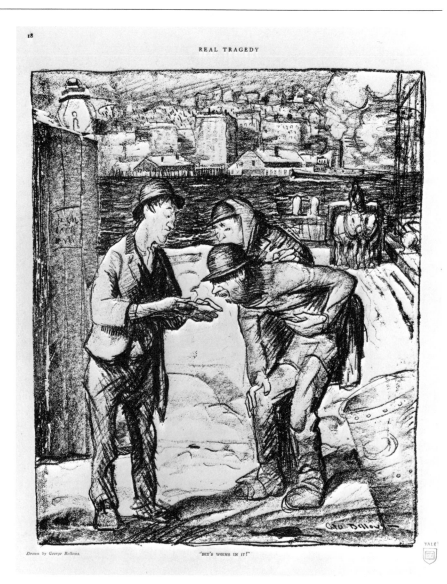

REAL TRAGEDY

Drawn by George Bellows.　　　"DEY'S WORMS IN IT!"

10.
"Dey's Worms in It!"
The Masses 5 (February 1914): 18
The Yale Collection of American Literature,
Beinecke Rare Book and
Manuscript Library,
Yale University,
New Haven, Connecticut

20. "Foremost American Illustrators: Vital Significance of Their Work," *Craftsman* 17 (December 1909): 266–280. For studies of Bellows' magazine illustrations in connection with his lithographs, see Charlene Stant Engel, "George W. Bellows' Illustrations for the *Masses* and Other Magazines and the Sources of His Lithographs of 1916–17" (Ph.D. diss., University of Wisconsin-Madison, 1976), and Engel, "The Realists' Eye: The Illustrations and Lithographs of George W. Bellows," *Print Review* 10 (1979): 70–86.

21. The drawing accompanied a story by Curt Hansen, "Fixing the Responsibility," *Harper's Weekly* 58 (April 11, 1914): 18–19; two copies of the drawing were recorded in the artist's Record Book A, p. 284.

A similar theme is treated in the oil *The Cliff Dwellers* of 1913 (Los Angeles County Museum of Art) and the related work *Why Don't They Go to the Country for a Vacation?* (1913, Los Angeles County Museum of Art), apparently a transfer lithograph reworked with pen, published in the August 1913 issue of the *Masses*. See Rebecca Zurier, *Art for the Masses (1911–1917): A Radical Magazine and Its Graphics* (New Haven: Yale University Art Gallery, 1985), p. 143.

The Street, 1917
Lithograph
18 15/16 × 15 1/8 in.
Amon Carter Museum

drawing (fig. 13) the focus shifts from the boy and policeman to two female figures. Bellows based his print on this second drawing, further removing it from the original narrative by replacing the policeman with a scolding woman. Minor onlookers in the first drawing, the two strolling women are now prominently placed in the foreground, their elegant bearing emphasized by the contrast of their white gowns against the shadows of the darker background. Their insouciant attitude accentuates the economic disparity between the classes, a subject favored by some of Bellows' associates but less common in his own work. Class distinction was, however, a pervasive theme of the radical magazine *Masses*, which published the lithograph in July 1917.

Three prints of 1916, *Business-Men's Class, Reducing No. 1*, and *Reducing No. 2*, based on drawings that had appeared in the *Masses*, demonstrate Bellows' penchant for satire. *Business-Men's Class* (fig. 14), which depicts a motley group of health enthusiasts, has a cartoonlike quality imparted by the exaggerated, ungainly physiques and nonchalant visages. A talented and well-rounded athlete himself, Bellows had played basketball and semi-professional baseball in Ohio, and he continued to participate in sports following his move to New York. His own athletic ability probably prompted his playful, slightly disdainful view of professional men whose sedentary jobs allow only this futile attempt to mimic the perfect, attenuated form of their instructor. In the generalized, linear treatment of the figures and background and its emphasis on gesture the print is reminiscent of the lithographs of Honoré Daumier. Interestingly, Bellows' original "drawing" of this scene (fig. 15) appears to be a monoprint, the design drawn on paper that had been placed face down on an inked surface, the image then heavily worked over with ink, crayon, graphite, and collage.[22] In making the translation to lithograph,

22. I am grateful to Marjorie B. Cohn, Head Conservator, Fogg Art Museum, for this information. This drawing has also been identified as a transfer lithograph; see Zurier, *Art for the Masses*, p. 113 and p. 137, n. 25, who identifies three early works as being reworked transfer lithographs: *Philosopher-on-the-Rock* (Collection of Yvette Eastman), *Why Don't They Go to the Country for a Vacation?* (Los Angeles County Museum of Art), and *Splinter Beach* (Dr. and Mrs. Harold Rifkin).

"I WAS BEATIN' 'IS FACE."

12.
I Was Beatin' 'is Face, 1913
Crayon, ink, and graphite on paper
24¼ × 18 in.
The Nelson-Atkins Museum of Art, Kansas City, Missouri;
Gift of Mr. and Mrs. Herbert O. Peet

13.
Pinched ("I Was Punchin' His Face."), 1914
Graphite, black crayon, and pen and ink on composition board
26⁷⁄₁₆ × 19⁵⁄₈ in.
Boston Public Library,
Print Department;
Gift of Albert Henry Wiggin

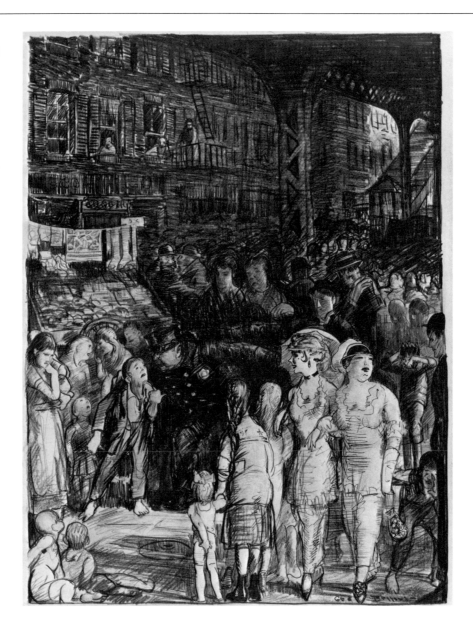

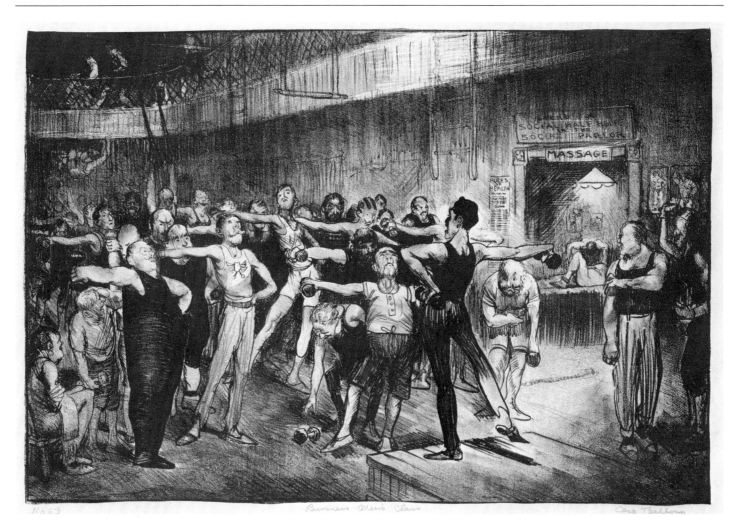

14.
Business-Men's Class, 1916
Lithograph
11½ × 17¼ in.
Amon Carter Museum

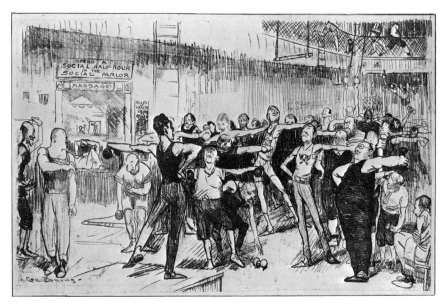

15.
The Businessmen's Class, 1913
Monotype with ink, crayon,
graphite, and collage on paper
22¼ × 28¹⁄₁₆ in.
Boston Public Library,
Print Department;
Gift of Albert Henry Wiggin

Bellows retained the pen and ink quality of the original yet heightened the atmospheric quality, yielding a more finished composition and a moderation of the pointed satirical content.

Reducing, another pictorial essay on physical fitness, reveals Bellows' increasingly sophisticated handling of the lithographic medium. Based on a drawing published in the *Masses* in November 1915, the lithograph was issued in two versions in 1916, the first (fig. 16) evidently unsatisfactory to the artist as it was printed in a small edition (see Appendix A). The second version (fig. 17) resolves the awkward compositional problems of the earlier print. (Later, in 1921, Bellows made a third version of the print; fig. 61.) In the first version, the corpulent female figure is crudely foreshortened, while in the second version the woman's limbs are more gracefully arranged, her left rather than her right leg is stretched above her body, and the dispersal of light and dark passages is more balanced. Evidently Bellows considered this print an exercise in composition and tone; he described it in the 1919 Roullier catalogue as "a study which started out in a humorous vein but developed into a drama of light and dark. The picture is as interesting upside down." The lithographic medium was a favored outlet for Bellows' good-natured humor; the gallery note continues: "Gymnastics before retiring are supposed to reduce the flesh. The husband is contented with his figure." The frankness of this intimate scene was not palatable to all of the artist's audience, however, and it received some harsh words from the critics and more sensitive members of the public. Bellows' treatment of social mores again suggests Daumier's precedent. The diagonal placement of the bed and the figure on the floor in her bedclothes specifically recall the French artist's *Rue Transnonain* (fig. 18), of which Bellows made a copy in 1908.[23] The subject of Daumier's scene, however—political strife in France dur-

23. Bellows' gallery note can be found in the 1919 Roullier exhibition catalogue, n.p. He records his copy of the Daumier print in Record Book A, p. 50.

Rollo Walter Brown recounts that "a very stout woman," who at first glance thought the print depicted a lovely shell, was outraged when she recognized the subject (*Lonely Americans,* pp. 137–138).

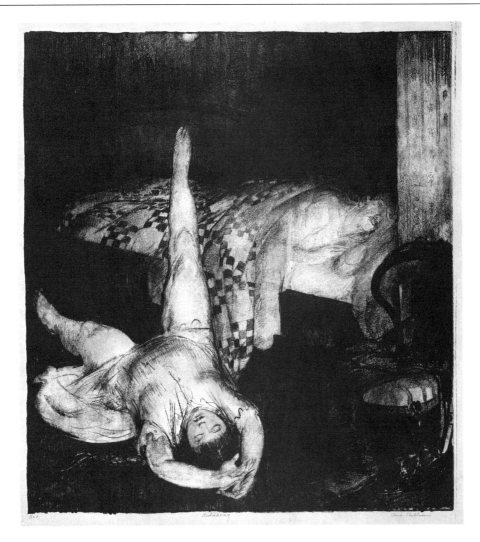

16.
Reducing No. 1, 1916
Lithograph
17 13/16 × 16 1/2 in.
Amon Carter Museum

17.
Reducing No. 2, 1916
Lithograph
17¹¹/₁₆ × 16½ in.
Amon Carter Museum

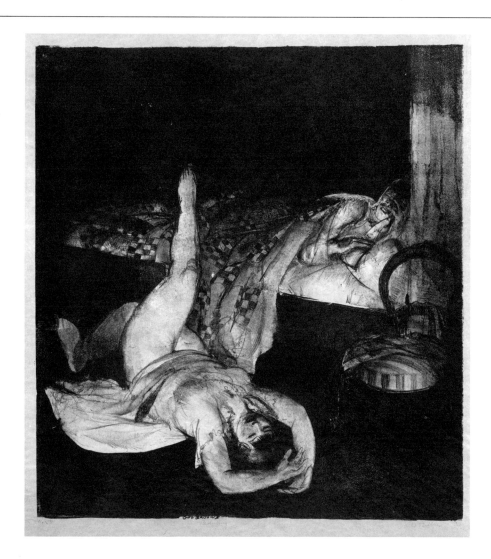

18.
Honoré Daumier
Rue Transnonain, 1834
Lithograph
11⁷/₁₆ × 17½ in.
Museum of Fine Arts, Boston

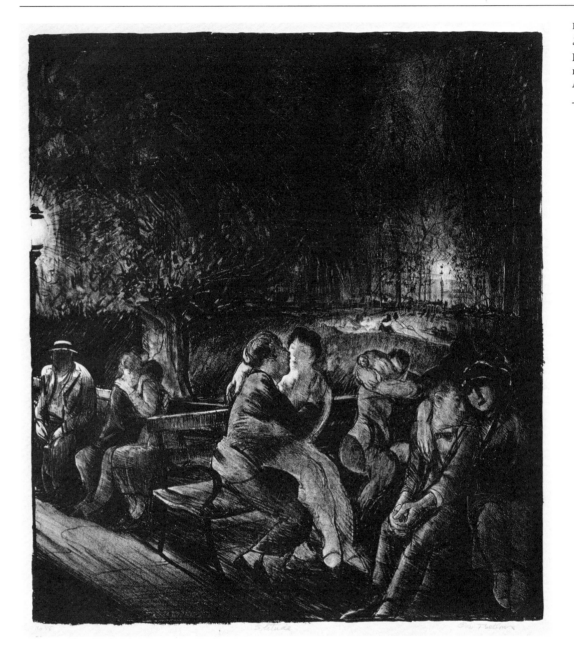

19.
Solitude, 1917
Lithograph
17 1/16 × 15 3/8 in.
Amon Carter Museum

20.
The Strugglers, 1913
Ink, crayon, scratchwork, and
collage on paper
27¾ × 23¼ in.
Boston Public Library,
Print Department;
Gift of Albert Henry Wiggin

ing the 1830 revolution—could not be further
removed in spirit from the domestic, light-
hearted moment depicted by Bellows. Al-
though Bellows would later treat themes of
greater social consequence, it was the humor-
ous, satirical approach that characterized many
of his best prints during the first years of his
lithographic production.

In two other lithographs from this period, set
outdoors, Bellows exploited the black and white
medium's potential for rich atmospheric effects.
The 1917 lithograph *Solitude* (fig. 19), together
with the related drawing known as *The Strug-
glers* (fig. 20), provides insight into his experi-
ments in method. The scene is nocturnal; two
lamps illuminate embracing couples while a sol-
itary man, his face obscured by shadows, gazes
upon the lovers. Published in the *Masses* in June
1913, *The Strugglers* is a rough, unpretentious
drawing, heavily textured and worked over in a
variety of media. Its dense blacks are mitigated
only by a few traces of pen and ink, with high-
lights created by scratching into the rich, pig-
mented surface. In translating the drawing to
print, Bellows retained the key highlights, cut-
ting down the composition to give more em-
phasis to the figures. A related lithograph of
1916, *Philosopher on the Rock* (fig. 21), depicts a
group of children in a park; though a daytime
subject, it seems almost nocturnal because of the
extensive use of tusche for the foliage—a tech-
nique Bellows employed more effectively in the
lithograph *In the Park* (figs. 23, 24). *Philosopher
on the Rock* and *Solitude* bear a similarity to Bel-
lows' paintings of nocturnal scenes, *Summer
Night, Riverside Drive* (1909, Columbus Mu-
seum of Art) and *Rainy Night* (1916, Museum of
Fine Arts, Boston). His interest in rendering
light and dark contrasts was readily translated to
the black and white medium of lithography.

For Bellows, drawing was the foundation of
all artistic endeavor: "[painting] occurs simulta-
neous with and is inseparable from the act of
drawing; depends for its artistic value on its
beauty and significance, on the shapes, direc-
tions, contrasts and relations with which it is
drawn." Practically as well as theoretically,

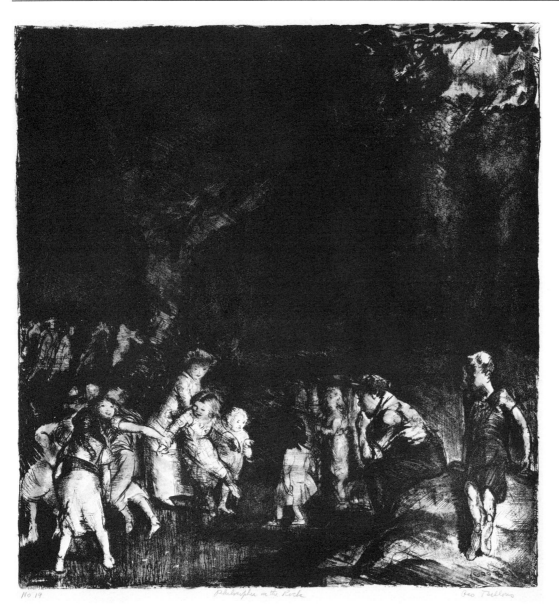

No 19 Philosopher on the Rock Geo Bellows

21.
Philosopher on the Rock, 1916
Lithograph
19¾ × 18⅞ in.
Amon Carter Museum
ALSO FIG. 150

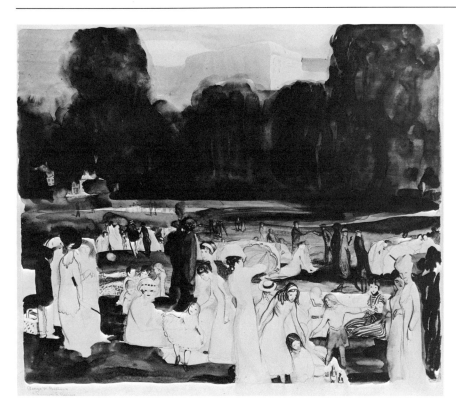

22.
Luncheon in the Park, 1912
Ink wash on paper
16¾ × 20¾ in.
Albright-Knox Art Gallery,
Buffalo; George Cary Fund, 1965

drawing (and, by extension, printmaking) de-
served recognition: "It is a pathetic and unfor-
tunate fact that beautiful, valuable, significant
drawings by living American artists are prac-
tically never sold and yet sums from 20 to 100
dollars would buy most of them, and prints at
even less. For the price of a theatre ticket or so
one can buy the proof of an etching by John
Sloan who in my humble opinion is the greatest
living etcher and a very great artist."[24] Bellows
employed a variety of media—watercolor, pen
and ink, and crayon—in his drawings of this
period, and his lithographs reflected some of
this technical diversity.

His two 1916 lithographs titled *In the Park*,
for example, based on an ink wash executed
some four years previous (fig. 22), retain the
fluidity of the drawing. Bellows had also essayed
the park setting in earlier paintings in which he
set a band of figures across the picture plane,
framing them with foliage.[25] The lithograph
exists in multiple states, the darker versions
known as *In the Park, Dark* (fig. 23) and that in
which the upper section is more distinct as *In
the Park, Light* (fig. 24). (The complicated rela-
tions of these multiple states are discussed in
Appendix A.) The figures in these prints are
rendered with a minimal use of descriptive line,
enabling them to be seen against the dark back-
ground. While in his paintings Bellows could
make distinctions between forms through
color, in the lithographs spatial definition was
achieved through variation in tone. In the
darker versions the figures are placed against a
nearly opaque background that suggests a noc-

24. George Bellows, essay printed in Emma S. Bellows,
The Paintings of George Bellows (New York: Alfred A.
Knopf, 1929), p. viii; transcript of a speech to the National
Arts Club (1920), Charles Morgan Papers, Amherst Col-
lege Archives, box V, folder 18.

25. See, for example, *Central Park* (1905, The Ohio State
University, Columbus) and *May Day in Central Park* (1905,
private collection).

An oil painting (1913, The Detroit Institute of Arts) was
executed after the drawing on which *In the Park* was based.
Bellows himself described the evolution of the theme:
"This study has been through various states. First as a wash
drawing, second as a painting owned by the Detroit Mu-
seum of Art, together with two distinct states in the litho-
graph. In the second state all the upper half is re-drawn.
This is a study in which beauty of color and design are the
whole motive." (Roullier Galleries, exhibition catalogue,
1919, n.p.)

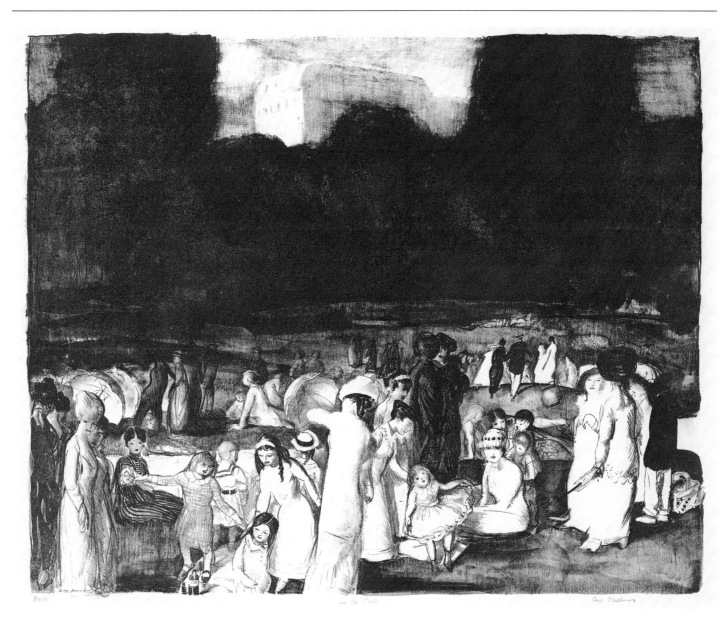

23.
In the Park, Dark, 1916
Lithograph
17 1/16 × 21 3/8 in.
Amon Carter Museum
ALSO FIG. 135

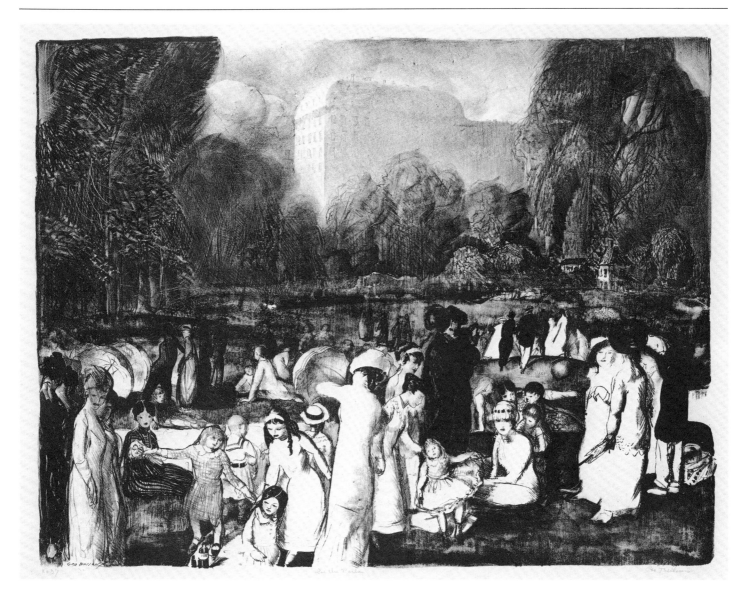

24.
In the Park, Light, 1916
Lithograph
16⅛ × 21⁵⁄₁₆ in.
Amon Carter Museum
ALSO FIG. 132

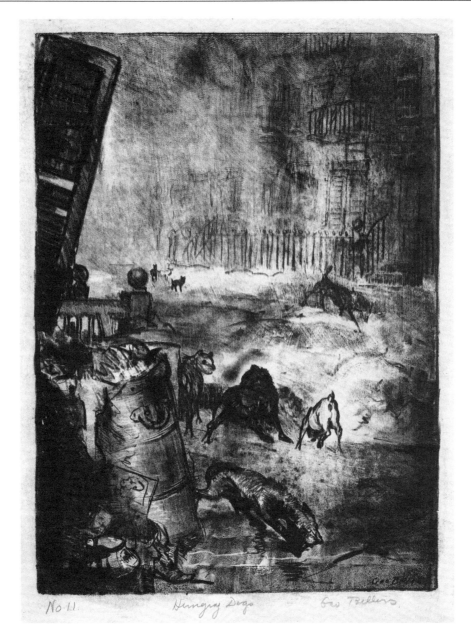

No 11. Hungry Dogs Geo Bellows

25.
Hungry Dogs No. 1, 1916
Lithograph
13⅛ × 9¹³⁄₁₆ in.
Amon Carter Museum
ALSO FIG. 129

turnal setting, although the activity is clearly taking place in the daytime hours. In the other state, Bellows produced a print in which the setting is more legible. He apparently considered both versions satisfactory, for they were exhibited together.

Although the subjects of many of Bellows' early lithographs were based on his commissioned illustrations, he also drew upon earlier, finished drawings unrelated to commissioned works. The 1916 lithograph *Hungry Dogs* (fig. 25), a charmless and gritty scene of dogs rummaging through the trash in a New York City street, is befitting of the "Ashcan School" designation often assigned to some of Bellows' colleagues. Based on a drawing of 1907, the image was reproduced in *Harper's Weekly* in 1913. Bellows closely followed his original 1907 conception in the lithograph, which is nearly the same size as the drawing and bears the hallmarks of Bellows' early experiments in lithography. The image exists in at least three closely related versions—the entire first print was redrawn on a second stone, and this second version was then executed in two states (see Appendix A). Bellows also experimented with different colors of ink, and one impression was executed on tissue paper and then adhered to a stronger paper. Bellows' early prints often came off the press too dark, and in this series he employed the subtractive method of removing selected dark areas to lighten the print. At last achieving the desired effect in the final state, he marked one impression "first good proof."[26]

Ten years separated the 1907 crayon and charcoal drawing *Dance in a Madhouse* (fig. 26) and the subsequent lithograph (fig. 27). Like some of his other uncommissioned work, this drawing has a broad, gestural quality, unlike the more linear style he used in his illustrations. His subtle control of atmospheric effects has stronger ties to his work in other media such as the 1906 oil *Kids* (fig. 28), where similarly amorphous figures are accented by strong highlights.

The emphasis on gesture and on richly shadowed faces imparts to the work a vaguely unsettling tone. The *Dance in a Madhouse* lithograph captures the dramatic impact of the drawing, repeating its irregular textures and its incongruous combination of despair and pleasure. Bellows depicts the residents of the hospital for the insane in Columbus, Ohio, where a family friend served as the superintendent. The grotesque aspect of this frenzied scene of patients dancing during a social hour is reminiscent of Goya, to whose work Bellows powerfully responded. His own description of the scene reveals a sensitivity to the humanity of his subjects: "For years the amusement hall was a gloomy old brown vault where on Thursday nights the patients indulged in 'Round Dances' interspersed with two-steps and waltzes by the visitors. Each of the characters in this print represents a definite individual. Happy Jack boasted of being able to crack hickory nuts with his gums. Joe Peachmyer was a constant borrower of a nickel or a chew. The gentleman in the center had succeeded with a number of perpetual motion machines. The lady in the middle center assured the artist by looking at his palm that he was a direct descendant of Christ. This is the happier side of a vast world which a more considerate and wise society could reduce to a no inconsiderable degree."[27] Putting pencil to paper allowed Bellows free reign to communicate these impressions, an immediacy he translated very effectively to the lithograph.

26. The print with the tissue paper is in the collection of the Amon Carter Museum. The inscribed print is owned by the Mead Art Museum, Amherst College. The original drawing was reproduced in *Harper's Weekly* 58 (September 6, 1913): 21.

27. Roullier Galleries, exhibition catalogue, 1919, n.p. The charcoal drawing of *Dance in a Madhouse* was published in *Harper's Weekly* on August 23, 1913.

The analogy to Goya's work was frequently remarked upon by contemporary critics. See, for example, Edmund Wilson, "George Bellows," *New Republic* 44 (October 28, 1925): 254–255. Bellows may have been familiar with the collection of Goya's prints at the New York Public Library. Bellows' own library included a book on Goya, *Aureliano de Beruete, Goya, Pintor de Retratos*. See Eleanor M.Tufts, "Bellows and Goya," *Art Journal* 30 (Summer 1971): 362–368, and Tufts, "Realism Revisited: Goya's Impact on George Bellows and Other American Responses to the Spanish Presence in Art," *Arts Magazine* 57 (February 1983): 105–113. Besides *Dance in a Madhouse*, Tufts has identified other parallels with Goya's work among Bellows' lithographs, including *Two Girls, Initiation in the Frat, Girl Fixing Her Hair, A Knock-Out, Benediction in Georgia, The Drunk*, and the lithographs from Bellows' war portfolio.

While Bellows' early lithographs were frequently inspired by a single drawing, some continued themes he explored repeatedly. The leisure moments of his fellow New Yorkers were treated in a number of oils and lithographs devoted to young boys swimming in the East River. The lithograph *Splinter Beach* (fig. 29) selects episodes from youthful play—lounging, arguing, and swimming or preparing to swim. The youths are situated underneath the Brooklyn Bridge, their activity set against a sweeping view of the city—a composition Bellows favored in his oils (fig. 30). The theme was first developed in two paintings, *Forty-two Kids* (1907, The Corcoran Gallery of Art, Washington, D. C.) and *River Rats* (1906, Everett D. Reese, Columbus, Ohio). Then, in 1912, Bellows made a drawing—like the drawing for *In the Park*, an ink and wash sketch—that introduced the composition later developed in the lithograph. In the drawing (fig. 31) he eliminated the distant, bird's-eye vantage point of the oils, focusing on the slight figures and good-humored interaction of the youths. In a second drawing, reproduced in 1913 in the *Masses*, Bellows reversed the composition of the earlier drawing, eliminating some of the figures (fig. 32) and making other minor changes.[28] For the lithograph he again reorganized the figures, preserving those poses he found particularly successful, adding more nude figures, and giving increased emphasis to the playful vigor of the youths. As a final amusing touch, he added his signature to the tugboat that navigates the river in the middle ground of the composition.

Of all the subjects drawn from Bellows' career as an illustrator and painter, it was the theme of sports, and boxing in particular, that earned his prints the greatest renown. In 1907 and 1909 he had portrayed the boxing arena in three oils, *Club Night* (National Gallery of Art), *Stag at Sharkey's* (Cleveland Museum of Art), and *Both Members of This Club* (National Gallery of Art).

26.
Dance in a Madhouse, 1907
Black crayon, charcoal, and pen and ink on paper
18⅞ × 24⅝ in.
The Art Institute of Chicago;
Charles H. and Mary F.S.
Worcester Collection

28. In his Record Book A, Bellows wrote: "Black & White, SPLINTER BEACH WHARF RATS, Feb. 1912, wash & crayon, 17 x 22" (p. 132) and "June, 1913, Drawings, Pub. in MASSES, PARK BENCHES, Sept. 1913, MASSES/Drawing, SPLINTER BEACH, Pub. in MASSES, Aug. 1913" (p. 160). Figure 32 has also been identified as a transfer lithograph; see note 22.

27.
Dance in a Madhouse, 1917
Lithograph
18⅜ × 24⁷⁄₁₆ in.
Amon Carter Museum

28.
Kids, 1906
Oil on canvas
32 × 42 in.
Rita and Daniel Fraad Collection

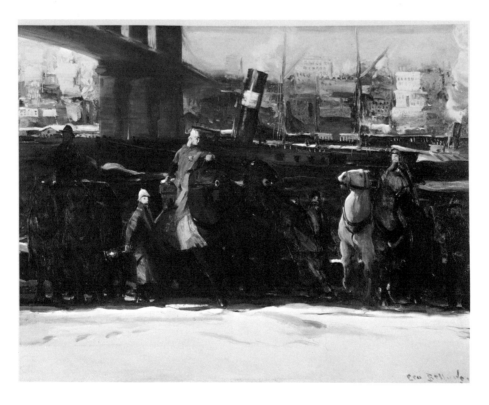

30.
Snow Dumpers, 1911
Oil on canvas
36⅛ × 48⅛ in.
Columbus Museum of Art,
Columbus, Ohio;
Museum Purchase, Howald Fund

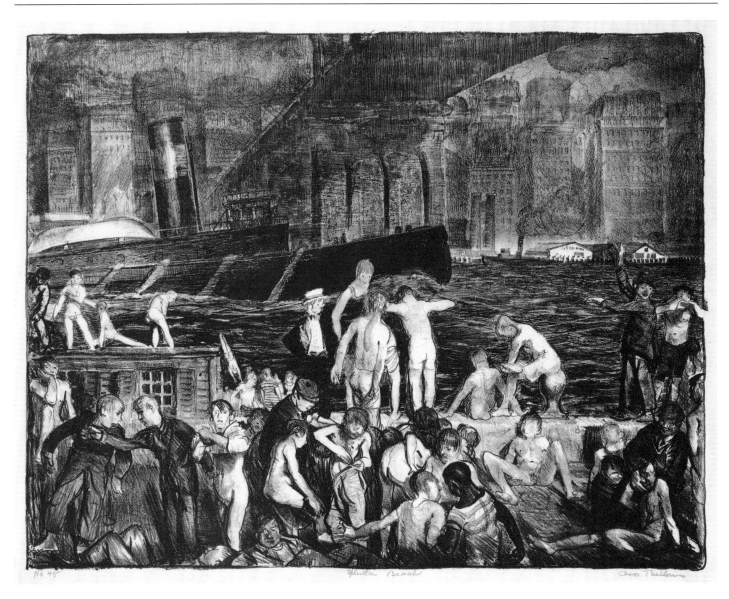

29.
Splinter Beach, 1916
Lithograph
15 1/16 × 19 7/8 in.
Amon Carter Museum

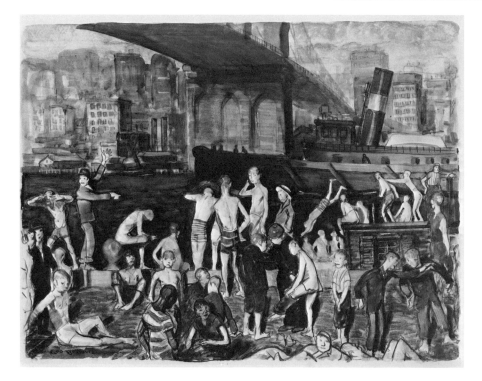

31.
Splinter Beach, 1912
Graphite, black crayon, pen and
ink, and ink wash on paper
21¹³⁄₁₆ × 27¼ in.
Boston Public Library,
Print Department

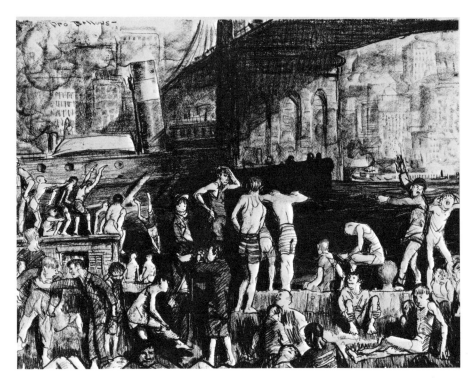

32.
Splinter Beach, 1913
Graphite on paper
17 × 22½ in.
Collection of Dr. and Mrs. Harold
Rifkin

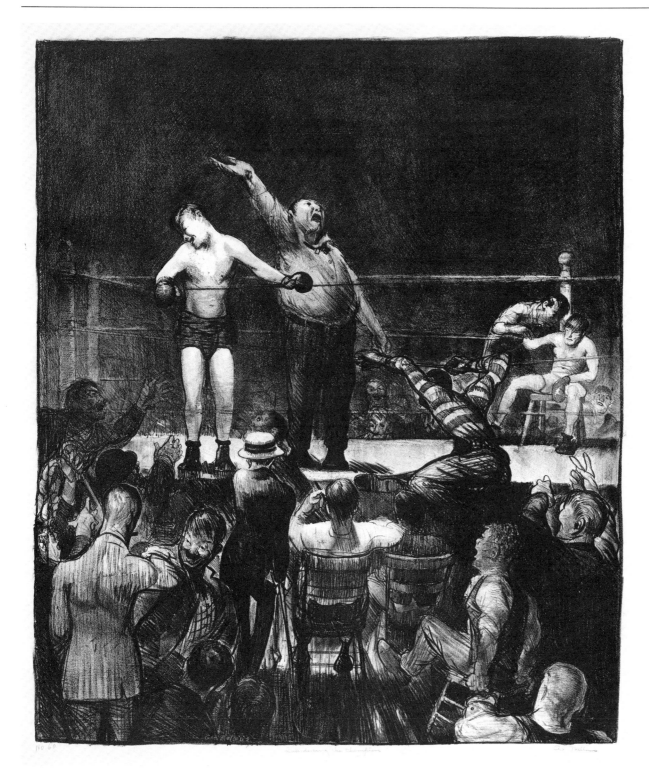

33.
Introducing the Champion,
1916
Lithograph
24 9/16 × 21 1/16 in.
Amon Carter Museum

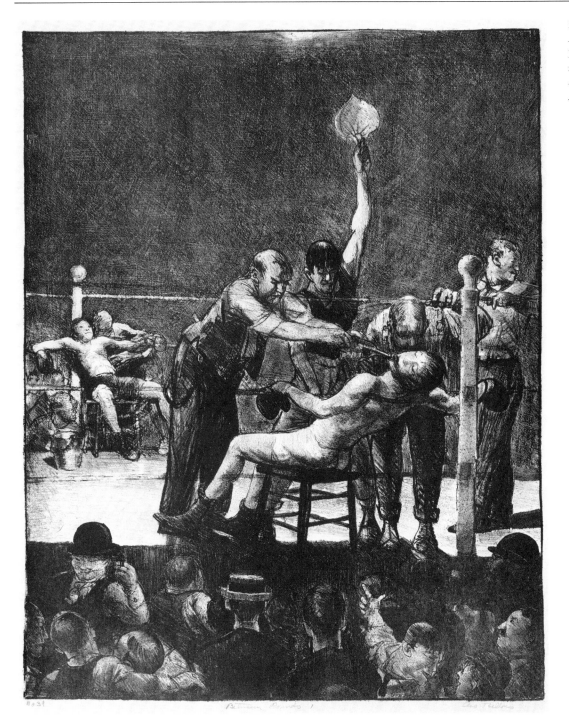

34.
Between Rounds No. 1, 1916
Lithograph
20⅝ × 16⁹⁄₁₆ in.
Amon Carter Museum

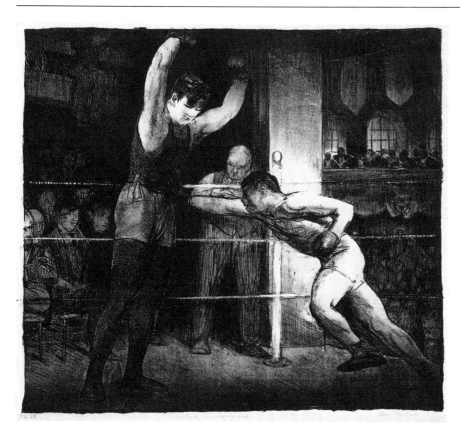

35.
Training Quarters, 1916
Lithograph
15⅜ × 17½ in.
Amon Carter Museum

Thereafter Bellows was sought out by newspapers and magazines for his records of sporting events, both actual and fictional. His illustrations often emphasized groups of bodies in motion rather than the individual athlete. He favored elongated, plunging forms, as in the drawing for the football story "Hold 'Em," that recall his boxers lunging at their opponents. In the best of these sporting illustrations, he captured the camaraderie and competitive spirit of gamesmanship that he knew so well from first-hand experience.

In April 1913 *American Magazine* acquired four illustrations by Bellows to accompany a short story by L.C. Moise, "The Last Ounce." Bellows later used these illustrations as the basis for a number of lithographs, beginning with two in 1916, *Introducing the Champion* (fig. 33) and *Between Rounds No. 1* (fig. 34). Moise's story involved the relationship between a former champion, Jimmy Nolan, currently down on his luck, and his rival, both in and out of the ring, Tornado Black. *Introducing the Champion* emphasizes the confidence of Tornado Black, the reigning champion, before the fight commences. In *Between Rounds*, Nolan is resuscitated by his trainer during a rest period.[29] The drawings Bellows made for *American Magazine* were conceived in illustrational, descriptive terms, with a network of small lines describing both the figures and the shaded areas. This style was carried into the 1916 prints where, as in the drawings, attention is dispersed among multiple interactions of spectators and figures in the ring.

Two other lithographs treat subjects drawn from a historical boxing match. In 1916 Bellows was commissioned by *Collier's* to make three drawings of Jess Willard, who had defeated Jack Johnson and was training for a fight with Frank Moran. The drawings are now unlocated, but Bellows' lithographs *Training Quarters* (fig. 35)

29. Bellows returned to subjects from this commission in several lithographs of 1921 and 1923. See Linda Ayres, "Bellows: The Boxing Drawings," in E. A. Carmean, Jr., et al., *Bellows: The Boxing Pictures* (Washington, D. C.: National Gallery of Art, 1982), pp. 54–57 for a discussion of this series.

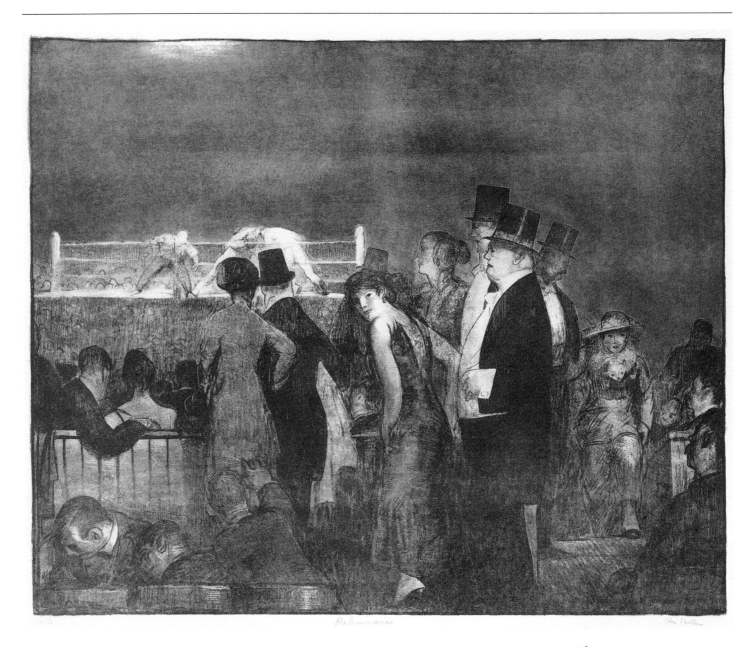

36.
Preliminaries, 1916
Lithograph
15¹³/₁₆ × 19¾ in.
Amon Carter Museum

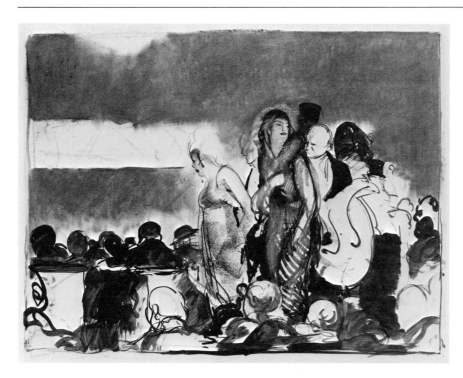

37.
Preliminaries to the Big Bout,
1916
Black crayon and brush and india
ink wash on paper
21⁵/₁₆ × 26 in.
Boston Public Library,
Print Department

and *Introducing John L. Sullivan* (fig. 121) derive from the same occasion. The former is an action scene, featuring Willard and a sparring partner. Bellows' interest in boxing also extended beyond the action in the ring to the characters he found there; a noncombative scene is the subject of *Introducing John L. Sullivan*. Bellows described his fascination with the aging Sullivan, a former boxing champion, who appears to the left of the announcer in the print: "I saw Sullivan only once, and as I have him in this print. He was a great old Viking, walked on his toes, conscious of his breadth of beam and vast shoulders; and had a smile which included the whole of humanity with himself well in the center. Robert Fitzsimmons is on the left; Willard is having his gloves adjusted for his fight with Moran."[30] In both prints, Bellows places the viewer in the boxing ring itself, close to the action. The pictorial device of gesture also has an important organizational function for Bellows, and, as in the lithographs made after drawings for "The Last Ounce," the artist relies on the expressiveness of pose to further the narrative.

Two uncommissioned works, *Preliminaries* and *A Stag at Sharkey's*, show the full extent of Bellows' creative range in rendering boxing scenes in lithographic form. The focus of *Preliminaries* (fig. 36), an elegant contrast to the powerful *Stag at Sharkey's*, is not the boxing match itself but the upper classes of society who patronize it. The scene is set in Madison Square Garden, where the more fashionable spectators, removed a considerable distance from the heat of the ring, comprise a relatively subdued audience. Probably derived from a crayon, ink, and wash sketch (fig. 37), the lithograph adds a woman turning to engage the viewer, a graceful note of psychological interplay uncommon in Bellows' prints. Contrasting with the refined beauty of *Preliminaries, A Stag at Sharkey's* (fig. 38) is placed in the masculine world of a New

30. Roullier Galleries, exhibition catalogue, 1919, n.p. On *Training Quarters*, see Ayres, "The Boxing Drawings," p. 58. The *Collier's* commission was presumably for drawings, although the artist's account book for 1916 lists the commission as "3 Lithos 300.00." ("Sales and Proffesional [*sic*] Income," n.p., manuscript in possession of Jean Bellows Booth.)

York bar, Sharkey's Athletic Club, to which Bellows had been introduced by a friend. At the time he made the oil version of *Stag at Sharkey's* in 1909, public boxing was illegal in New York (the law was repealed in 1910). Sharkey's was able to sponsor boxing contests by operating as a private club with paying memberships.[31] Perhaps because this print was not taken from a published illustration, Bellows holds anecdotal detail to a minimum. The print retains the dramatic impact of the oil with its spotlighting of the boxers—highlights are concentrated in the central portion of the composition where the clashing of heads and arms provides a powerful focal point for the print. The spectators that emerge from the dark arena reinforce the action rather than distract from it. The dark black ink employed by Bellows is a rich foil to the white paper. In this print Bellows proved himself a master of the lithographic medium, achieving a harmonious union of technique and subject. As in the best of his early prints, *Stag* resonates with a forceful emotive content, the product of an expressive technique and a provocative subject.

The emotional intensity of Bellows' boxing scenes was also expressed in his lithographs of social satire. His choice of subject matter reflects his interest in issues of the day, and his association with the *Masses*, an important forum for radical ideas, ensured that he remained at the forefront of current events. Through the writings of Floyd Dell, John Reed, Max Eastman, and others, the *Masses* gave voice to socialist philosophy. It also gave space to artists and writers attacking social or political convention, reflecting a larger sentiment among New York intellectuals of the pre-World War I period.[32]

Bellows' first illustration for the *Masses, Business-Men's Class*, was published in the April 1913 issue, and his name first appeared on the masthead as one of the art editors the following June. The tone of the magazine was conducive to satirical prodding, as seen in *Business-Men's Class* with its subtle criticism of the privileged upper classes. Issues of greater import were frequently addressed by Bellows and other artists in the pages of the *Masses*, among them capital punishment, prohibition, women's rights, religion, and political graft.

The *Masses* maintained high standards for its illustrations. In addition to Bellows it attracted the talents of Henri's associates, John Sloan and Stuart Davis, who went beyond their mentor in their political commentary. An editorial in the magazine's first issue set the standard for artistic excellence: "The Masses will print cartoons and illustrations of the text by the best artists of the country, on a quality of paper that will really reproduce them." In its sympathies for the working classes the art of the *Masses* demonstrated a kinship with contemporary European illustrators, and its rough, expressionistic style resembled that of Steinlen, Daumier, and Forain.[33]

Bellows was sympathetic with the goals of his more politically oriented colleagues at the *Masses* and worked comfortably within their milieu. Some of his illustrations for the periodical, such as *Philosopher on the Rock* and *Solitude*, did not take on controversial issues; others carried more blatant social commentary. Ultimately Bellows' involvement with the *Masses* was more artistic than political, and he had no interest in an overtly propagandistic approach. By 1917, feeling the magazine was treating its art staff as a mouthpiece for the opinions of the editors, he proposed that the art and literature departments should be maintained separately, allowing the artist to exercise control over his subject rather than serving the viewpoint of the writer: "You have got to get rid of obvious, heavy propaganda.—The public will not read it—and make what propaganda there may be,

31. See E. A. Carmean, Jr., "Bellows: The Boxing Paintings," in Carmean et al., *The Boxing Pictures*, pp. 29–30, 36. The setting of *Preliminaries* is given in the 1919 Roullier catalogue. In June 1923 Bellows executed a painting (Whitney Museum of American Art) based on the lithograph *Introducing John L. Sullivan*.

32. See Arthur Frank Wertheim, *The New York Little Renaissance: Iconoclasm, Modernism, and Nationalism in American Culture, 1908–1917* (New York: New York University Press, 1976).

33. *Masses* 1 (January 1911): 1; Zurier, *Art for the Masses*, pp. 108–112.

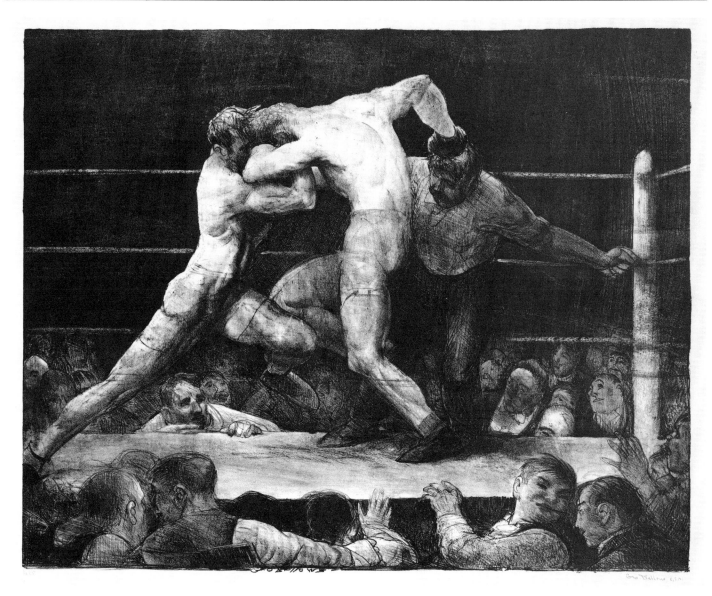

38.
A Stag at Sharkey's, 1917
Lithograph
18⁹⁄₁₆ × 23¹³⁄₁₆ in.
Amon Carter Museum

subtle, interesting, full of wit and art, or not at all. The social cartoon is an obvious and tiresome affair." [34] An idealist by nature, Bellows was friendly with the radical Emma Goldman and taught at her anarchist center, the Ferrer School. The recollections of his friends and colleagues make it clear that Bellows himself was far from a political activist. [35] Although he supported strikers and their ideals, he did not depict that quintessential socialist subject, the worker, nor did he equal some of his associates (Sloan, an active socialist, for example) in the bite of his satire. Nonetheless he took on the current issues that were closest to him, often diluted with humor, and these received their fullest expression in his lithographs.

One phenomenon that deeply affected Bellows was the pervasive influence of religious dogma in contemporary society. A section of the first exhibition to feature Bellows' lithographs exclusively, in November 1918 at New York's Keppel Gallery, was titled "Studies in Belief" and numbered five lithographs, *The Sawdust Trail, Benediction in Georgia, Prayer Meeting, The Novitiate,* and *In an Elevator.* An underlying theme of these prints is what Bellows considered to be the religious hyperbole of the era, a concern echoed in the pages of the *Masses,* which took a stand against organized religion. Bellows' ironic "studies," ranging from the preacher in *Benediction in Georgia* whose

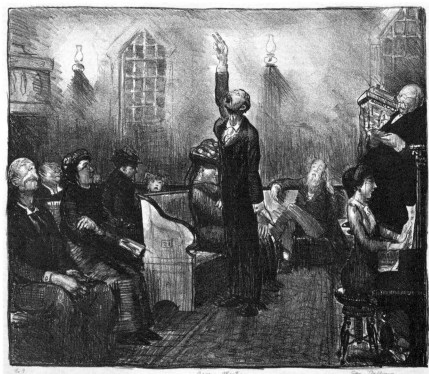

39.
Prayer Meeting No. 1, 1916
Lithograph
17⅞ × 21¾ in.
Amon Carter Museum

34. Bellows Papers, Amherst College, box IV, folder 4, quoted in Engel, "Bellows' Illustrations for the *Masses,*" p. 16. Bellows' final contributions to the *Masses* appeared in the July 1917 issue. His name continued to appear on the masthead through the last issue, November 1917.

35. The critic Forbes Watson, in recalling the many discussions of the Henri group, stated that although the participants might touch upon Emma Goldman, Alexander Beckman, Isadora Duncan, and the Ferrer School, the conversation always returned to painting: "talk of [Emma Goldman] made us feel pleasantly liberal if not radically advanced." (Typescript of a talk on Bellows given at the National Gallery of Art, Washington, D. C., May 27, 1945, Archives of American Art, Forbes Watson Papers, roll D54, frame 1348.) See also the recollections of Ed Keefe, Leon Kroll, Emma Bellows, and Eugene Speicher in Seiberling, "George Bellows," pp. 208, 214, 220, 228. Art Young, a fellow artist on the *Masses* staff, recalled Bellows' anarchist leanings in *Art Young: His Life and Times* (New York: Sheridan House, 1939), p. 388.

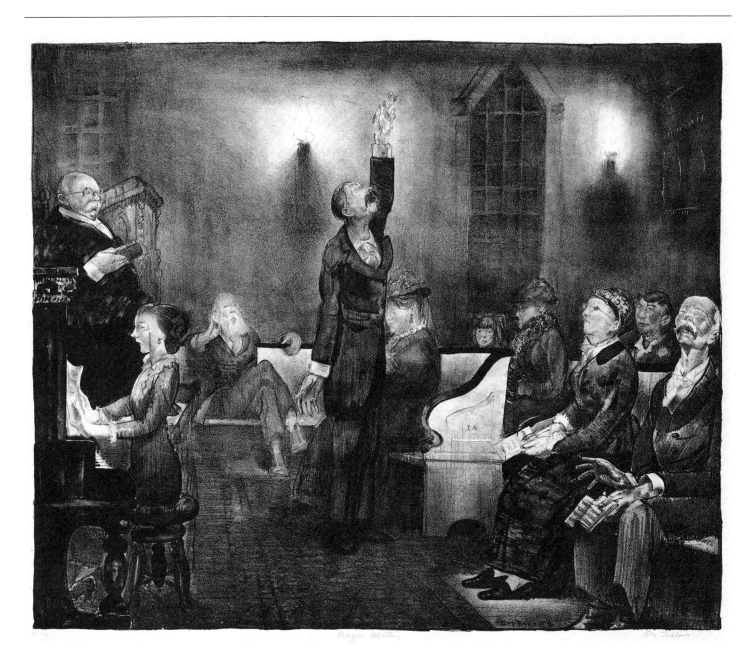

40.
Prayer Meeting No. 2, 1916
Lithograph
18⁵⁄₁₆ × 22¼ in.
Amon Carter Museum

41.
Prayer Meeting No. 1,
c. 1911–14
Pen and ink and ink wash on paper
5³⁄₁₆ × 6⁹⁄₁₆ in.
Boston Public Library,
Print Department;
Gift of Emma Story Bellows

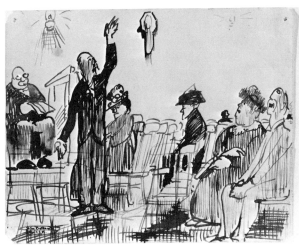

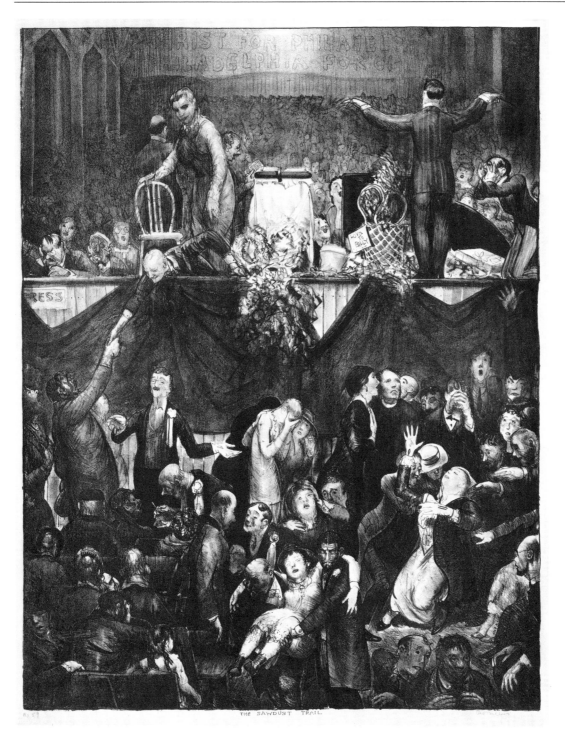

THE SAWDUST TRAIL

42.
The Sawdust Trail, 1917
Lithograph
25½ × 20 in.
Amon Carter Museum
ALSO FIG. 162

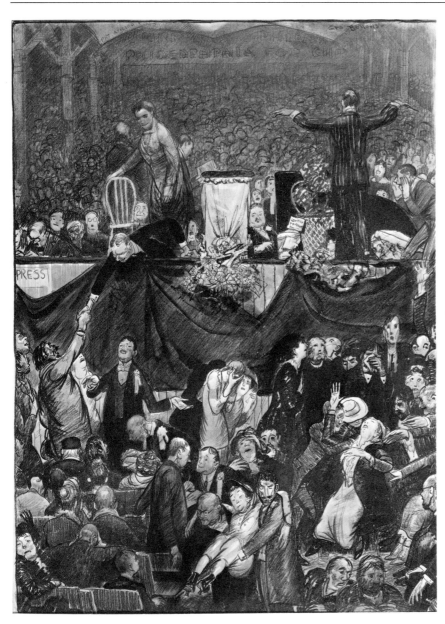

43.
The Sawdust Trail, 1915
Graphite(?), black crayon, pen and
ink, and ink wash on paper
28 1/16 × 22 1/8 in.
Boston Public Library,
Print Department;
Gift of Albert Henry Wiggin

ministrations fall on deaf ears to the disconcer-
tingly hypnotic power of the evangelist Billy
Sunday, were timely subjects readily compre-
hensible to his contemporary audience.

Bellows traveled to Monhegan Island, Maine,
in the summers of 1911, 1913, and 1914, and there
he witnessed the small band of worshipers that
he translated into a scene of religious devotion
in at least three drawings and, later, in two
lithographs entitled *Prayer Meeting* (figs. 39,
40). The essential pictorial elements are laid out
in a small ink sketch (fig. 41) where the main
figures display distinctive physiognomies that
accentuate their comic aspect. In a later draw-
ing, which appeared as an illustration in *Har-
per's Weekly* in 1914, the figure of the speaker is
moved toward the center of the composition;
his arm is thrust heavenward, providing a
strong focal point. This drawing became the
basis for the two prints. Faces as barometers of
personality types fascinated Bellows; in the sec-
ond version of the lithograph the faces are high-
lighted, each individual lost in private reverie,
oblivious to the other worshipers. The first
version of the print with its sketchy parallel
lines closely approximates the drawing that ap-
peared, in reverse, in *Harper's Weekly*. The sec-
ond version demonstrates a deeper appreciation
of the atmospheric qualities the lithographic
stone could yield, and the resultant image is a
more fluid one. The background was created by
rubbing on the ink with his fingers, a method of
application that allows a subtle range of tonal
variations. Bellows apparently was satisfied
with both versions of the print, for each was
printed in a large edition.[36]

While *Prayer Meeting* was a gently satirical
view of religious devotion, Bellows was less tol-
erant of a more aggressive side of religion. In
1915 *Metropolitan Magazine* sent Bellows to Phil-
adelphia to provide illustrations for a story on
the popular evangelist Billy Sunday, to be writ-

36. See Appendix A for a discussion of the edition sizes
of the two versions of *Prayer Meeting*.

The 1919 Roullier catalogue identifies the subject of
the lithograph as "Humoresque of Deacon Smith on a
Wednesday night at Monhegan Island." In the artist's
Record Book A, Bellows lists two commissioned wax
crayon drawings by that title for December 1913, one of
which was reproduced in the *Masses* in January 1914,
pp. 16–17.

ten by John Reed. Reed's story, which appeared in the magazine along with Bellows' drawings in May of that year, relates the writer's interviews with Sunday and his followers and describes the revival meeting held in a large tabernacle. Sunday (1862–1935) was a *cause célèbre* of the period. Newspapers were filled with accounts of his evangelistic travels around the country; his flamboyant persona made him a favorite target for the satirical gibes of writers for the *Masses*. On their reportorial mission, Reed and Bellows followed Sunday and his entourage for several days, interviewing the evangelist, his wife, and other members of his staff as well as Sunday's Philadelphia sponsors—businessmen and community leaders. Reed, who was philosophically opposed to Sunday and his tactics, generally portrayed members of Sunday's entourage in unflattering terms. He described Homer Rodeheaver, Sunday's choir director who appears in *The Sawdust Trail* with arms upraised, as a "short, stocky man with a deep sanctimonious voice, suspicious eyes, and the kind of a clammy hand that won't let yours go." Reed, a fervent socialist, described Sunday's success in terms of the class struggle, portraying Sunday as a pawn of the wealthy, who took advantage of his spiritual hold over the masses to keep labor agitation in check. In spite of their differences and the fact that Sunday's wife tried to sabotage Reed's interview with her husband, the writer found Sunday to be sincere, a quality that endeared him to his followers. Yet Sunday was, in Reed's view, a victim as well. "As to the social, economic and political relations of the world about him, I think he is just ignorant, that's all."[37]

Bellows' lithographs *The Sawdust Trail* (1917, fig. 42) and *Billy Sunday* (1923, fig. 44), based on drawings (figs. 43, 45) that appeared in *Metropolitan*, emphasize the charismatic power of Sunday. The drawings were closely followed in translation to print, especially in *The Sawdust Trail*, which retains the flat, illustrational quality of the drawing. The later lithograph, *Billy Sunday*, while compositionally identical to its drawing, is significantly smaller, and Bellows eliminates the crayonlike texture of the earlier work. Here he depicts the evangelist in a moment of religious fervor silhouetted against the great chasm of the wood and tar tabernacle that had been constructed especially for Sunday's revival meetings. Like the lunging figure in *A Stag at Sharkey's*, Sunday's lean body lurches forward as he engages the crowd in his diatribe. This athletic pose was one of Sunday's hallmarks—he was, in fact, a former professional baseball player—and he was frequently photographed in exaggerated poses. Reed described the function of Sunday's histrionics, the climactic event occurring when the evangelist jumped through a trap door on the stage: "Sunday, the sweat pouring from his red face, his trembling tense left leg thrust out behind, both arms stretched wide, as he leaned out over the vast crowd like a diver, shouted hoarsely . . ."[38]

The Sawdust Trail focuses, like *Prayer Meeting*, on the people at a religious gathering, in this case a more public one, in an urban rather than a rural setting. Women swoon and weep as they form a procession along the "sawdust

37. John Reed, "Back of Billy Sunday," *Metropolitan* 42 (May 1915): 9, 66. The journalist John Reed (1887–1920) joined the *Masses* staff in 1913. In 1914 he was sent to Mexico by *Metropolitan Magazine* to cover the Mexican Revolution. His experiences in Russia, where he witnessed the Bolshevik Revolution in November 1917, were the basis for two popular books, *Red Russia* and *Ten Days That Shook the World*.

For the treatment of Billy Sunday in the *Masses*, see the satire by Charles Erskine Scott Wood, "Billy Sunday in Heaven," *Masses* 9 (July 1917): 33–34, and two poems, Frederic W. Raper's "Billy Sunday," *Masses* 7 (April 1915): 13, and Carl Sandburg's harsh condemnation "To Billy Sunday," *Masses* 7 (September 1915): 12, in which he refers to Sunday as "a bughouse peddler of second-hand gospel."

38. Reed, "Back of Billy Sunday," p. 9. Choirmaster Rodeheaver recalled: "He was the delight of newspaper photographers. His athletic training gave him grace in every movement. He could quickly reproduce any gesture or pose which he may have used on the platform . . . He was known to go to the roof of a hotel, where the light was better, in zero weather, and pose for half an hour for the news photographers." Homer Rodeheaver, *Twenty Years with Billy Sunday* (Winona Lake, Indiana: The Rodeheaver Hall-Mack Co., 1936), pp. 102–103.

Sunday played professional baseball for eight years (1883–1891) with teams in Chicago, Pittsburgh, and Philadelphia and was noted for his speed. William G. McLoughlin, Jr., *Billy Sunday Was His Real Name* (Chicago: University of Chicago Press, 1955), pp. 5–7.

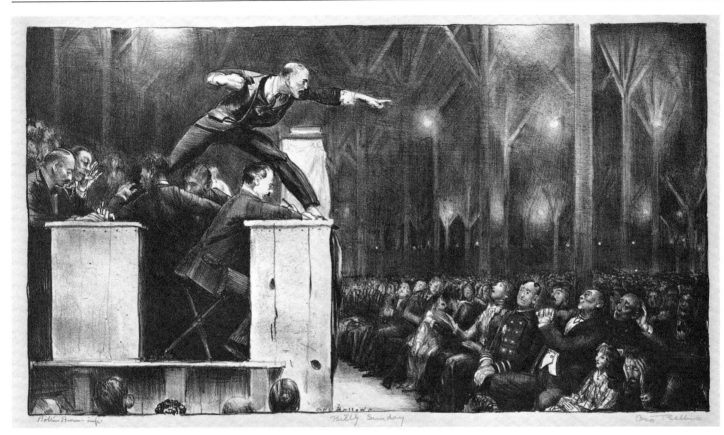

44.
Billy Sunday, 1923
Lithograph
8⅞ × 16⅛ in.
Amon Carter Museum

45.
Billy Sunday, 1915
Graphite(?), black crayon, pen and ink, and ink wash on paper
15⅛ × 28½ in.
Boston Public Library, Print Department; Gift of Albert Henry Wiggin

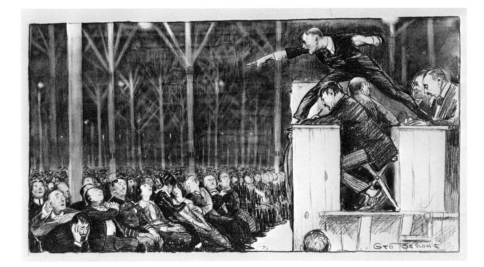

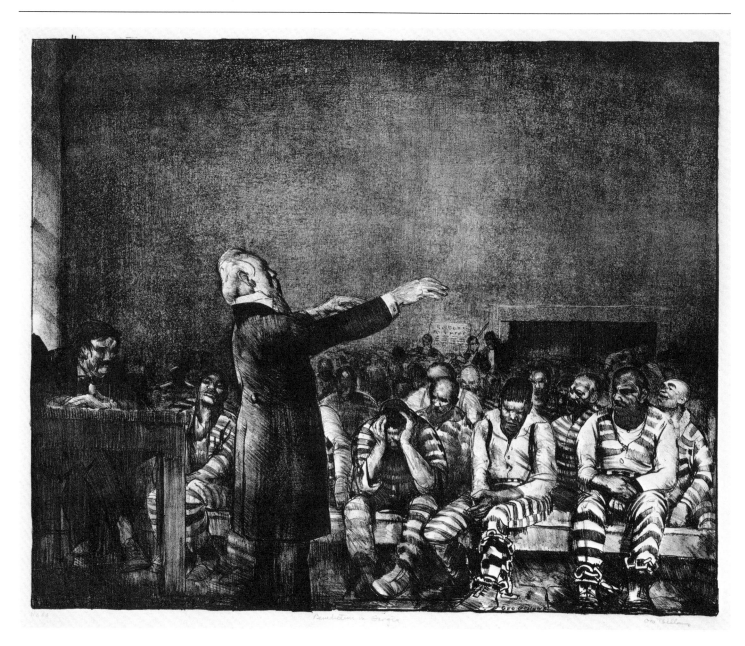

46.
Benediction in Georgia, 1916
Lithograph
16⅛ × 19¹⁵⁄₁₆ in.
Amon Carter Museum

trail," a pathway to the podium where the newly saved presented themselves. Bellows furthers the action by emphasizing the gestures of the crowd, a compositional feature he employed to similar effect in the early boxing prints. This crowded scene appealed to Bellows, and after making the drawing for the *Metropolitan* he treated the subject in a 1916 painting of the same title (Milwaukee Art Museum). The print itself exists in two states (see Appendix A). The first is based on the drawing in the Boston Public Library with the triangles of the patent "aucusticon" evident in the upper portion of the composition. In the second state, as in the oil, Bellows removes the "aucusticon," tightening his composition and giving increased emphasis to the figures and the activity below the stage.

Although John Reed opposed the fundamentalist fervor that drew thousands of the faithful to each of Sunday's appearances, he was awed by the expansive spirit of the event. In the end the evangelist's charisma could not be denied and Reed found himself singing along with the crowd, ending his article on a resigned note: "We left yet unconverted; but there didn't seem to be anything else to do. Philadelphia was saved." Bellows for his part made his feelings about Sunday clear in a 1917 interview: "I like to paint Billy Sunday, not because I like him, but because I want to show the world what I do think of him. Do you know, I believe Billy Sunday is the worst thing that ever happened to America? He is death to imagination, to spirituality, to art. Billy Sunday is Prussianism personified. His whole purpose is to force authority against beauty. He is against freedom, he wants a religious autocracy, he is such a reactionary that he makes me an anarchist. You can see why I like to paint him and his devastating 'saw-dust-trail.' I want people to understand him."[39] Yet for Bellows, as for Reed, the event held a certain inevitable attraction, for he was drawn to the spectacle and excitement of an arena where the audience's enthusiasm matched the power of the protagonists on stage in an emotional and physical conjunction.

Benediction in Georgia (fig. 46), another print grouped with "Studies in Belief," was reproduced in the May 1917 issue of the *Masses*. Like the Billy Sunday series it features a preaching figure whose true interest may be in wielding power over the audience rather than in improving their lot. A white minister preaches to a group of black convicts who, in their despair, are unmoved. Bellows confines the prisoners to the lower portion of the print, diminished in their humanity by the older man towering over them. Prison reform was a social concern of many liberals in the period, and in this print Bellows merges this issue with a condemnation of religious hypocrisy.[40]

The issue of the death penalty also provoked controversy and was frequently discussed by progressive reformers in the pages of the *Masses*. A focal point for this debate was Thomas J. Mooney (1884–1945), an anarchist leader sentenced to death for the bomb killings in the San Francisco Preparedness Day parade in 1916 but widely believed to be innocent.[41] President Woodrow Wilson eventually commuted Mooney's sentence to life imprisonment. Before Wilson intervened, however, the battle raged over the upcoming execution, and the currency of this issue may have led Bellows to his grim depiction of capital punishment in his lithograph *Electrocution* (fig. 47). In the print, a condemned man sits strapped to the electric chair,

39. Reed, "Back of Billy Sunday," p. 72; "The Big Idea: George Bellows Talks About Patriotism for Beauty," *Touchstone* 1 (July 1917): 270.

40. The caption in the 1919 Roullier catalogue stated: "The white Georgian preaching the gospel to the negroes is a satire on hypocrisy." Not all of Bellows' prints dealing with religious subject matter carried equal gravity. Of his 1916 print *The Novitiate* (Mason 33), representing three nuns, he said: "The characters of three nuns once impressed me in the Pennsylvania railroad station as I passed through. I don't know why this drawing is further than this." *In an Elevator* (1916, Mason 32) depicts a nun who, while surrounded by a crowd, stands apart from the rest of the figures in the composition. To this print Bellows assigned the caption: "Study of the relation of a nun to society" (1919 Roullier exhibition catalogue, n.p.).

A drawing related to *Benediction in Georgia* is in the collection of the Duke University Museum of Art.

41. See Curt Gentry, *Frame-Up: The Incredible Case of Tom Mooney and Warren Billings* (New York: W. W. Norton, 1977).

moments before his execution. The prisoner, his face covered, is attended to by a minister reading from the Bible and other witnesses. Bellows labored over this image, creating three states (see Appendix A), the third of which he cut down into two smaller details to increase the relentless focus on the doomed individual. The print is rendered in dark, harsh tones that convey the hopeless mood of the scene. Bellows' graphic art was often an outlet for his personal views; in this small print he could express a more intimate and powerful statement than would have been possible in paint.

In general, Bellows' early lithographs and many of his drawings pursued different subjects from those of his oils of the same period. These were primarily landscapes and seascapes executed in a vigorous, painterly style. He reserved the expression of his everyday activities for his prints and drawings. In 1916 he produced a series of prints in which he portrayed himself as a participant in the rich context of the art community.

One of Bellows' primary points of contention with the art establishment concerned the jury system of that time. Both he and Henri actively sought to reform the system, which they recognized as being tainted by favoritism, and they promoted the idea of an independent exhibition open to all artists. The Society of Independent Artists, which Henri helped found in 1916, guaranteed that all dues-paying members were entitled to exhibit, eliminating the use of a jury entirely.[42] In the lithograph *The Jury* (fig. 48) Bellows expresses his opinion in pictorial form, as works of art are paraded in front of the jurors in assembly-line fashion. The jurors are seated in one corner of the composition; on the right Bellows' bald head is visible as he smokes a cigar, contemplating, ironically, his own painting (marked with his name and address) about

47.
Electrocution, 1917
Lithograph
8⅛ × 11¹¹⁄₁₆ in.
Amon Carter Museum
ALSO FIG. 154

42. Homer, *Henri and His Circle*, pp. 170–172. Henri published a satirical drawing of an art jury in the January 1913 issue of the *Masses*. In 1919, Bellows presented a proposal for a more democratic method of selection for an exhibition of American paintings to travel to the Luxembourg Gallery in Paris. Some of the more modern paintings selected through this process were censured despite the protests of Bellows and Henri. Morgan, *George Bellows*, pp. 226–227, 232–233.

48.
The Jury, 1916
Lithograph
12³⁄₁₆ × 16³⁄₈ in.
Amon Carter Museum
ALSO FIG. 139

48.
The Jury, 1916
Lithograph
12$\frac{3}{16}$ × 16$\frac{3}{8}$ in.
Amon Carter Museum
ALSO FIG. 139

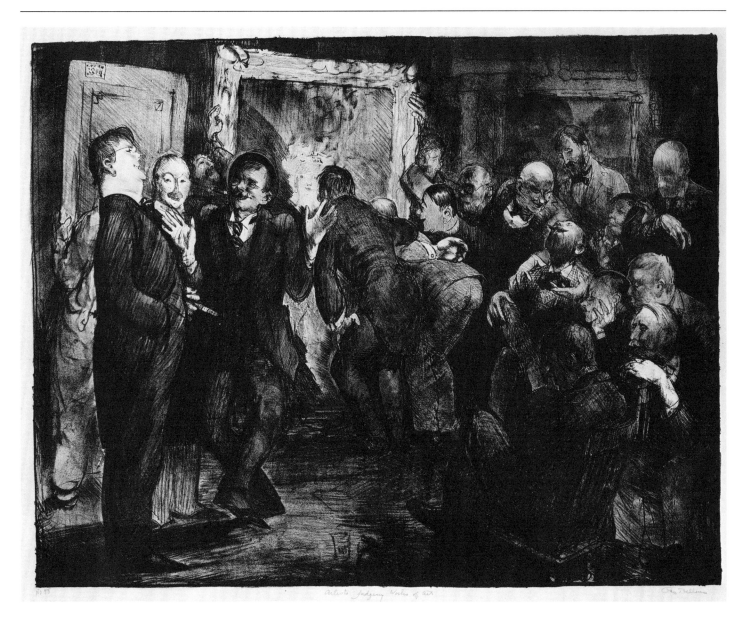

49.
Artists Judging Works of Art,
1916
Lithograph
14¾ × 19¹⁄₁₆ in.
Amon Carter Museum
ALSO FIG. 126

to come before the group. Passing judgment on one's own work was a contradiction that was particularly nettlesome to critics of the jury system. The attentiveness of other jury members appears to be flagging—the two artists in the front of the composition, one of them in a dandified attire, may be discussing other matters entirely. As with other early prints, Bellows made several versions of the image, seeking to achieve a satisfactory balance of light and shade (see Appendix A).

Another unflattering assessment of the jury system, the lithograph *Artists Judging Works of Art* (fig. 49), was based on a drawing that appeared in the *Masses* in April 1915 with the caption "Jury Duty." There, the drawing was accompanied by a sarcastic description of the "giant intellect of the connoisseur in the left foreground, straining itself to its aesthetic utmost, and at last bringing forth its prodigious judgments." The man with a mustache again appears seated at the right side of the composition while other jurors lean over the large painting in the center, perhaps more enamored of the female subject of the painting under review than the merits of the work. Bellows again observes the proceedings from the sidelines, falling with the other figures in an arcing composition that recedes into the pictorial space. This arrangement is similar to that of *The Jury*, the focus of attention dispersed to the sides of the composition. As in *The Jury*, the figures have sufficient individual characteristics to be recognized, as Bellows hints: "The result of a young artist's first service on an official jury. For fear of offense none of the 'likenesses' will be pointed out. They are whoever they are."[43]

Bellows' skill at caricature dated to his school days, when he skewered friends and teachers. His own visage in *The Jury* and *Artists Judging Works of Art* remains in the shadows, however, perhaps owing to the fact that he never felt able to make a satisfactory caricature of himself. (He wrote his friend Frank Crowninshield, the editor of *Vanity Fair*: "I have often tried to make a thoroughly funny caricature of myself, always however, the results seem to be hinged with an egotism which doesn't allow me to go far

enough—hence failure.")[44] His satirical treatment of subjects again recalls Daumier, although, unlike Daumier, he did not triumph in political caricature, preferring to lampoon the art community he knew so well. Bellows' crowded compositions, caricatured faces, and expressive postures all suggest Daumier's spirited precedent (fig. 50).[45]

Camaraderie with his fellow artists is also the subject of the 1916 lithograph *Artists' Evening* (fig. 51). Gregarious by nature, Bellows frequented informal gatherings of friends generally drawn from the art community. Bellows relished these opportunities to fraternize and expound his views. One popular meeting place was Petitpas, the boarding house and French restaurant on West 29th Street that Bellows depicted in *Artists' Evening*. The bearded man in the print, John Butler Yeats, father of the poet William Butler Yeats, was a resident of Petitpas. An artist and literary figure in his own right, Yeats was noted for his entertaining conversation peppered with provocative viewpoints. He was much respected by the younger crowd of artists who gravitated to Petitpas for the opportunity to converse with him.[46] Bellows appears

43. *Masses* 7 (April 1915): 10–11; 1919 Roullier exhibition catalogue, n.p.

44. Bellows to Crowninshield, March 10, 1924, Bellows Papers, Amherst College, box I, folder 6.

45. Both Henri and Sloan owned reproductions of Daumier's prints. See Francine Tyler, "The Impact of Daumier's Graphics on American Artists: c. 1863–c. 1923," *Print Review* 11 (1980): 120–121.

46. See James C. Young, "Yeats of Petitpas'," *New York Times Book Review and Magazine*, February 19, 1922, p. 14, and Wertheim, *The New York Little Renaissance*, p. 132. Bellows recommended the restaurant to his friend Joseph Taylor in anticipation of Taylor's visit to New York: "When you go there you will probably see an old man with a white beard surrounded usually by several people engaged in talk. This is John Butler Yeats father of W. B. Yeats (the Irish poet). He in his prime was a great portrait painter. George Moore says he's the greatest conversationalist he ever met. I think so. Go up and introduce yourself to him and tell him I told you to. You'll probably have a fine evening with the old man if he's feeling fit." (Bellows to Taylor, August 13, 1919, Bellows Papers, Amherst College, box I, folder 14.) In 1966 Bellows' friend Leon Kroll reminisced to Bellows' biographer, Charles Morgan, about the convivial and stimulating atmosphere at Petitpas. (Kroll to Morgan, November 10, 1966, Morgan Papers, Amherst College, box XIII, folder 2.) Both Sloan and George Luks depicted the restaurant, Sloan in an oil, *Yeats at Petitpas'* (1910, The Corcoran Gallery of Art, Washington, D. C.) and Luks in a watercolor, *John Butler Yeats at Petitpas'* (n.d., IBM Corporation).

next to Yeats, again in the role of silent observer. Emma Bellows is seated in the foreground, while Henri converses with Yeats; Henri's wife, Marjorie, is shown drawing at the table to the left. The print, which was reproduced in the July 1916 issue of the *Masses*, features dense, un-modulated dark areas, building upon those in the preparatory drawing executed in February 1914 (fig. 52).[47] In the lithograph Bellows transformed the linearity of the drawing to a more romantic, atmospheric conception.

During these years, Bellows also played a leading role in winning recognition of lithography as a fine art in America. Following the turn of the century, print activity in the New York galleries was devoted primarily to foreign prints, as exemplified by the Keppel show of 1916 in which Bellows' lithographs were exhibited alongside those of Daumier, Gavarni, and Toulouse-Lautrec. Lithographs, in particular, were less commonly shown than etchings or woodcuts, as few American artists had yet explored the medium. Frank Weitenkampf (1866–1962), curator of prints at the New York Public Library and proselytizer for the artist-lithographer, lamented the absence of a strong lithographic tradition and offered a challenge in the early years of the twentieth century: "Our country's record of achievement in this field is not a very remarkable one, but enough has been done to point the way."[48] Weitenkampf published numerous articles encouraging artists to take up lithography, outlined the basic technique, and extolled its versatility and autographic capabilities. He criticized the neglect of lithography as an artist's medium in favor of its commercial application, and he applauded the advances that nineteenth-century European lithographers, especially the French, had made, hopeful that the example of Pennell and Whistler would be followed. He also cited Bellows and Sterner as promising talents.[49]

47. Listed in the artist's Record Book A, p. 282, as "Night at Petitpa's (Drawing, Feb 1914)."

48. Frank Weitenkampf, "Painter-Lithography in the United States," *Scribner's* 33 (May 1903): 550.

49. See Frank Weitenkampf, "Lithography for the Artist," *Independent* 47 (August 15, 1895): 7–8; "Lithography for the Artist," *Scribner's Magazine* 60 (November 1916): 643–646; and *American Magazine of Art* 9 (July 1918): 352–355.

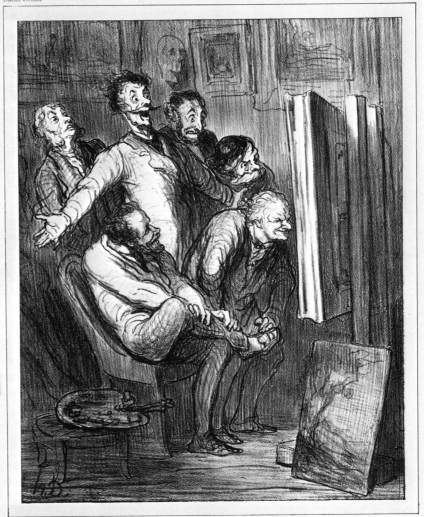

50.
Honoré Daumier
A Travers les Ateliers, 1863
Lithograph
9¹⁵/₁₆ × 8¼ in.
Museum of Fine Arts, Boston;
Bequest of W. G. Russell Allen

As their own work in this medium advanced, each of these artists was instrumental in promoting lithography. Bellows increasingly made appearances in print exhibitions, and Weitenkampf included him in the exhibition "The Making of a Lithograph" at the New York Public Library in May of 1918. Pennell, the champion and biographer of Whistler, enthusiastically promoted his own work and lectured and gave public demonstrations on lithography. Taking note of the glimmer of hope these artists represented, the elderly wood engraver Timothy Cole (1852–1931) presciently remarked in 1918: "Lithography will be practiced by artists and developed to a finer degree. Very few artists practice it. It is only through Joseph Pennell and a few others that we can appreciate the fineness of the art."[50]

Owing to his high profile in the New York art community, Bellows was able to exert his influence in the cause of lithography. The overlooked status of the medium presented a challenge to Bellows' crusading spirit: "I have been doing what I can to rehabilitate the medium from the stigma of commercialism which has attached to it so strongly. I didn't have this motive as a starter and it is by no means dominant. I chose to lithograph instead of to etch as I like it better. It is really in the same high plane as a medium, but the mechanics are such as to drive away the artists who contemplate its use." According to one biographer, Bellows was discouraged from making lithographs by friends who saw no demand for them. "Then," he replied with characteristic enthusiasm, "we'll put lithographs on the map!"[51]

Bellows was one of the founders of the Painter-Gravers of America, an organization for the promotion of printmaking as a fine art. The group first met in Albert Sterner's studio in January 1917, with Childe Hassam (who was elected chairman), Sterner, Bellows, F. Luis Mora, George Elmer Browne, Boardman Robinson, William G. Watts, S. Anthony Guarino,

Ernest D. Roth, Allen Lewis, and Leo Mielziner in attendance. Accustomed to organizing splinter groups to promote the cause of art, Bellows played a prominent role in the brief history of this group and exhibited his lithographs in the four non-juried annual exhibitions that were held before the group disbanded in 1920.[52]

The members of the Painter-Gravers of America considered printmaking no less serious an artistic endeavor than oil painting and saw themselves in the great tradition of artist-printmakers such as Dürer and Daumier: "None of the old masters were content with expressing themselves in one form of art." In order to bring prints before the American public, the group sought to provide a common meeting ground where the print collector could learn firsthand from the artists. They also hoped to maintain a studio (never realized) where the public could witness "the breathless moment when the first impression is drawn from the plate or stone."[53] The Painter-Gravers annuals included lithographs as well as engravings, etchings, and woodcuts. Sterner and Bellows (who in 1918 were elected chairman and vice-chairman, respectively) were the most prominent members to practice lithography. The organization attempted to counter misleading practices associated with etching; they promoted the concept of limited editions and were opposed to the practice of making a distinction between print states, considering it a form of preciosity.[54] The Painter-Gravers sought to exhibit the best of contemporary prints and to promote public education through their annual exhibitions, which were to travel throughout the country.

50. Quoted in "An Old Artist's Prophecy," *National Lithographer* 25 (April 1918): 41.

51. Bellows to Joseph Taylor, March 15, 1917, Bellows Papers, Amherst College, box 1, folder 13; Rollo Walter Brown, "George Bellows—American," *Scribner's* 83 (May 1928): 581 (repeated in Brown, *Lonely Americans*, p. 136).

52. For the founding of the Painter-Gravers, see *First Annual Year Book of the Painter-Gravers of America, with an Etching by Eugene Higgins and an Introductory Note by Albert Sterner* (New York: n.p., 1917–18). Bellows was involved in a number of art movements that ran counter to convention: he helped to organize the Independent Artists Exhibition in 1910, the Association of American Painters and Sculptors in 1913, and the New Society of American Artists in 1919, for which he produced a lithographed dinner card (Mason 149).

53. "Painter-Gravers' Aim Is to Cultivate American Taste for Graphic Art," *New York Times*, March 25, 1917, section 9, p. 2; *First Annual Year Book*, n.p.

54. "Painter-Gravers' Aim," p. 2.

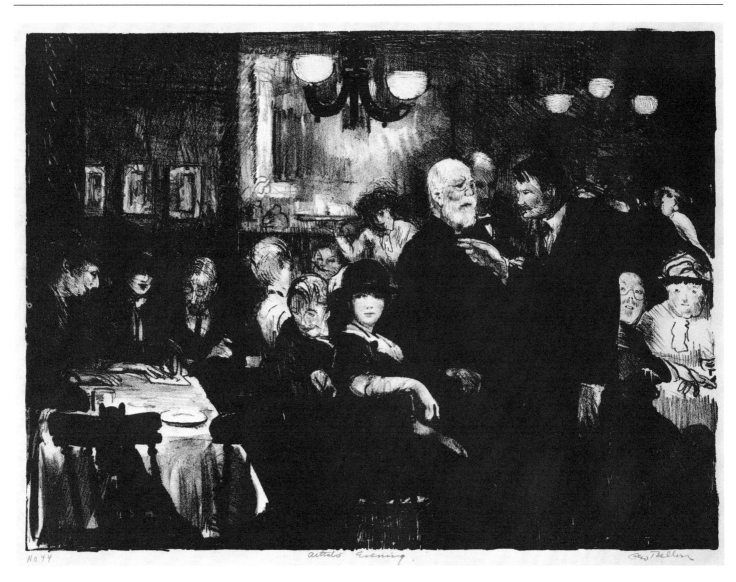

NO 44 Artists' Evening. Geo Bellows

51.
Artists' Evening, 1916
Lithograph
8¾ × 12³⁄₁₆ in.
Amon Carter Museum

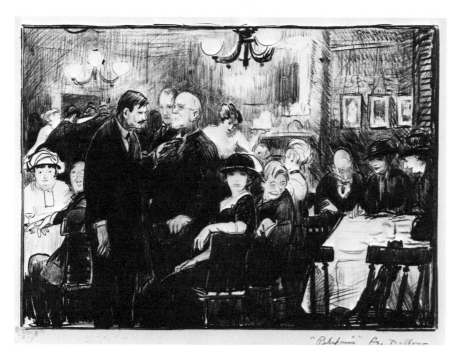

52.

Night at Petitpas', 1914

Graphite and black crayon on paper

8⅝ × 12³⁄₁₆ in.

Boston Public Library,

Print Department;

Gift of Albert Henry Wiggin

Bellows made generous financial contributions to the group, and designed the galleries for the first exhibition.[55] He exhibited increasingly fewer lithographs with the group, perhaps because he produced only a few prints in 1919–20, the years of the final two exhibitions. His efforts on behalf of lithography were evidently successful, however, for while his own representation in the exhibitions tapered off, the proportion of lithographs to other print media increased. The demise of the Painter-Gravers appears to have been, in part, a result of the upheaval caused by the United States' entry into World War I, an event that added a radical new subject and mood to Bellows' lithographs.

The sixteen lithographs Bellows produced during 1918 were devoted to events of World War I. The gravity of the subject matter is reflected in the somber tone of the prints—his first sustained attempt to treat subjects of a serious nature. Like *A Stag at Sharkey's*, the impact of most of the war lithographs is predicated on their violent content, but in the war series Bellows dealt with the actual destruction of life and property. Bellows never witnessed the war at first hand, yet he was moved by the enormity of this cataclysmic event to undertake an extensive series of oils, drawings, and prints. The lithographs were followed by paintings based on five of the prints—*Return of the Useless, Massacre at Dinant, The Germans Arrive, The Barricade*, and *Edith Cavell*.[56]

55. *First Annual Year Book*, n.p. An intriguing reference to Bellows' preferred means of framing prints appears in a letter to Bellows' widow from Jessie Young of Rockland, Maine, who describes Bellows' interest in framing her impression of *Sawdust Trail*. "We had it framed exactly as he told us, on a white mount, with narrow white frame . . ." (Jessie Young to Emma Bellows, September 24, 1943, Bellows Papers, Amherst College, box III, folder II.)

56. See *George Bellows and the War Series of 1918* (New York: Hirschl & Adler Galleries), 1983. Bellows had previously treated a war subject in his illustrations for the short story of Perceval Gibbon, "Russia's Red Road to Berlin," *Everybody's Magazine* 32 (April 1915): 401ff., and in his 1916 lithograph *"Prepare, America!"* (Mason 34). The five paintings were executed in the summer and fall of 1918. Although Bellows' biographer, Charles Morgan, believes that the lithographs were produced in April and May of 1918 (*George Bellows*, p. 218), the specific chronology has not been documented. See Krystyna Wasserman, "George Wesley Bellows' War Lithographs and Paintings of 1918" (M.A. thesis, University of Maryland, 1981), p. 13.

Like many of his countrymen, Bellows was opposed to the war at its outset, but he eventually joined with those Americans calling for the United States to provide military support for the Allied Forces. The *Masses* was staunchly pacifistic, and as late as July 1917, a few months after the United States entered the war, Bellows contributed a drawing of Christ in chains, imprisoned for dissuading men from enlisting. As the war progressed, and animosity toward Germany grew, Bellows' position on neutrality changed and he himself volunteered for the tank corps, although he was never called to serve. Echoing the language of Woodrow Wilson, Bellows said, "I would go to war for an ideal . . . Democracy is an idea to me, is the Big Idea." Only one of Bellows' lithographic portrayals of wartime activity depicts a moment of healing, the lithograph *Base Hospital* (fig. 53), a solemn rendering of a doctor treating a wounded patient inside a church interior.[57] In general, Bellows echoes in the 1918 series the powerful anti-German sentiment of many Americans who had supported their country's intervention in the conflict in April 1917.

A document that served as a source for Bellows' portrayals of the German invasion of Belgium—the primary subject of the war series—was the Bryce Report.[58] Issued by a committee of British officials headed by Viscount James Bryce, a former British ambassador to the United States, the report was a sensational account of atrocities perpetrated against Belgian citizens during the August 1914 invasion. In-

57. The quotation is from an interview, "The Big Idea: George Bellows Talks About Patriotism for Beauty," *Touchstone* 1 (July 1917):269.

The 1919 Roullier catalogue suggests that a photograph served as the source for *Base Hospital*: "Study of a doctor's clinic at a dressing station in a cathedral. An effort to see what could be done with photographs as material."

58. On the Bryce Report, see Daniel M. Smith, *The Great Departure: The United States and World War I, 1914–1920* (New York: John Wiley and Sons, 1965), p. 4. Those prints that appear to be taken directly from the Bryce Report are *Village Massacre* (Mason 54), *The Last Victim, The Cigarette, The Bacchanale* (Mason 58), *The Germans Arrive* (Mason 59), *Belgian Farmyard* (Mason 60), and *The Barricade*. (Wasserman, "Bellows' War Lithographs," pp. 15–16.) As Wasserman points out (pp. 17–18), another source of information was the articles written in 1918 by Brand Whitlock, U.S. ambassador to Belgium from 1913 to 1917, published in *Everybody's Magazine*.

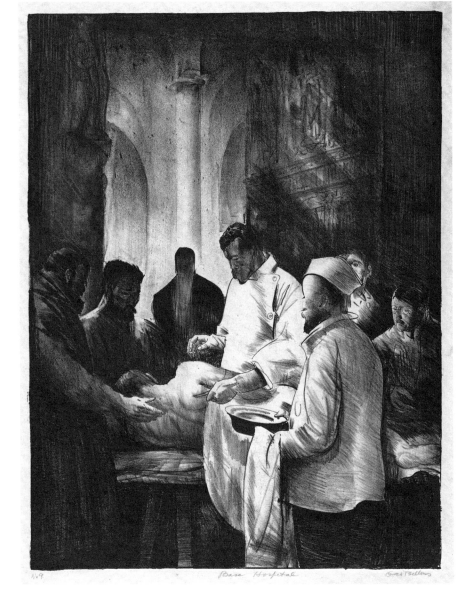

53.
Base Hospital No. 2, 1918
Lithograph
17⁹⁄₁₆ × 13³⁄₈ in.
Amon Carter Museum

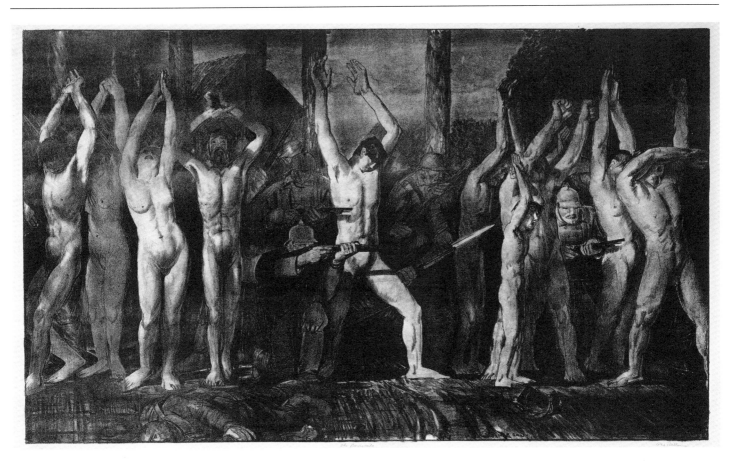

54.
The Barricade No. 2, 1918
Lithograph
16¹⁵⁄₁₆ × 29 in.
Amon Carter Museum

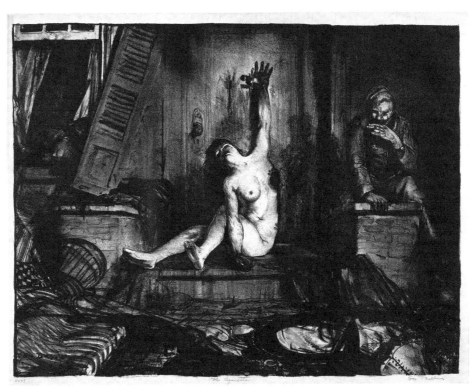

55.
The Cigarette, 1918
Lithograph
14½ × 19¼ in.
Amon Carter Museum

tended to incite public support for the British war effort, the report also stirred American sympathy for the anti-German cause when it was published in the *New York Times* in 1915, while America was still neutral. Bellows depicts the German troops' violent reaction to attempted resistance by Belgian citizens, echoing the Bryce Report's portrayal of the Germans as brutal vandals, rapists, and murderers.

Although Bellows did not support the war effort at the time the Bryce Report was published, a few of its numerous accounts clearly served later as the source for a number of the war lithographs. In such prints as *The Last Victim* (fig. 124) and *The Barricade* (fig. 54), the Germans, their faces either hidden in shadow or grotesquely sinister, are rendered in darker tonalities, while their victims are highlighted. Bellows' interest in portraying the nude figure apparently led him to take liberties in his rendering of *The Barricade*, for although the Bryce Report records incidents of Belgian citizens being used as human shields, there is no documentary evidence that the victims were nude.[59] The unclothed Belgians are arranged in classical poses, underscoring Bellows' interpretation of the citizens as tragic, universal victims.

The titles Bellows selected for these prints heighten the tension of the incidents portrayed and emphasize the callous indifference of the German soldiers. In *The Cigarette* (fig. 55), for example, a soldier smokes calmly next to the contorted body of his victim. Bellows cites the Bryce Report as the source for the scene: "Mutilated woman stripped and impaled to a door. A lieutenant smokes on the doorstep. The Bryce Report has much testimony about events of this character." Bellows' title *The Last Victim* leaves no doubt as to the fate of the woman who reacts with horror and despair at seeing the murdered members of her family. She is powerless to halt the inevitable brutality of the three German sol-

diers who approach her. In their unblinking reality, the prints treat the unsavory side of human nature, a theme embodied in Goya's "Disaster of War" print series. Bellows readily acknowledged his debt to the Spanish artist, replying when asked to paint more episodes based on the German atrocities, "I'll Goya."[60]

An English nurse, Edith Cavell, was also the recipient of much public sympathy during the war. Cavell, who operated a hospital in Brussels, was executed by the Germans in October 1915 for harboring wounded soldiers and abetting their escape across the Belgian border. Her tragic story provoked many emotional responses from illustrators covering the war. In one of his few treatments of a figure from modern history, Bellows depicts Cavell in the early morning hours, moments before her execution (fig. 56). Bellows emphasizes her heroic persona as an individual who stoically met her death. The artist portrays her small figure nearly overwhelmed by the stagelike setting, but moving toward her executioners of her own accord. Surrounded by guards, some of whom are still asleep, her gentle demeanor contrasts with the cavalier attitude of the soldiers and an ominous row of figures comprising the firing squad in the lower right portion of the composition. Bellows spent great effort on her figure, making subtle alterations in at least seven different states (see Appendix A) until he arrived at a figure emanating both beauty and grace.[61]

The style of the war lithographs reinforces their somber content. Because of the predominance of dark tonalities, the prints bear a gray overall tonality that precludes a wide range of definition. This quality may be due, in part, to the unknown printer responsible for them. In 1918 George Miller was no longer working with Bellows, for he had closed his own studio to join the Navy and did not reopen until the winter of 1918–19, after Bellows had already executed the war prints. An individual named Edward

59. See Bryce Report, *New York Times*, May 13, 1915, and Wasserman, "Bellows' War Lithographs," p. 39. When the first version of the lithograph was printed, Bellows realized that the gunners were shooting left-handed. He transferred the image to a zinc plate, and pulled a new set of proofs from the plate. (See Mason, p. 106.)

60. 1919 Roullier exhibition catalogue, n.p.; *New York Sun*, April 27, 1919, p. 12.

61. A crayon drawing related to the print is in the collection of The Art Museum, Princeton University, Princeton, New Jersey.

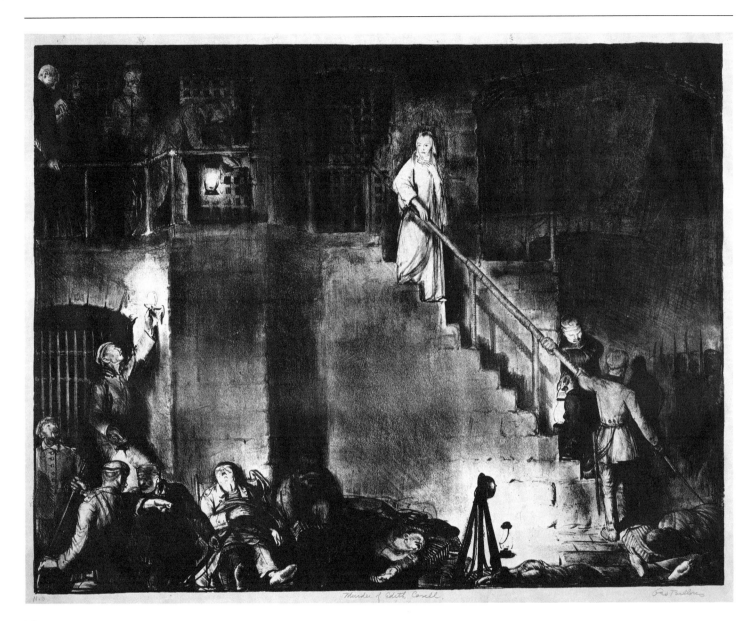

56.
Murder of Edith Cavell, 1918
Lithograph
19 × 24 13/16 in.
Amon Carter Museum
ALSO FIG. 178

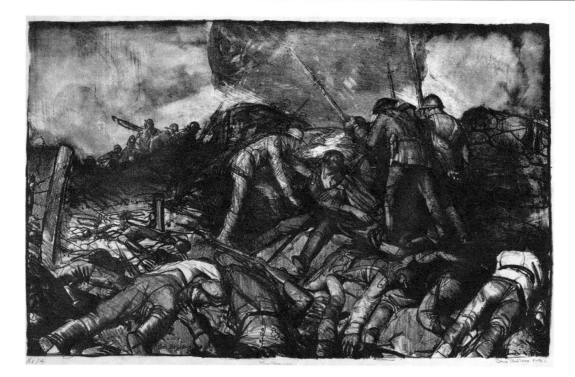

57.
The Charge, 1918
Lithograph
9⅞ × 16⅛ in.
Amon Carter Museum

Krause, perhaps an employee of one of the large commercial printing firms, has frequently been cited as the printer for these works, but no further information on him is known. The coarse, vigorous style may also be indebted to the European illustrators such as Steinlen as well as to American illustrators, among them Bellows' colleague on the *Masses*, Boardman Robinson, who illustrated articles by John Reed from the Russian front for *Metropolitan Magazine*. Bellows himself provided two lithographs for the July 1918 issue of *Collier's* to illustrate a short story on the uneasy alliance of British and Russian troops on the front lines. One of these lithographs, *The Charge* (fig. 57), was blocked off by Bellows to create three detailed versions (fig. 58).[62]

62. The original source for the reference to Edward Krause was apparently Frank Weitenkampf's article, "George W. Bellows, Lithographer," in *Print Connoisseur* 4 (July 1924):239. Weitenkampf mistakenly identified Edward Krause as the printer of all Bellows' lithographs executed through 1919.

In addition to *The Charge, Right Detail* (Mason 65) the lithographs related to this series are another state of the right detail, *The Charge* (Mason 63), *The Charge, Left Detail* (Mason 64), and *Sniped*. *Sniped* and *The Charge* were reproduced in a story by Donal Hamilton Haines, "Something_____!", *Collier's* 61 (July 13, 1918): 17ff.

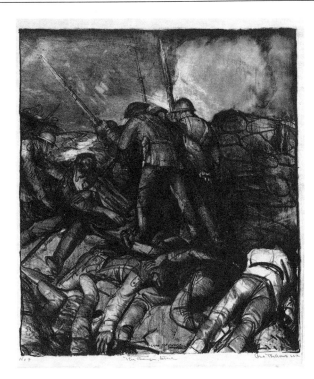

58.
The Charge, Right Detail,
1918
Lithograph
9⅞ × 8⅞ in.
Amon Carter Museum

Despite his harsh portrayal of the Germans in his war prints, Bellows made an effort to transcend national animosities: "In presenting these pictures of the tragedies of war, I wish to disclaim any intention of attacking a race or a people. Guilt is personal, not racial. Against that guilty clique and all its tools, who organized and let loose upon innocence every diabolical device and insane instinct, my hatred goes forth, together with my profound reverence for the victims." The almost caricatured aspect of the Germans, however, prevents the prints from being incisive, and the war series became a tool of the American propaganda machine. The series enjoyed widespread fame and was exhibited in New York, Philadelphia, Boston, and Chicago. In November 1918 some of the prints from the exhibition were reproduced in *Vanity Fair* with the heading "The Hun," accompanied by captions describing the German atrocities. One print, *The Enemy Arrives*, appeared as an ad in support of the Fourth Liberty Loan campaign, and the prints were used as progaganda by the Committee on Public Information, Division of Pictorial Publicity, whose chairman was the illustrator Charles Dana Gibson. He praised the war prints in a letter to Bellows: "Certainly they are the finest things that have been done anywhere, anytime." As purveyors of propaganda, Bellows and other lithographers gained, for the first time, widespread encouragement to produce lithographs.[63]

Two other lithographs, both versions of *The Case of Sergeant Delaney* (see Appendix A), depict an unidentified war subject. These lithographs are referred to in Bellows' Record Book B: "The Incident of Delaney I for US Navy large destroy" and "Delaney II OK USN large" (p. 253). In Emma Bellows' catalogue raisonné, she recorded one print with that title for 1918, in keeping with the rest of the war prints, and stated that it was after an illustration in *Century Magazine* (*Bellows: His Lithographs*, p. 249). In his account book for 1921, Bellows recorded "Com U.S. Navy 'Incident of Delaney' (Litho.)."

63. *Catalogue of an Exhibition of Lithographs by George Bellows* (New York: Frederick Keppel and Co., 1918), p. 3; ad in *Collier's* 62 (September 28, 1918): 31; Charles Dana Gibson to George Bellows, July 12, 1918, Bellows Papers, Amherst College, box II, folder 12. *Gott Strafe* (fig. 122) was also used by the Fourth Liberty Loan Campaign; see *Vanity Fair* 11 (November 1918): 36–37.

Frank Weitenkampf, "The War and Lithography," *International Studio* 65 (September 1918): 61–62, notes the number of artists who took up lithography as a means of promoting the war effort through posters and prints.

68

George, Jean, Emma,
and Anne Bellows
in Woodstock, New York,
c. 1923–24
Courtesy of George Wesley Bellows
Papers,
Amherst College Library,
Amherst, Massachusetts

Following the war series, Bellows made few prints over the next two and a half years. Painting commitments, including several portrait commissions, and a two-month visit at the end of 1919 to Chicago—where he taught at the Art Institute and witnessed the opening of a major exhibition of his work—prevented Bellows from undertaking more than sporadic attempts at lithography. In his record book, the artist listed only two lithographs for the year 1919, *The Sand Team* and a Christmas card, *Hail to Peace,* both copies after oil paintings. In 1920 Bellows again recorded just two lithographs, *Tennis* (fig. 59) and *The Tournament,* subjects taken from summers spent in Rhode Island the previous two years.[1] It was not until January 1921 that Bellows took up lithography in earnest again, in association with the printer Bolton Brown. Brown and Bellows had first collaborated in 1919; in the years 1921–24 they embarked on three intensive printmaking sessions that resulted in over 120 prints, a collaboration abruptly halted by Bellows' untimely death of appendicitis in January 1925.

During the 1920s the lithographic medium found a broader audience, and, even during the period when Bellows produced few new prints, his lithographs were widely exhibited. Concomitantly, sales of Bellows' lithographs increased, providing the artist with a steady source of income. In 1919–20 together, his print sales totaled more than $1,500.[2] The number of commercial galleries that carried Bellows' prints expanded from those that had sold his early prints—Keppel, Kraushaar, Milch, Brown-Robertson, and Marie Sterner—to include Knoedler, Weyhe, Rehn, Anderson, and Montross galleries as well as outlets in Boston, Chicago, and San Francisco. Through the 1920s, prices for Bellows' lithographs climbed steadily, although, as Bellows noted in a letter to his friend George Eggers, a limited subject range accounted for a large percentage of the sales: ". . . it is only a few of the more, for one reason or another, popular prints which sell at all, and the result is I have a very extensive collection of editions which I think are good, but which nobody seems to want to buy." Then, as now, the boxing subjects attracted the most willing buyers, and the increasing rarity of these lithographs was noted even during Bellows' lifetime.[3]

In his prints of the 1920s Bellows generally favored a smaller stone and also narrowed his range of subjects to a few favorite themes—portraits of family and friends, nudes, genre subjects, sporting events, and lithographs based on illustrations. Bellows' facility with the medium entered a new, more sophisticated and

1. "Book B Record of Pictures" (manuscript in possession of Jean Bellows Booth; hereafter referred to as Record Book B), p. 195. The artist inscribed "destroyed" by his entry for *The Sand Team* (Lauris Mason and Joan Ludman, *The Lithographs of George Bellows: A Catalogue Raisonné* [Millwood, N. Y.: KTO Press, 1977]—hereafter referred to as Mason—no. 69), although at least three impressions, none of them signed by Bellows, survive in the collections of the Amon Carter Museum, the Boston Public Library, and the Cleveland Museum of Art. The print relates to a 1917 oil of the same title (The Brooklyn Museum). *Hail to Peace* (Mason 68), the Bellows' Christmas card for 1918, made in an edition of 100, was based on a 1918 oil painting (Cincinnati Art Museum). Bellows also printed a single impression of *The Life Class No. 2* in 1919. See pp. 73–74.

Mason assigns an additional print to this period, *Well at Quevado* (Mason 70). The print could date as early as the winter of 1917–18, following the Bellows' family trip to California and New Mexico. In New Mexico Bellows witnessed the scene that inspired this print as well as a painting (Minnesota Museum of Art, Saint Paul), an india ink and crayon drawing (Boston Public Library, Print Department), and a watercolor (unlocated). The lithograph is not listed in the artist's record books and only two impressions are known (Amon Carter Museum and Boston Public Library, Print Department). "Quevado" is probably Quemado, a town in New Mexico.

The Tournament is Mason 72.

2. "Sales and Proffesional [*sic*] Income" (manuscript in possession of Jean Bellows Booth; hereafter referred to as Account Book), n.p.

3. Bellows to George Eggers, November 17, 1924, George Wesley Bellows Papers, Amherst College Library, box I, folder 7. In 1924, Bellows commented that his Dempsey and Firpo print was nearly sold out (Bellows to Crosby Gaige, December 8, 1924, Bellows Papers, Amherst College, box I, folder 7). The catalogue for Bellows' memorial exhibition, which opened at the Metropolitan Museum of Art in the fall of 1925, cited *A Stag at Sharkey's* as "the rarest of the artist's lithographs." (*Memorial Exhibition of the Work of George Bellows* [New York: Metropolitan Museum of Art, 1925], p. 36.) A review of Marie Sterner's exhibition of Bellows' lithographs and paintings the same year stated that *A Stag at Sharkey's* was no longer available (*Art News* 24 [October 17, 1925]: 2).

controlled phase; the pronounced dark and light contrasts of the earlier prints no longer predominated. With a few exceptions, Bellows consciously turned away from social commentary. The element of satire appears less frequently, although in *The Parlor Critic* (fig. 60), for example, he deftly sketches an incident at one society function in which an elegantly attired woman entreats a self-important critic to take note of a favorite artist.

One reason for Bellows' avoidance of satire may be that its informality did not lend itself to the compositional principles guiding him in this phase of his career. A fascination with art theoretician Jay Hambidge's system of pictorial organization, known as dynamic symmetry, had led Bellows to favor more rigidly structured compositions whose framework was a deliberately planned grid system. Hambidge held that a scientific, measurable foundation for form based on classical proportions governed all the arts. He believed that a division of the picture into geometrical shapes, based on preset formulas, would result in a harmonious and balanced image. Bellows' adherence to this "universal law" resulted in a more formal organizational structure in his paintings, drawings, and prints. Under Hambidge's influence Bellows enthusiastically studied classical art, sketching classical architecture, sculpture, and Greek vases in his search for ideal forms and making extensive calculations based on classical proportions.[4] The influence of this new ordering principle is clearly revealed by comparing an early print, such as *Reducing* (figs. 16, 17), with the same subject repeated after Bellows' exposure to Hambidge's theories, which occurred in 1917. The 1921 print (fig. 61) is a smaller, more tightly composed interpretation of the subject. The primary design elements of the composition fall into a deliberate pattern, coinciding with an imaginary network of lines running through the design at mathematically determined intervals.

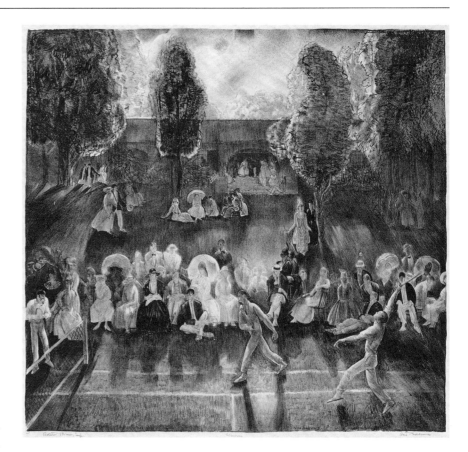

59.
Tennis, 1920
Lithograph
18³⁄₁₆ × 19⅞ in.
Amon Carter Museum

4. See George Bellows' notebooks, American Academy of Arts and Letters Records, Archives of American Art, Smithsonian Institution, Washington, D. C., roll NAA-1. For a discussion of Hambidge's theory, see Bellows' article "What Dynamic Symmetry Means to Me," *American Art Student* 3 (June 1921): 5–7.

60.
The Parlor Critic, 1921
Lithograph
8⁷⁄₁₆ × 7 in.
Amon Carter Museum

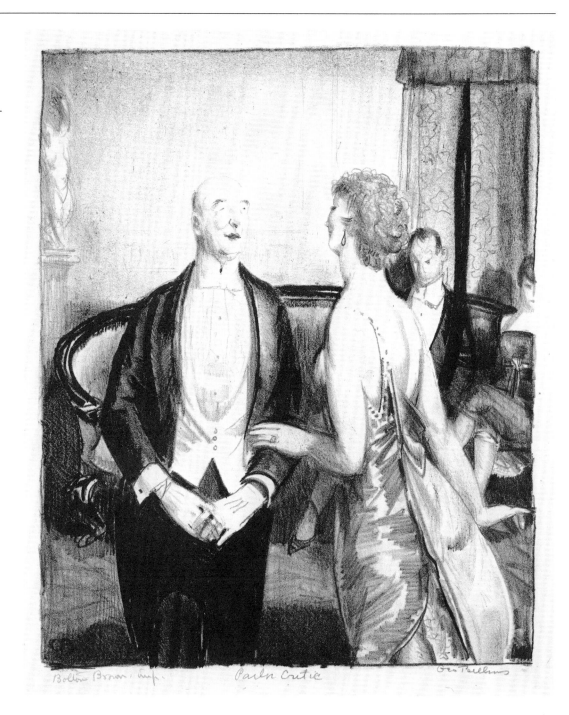

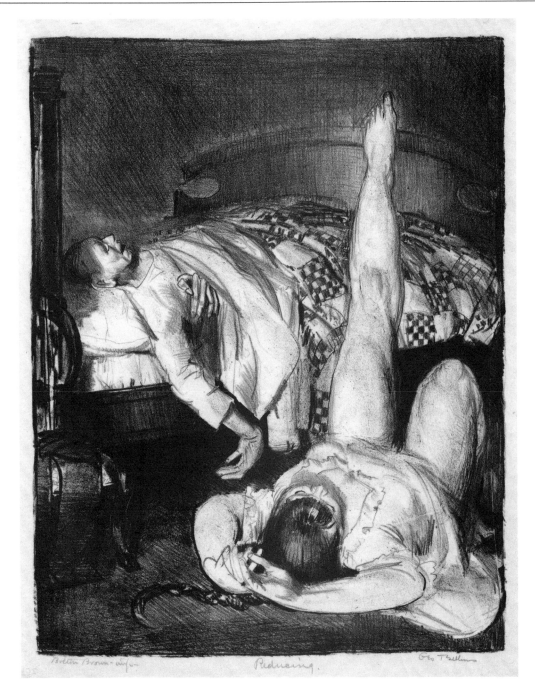

61.
Reducing No. 3, 1921
Lithograph
10¹³⁄₁₆ × 8⁹⁄₁₆ in.
Amon Carter Museum

Besides Hambidge, the individual who most influenced Bellows' later print career was the printer Bolton Brown (1864–1936), in association with whom Bellows produced well over half of his total lithographic output.[5] Formerly a painter himself, Brown had abandoned that career in midlife in order to devote his energies to making lithographs and to printing lithographs for other artists. Brown was a practicing artist and teacher at Stanford University before moving to Woodstock, New York, in 1902. Here he was involved for a short time in the founding of an art colony; afterward he remained in upstate New York, where he continued to paint. Albert Sterner played a vital role in introducing Brown to lithography, as he had for Bellows; it was Sterner's exhibition of lithographs at Martin Birnbaum's Berlin Photographic Gallery in early 1915 that inspired Brown to take up the medium. That spring Brown moved to London, where, amidst the air raids of World War I, he spent the following year teaching himself lithography, performing many arduous experiments in his own studio. His extensive journal notations reveal his obsessive testing of inks and papers and his efforts to perfect the complex mechanics of the lithography press. Upon his return to the United States he divided his time between Woodstock, where he spent the summer months, and New York City. In the winter of 1918–19 Brown set up his own studio in New York, calling it "The Artist's Press."

About that time, Brown came upon an impression of Bellows' *Murder of Edith Cavell* (fig. 56). His comment to the seller, Brown-Robertson Galleries (also Brown's agent), that the printing of the lithograph was flawed led to his introduction to Bellows. Brown, who had an irrepressible ego, recalled their first meeting at Bellows' studio:

I was there: prints under my arm; George, of course, his usual frank and genial self. He was new to me then; I thought he had beautiful eyes. Having looked at my prints, he said, "I have the best proof puller in the American Lithographic Company, and I can't get what you get right along." I asked, "What is the matter? Can't you get what you put on the stone?" "No, that's just what we can't." Then we examined some of his prints: they seemed pathetic; they also seemed puzzling; I couldn't make out how they 'got that way.' Textures of extraordinary coarseness and black marks quite without autographic quality, not even suggesting a lithographic crayon, . . .[6]

With Brown's help Bellows resolved these technical shortcomings, beginning with the type of stone he was using, which Brown identified as too soft. Working primarily on Bellows' own press, Brown labored diligently, and his distinctive printing is apparent in all Bellows' subsequent prints.

The specific print that marked their initial joint endeavor is uncertain—Brown recalled that it was a print of Gramercy Park, for which he pulled fifty impressions, though this cannot be identified with any known print.[7] An actual collaboration occurred in 1919 during a demonstration at the Pratt Institute in Brooklyn, where Brown printed stones for several artists including Sloan, Sterner, and Bellows. According to Brown's recollection, "Bellows evolved

5. Bellows' record books outline the three periods of their most active collaboration: January–March 1921, January–June 1923, and the winter of 1923–24. (Record Book B; "Book C" [manuscript in possession of Jean Bellows Booth; hereafter referred to as Record Book C].) Brown's journal confirms the first two periods. On May 2, 1921, he wrote "Last winter . . . I acted as a stone-preparer, crayon-maker, etcher & printer for upwards of fifty lithographic drawings by George Bellows. For the first time, I kept no written records." And, two years later, on June 1, 1923: "Last winter, in New York, I etched, rolled & printed a considerable number of stones for Bellows, at his studio." (Bolton Brown Papers, Archives of American Art, roll 3655, frames 110 and 151.)

During this period the only winter Brown and Bellows did not work together was that of 1921–22. In his record book, Bellows lists only one print for the year 1922, *Portrait of Mrs. Walter H. Richter* (Mason 131) with an edition of 40 prints. (Bellows also painted Mrs. Richter's portrait in April of that year [Record Book B, p. 270; Berry-Hill Galleries, New York]. In 1923 Bellows depicted the same sitter in another lithograph, *Study, Mrs. R* [Mason 130].)

For biographical information on Brown, see Clinton Adams, "Bolton Brown, Artist-Lithographer," in David Tatham, ed., *Prints and Printmakers of New York State, 1825–1940* (Syracuse: Syracuse University Press, 1986).

6. Bolton Brown, "My Ten Years in Lithography, Part II" with an introduction and notes by Clinton Adams, *Tamarind Papers* 5 (Summer 1982): 38.

7. Ibid. Brown kept an impression of every lithograph he printed for Bellows. This group of prints forms the basis of the Cleveland Museum of Art's extensive holdings of Bellows' prints.

a memory of the 'men's night class' a chaotic scene—an old stove, easels, one youth consuming a sandwich, another guzzling something out of an upturned bottle, and, as a centerpiece, the nude female model, standing." This description matches that of the print *The Life Class No. 2*, previously thought to date to about 1916.[8] Unlike George Miller, Brown cosigned nearly all the prints he and Bellows made together; the earliest of Bellows' prints to bear Brown's signature are the two tennis subjects, *Tennis* (fig. 59) and *The Tournament*, both dated in the artist's record book to March 1920. The lithographs were copies of oil paintings produced in 1919, two additional versions of which were painted in 1920.[9] As in the paintings, Bellows was concerned with the relationship of figures to the setting rather than with the figures themselves, and the lithographs repeat the emphasis of the oils on decorative patterning created by the contrasts of trees, parasols, and shadows.

Brown's strongly held views on the art of lithography and his efforts to perfect the process and materials of the medium had considerable impact on the prints Bellows produced with him. Brown opined that the unique properties of lithography should be exploited. In his prints of the 1920s, Bellows eschewed his previous habit of emulating other media, such as water-color, and largely abandoned the practice of combining both fluid and linear effects on a single stone. He had already rejected the transfer print process, which, in Brown's view, produced a vastly inferior print that did not merit classification as a true lithograph because it was essentially a drawing transferred to stone. (Brown considered the integrity of lithography to be compromised by Joseph Pennell's unapologetic use of the transfer method.) Urging artists to take up lithography, Brown maintained that, though it was related to drawing, it offered in addition a new range of experiences: "The aesthetic importance of lithography . . . lies in its giving the draughtsman an opportunity for a most delectable practice of his art." Bellows echoed this sentiment in the introduction to the brochure for his exhibition of lithographs at Keppel Gallery in 1921: "Lithography . . . offers opportunities for the artist greatly superior to any direct efforts on paper."[10] The impact of Brown's participation in the printing of Bellows' stones was immediately remarked upon by the critics in several reviews of the exhibition, in an unusual mention of the technical aspects of Bellows' prints.[11]

While still in London, Brown had perfected his own formulas for the manufacture of lithographic crayons, an area of experimentation on which he continued to expend much time and effort upon his return. Brown was fascinated by the subtle nuances of texture and tone he could achieve through the wide range of custom-made crayons. He designed crayons specifically for Bellows' use; in his notes he described the proportions of one such crayon consisting of wax,

8. Mason 8. This observation was made by Clinton Adams, who published a selection of Bolton Brown's writings in the *Tamarind Papers*. See Bolton Brown, "My Ten Years in Lithography, Part I" with an introduction and notes by Clinton Adams, *Tamarind Papers* 5 (Winter 1981–82): 18. The passage is also quoted in Adams, "Bolton Brown, Artist-Lithographer," p. 224.

Adams has placed Brown and Bellows' first meeting between December 19, 1918, the date Brown went to New York after spending the summer and fall in Woodstock, and mid-March 1919, when the demonstrations at the Pratt Institute took place.

9. The paintings *The Tournament* (August 1919, Everett D. Reese, Columbus, Ohio; Record Book B, p. 179) and *Tennis at Newport* (March 1920, private collection; Record Book B, p. 198) relate to the lithograph *The Tournament* (Mason 72), while the paintings *Tennis Tournament (at Newport)* (August 1919, The Metropolitan Museum of Art; Record Book B, p. 179) and *Tennis at Newport* (June 1920, National Gallery of Art, Washington, D.C.; Record Book B, p. 215) relate to the lithograph *Tennis* (Mason 71). In addition there is at least one drawing related to the series; *Tennis at Newport* (graphite on paper, Arkansas Arts Center) is nearly identical to the lithograph *Tennis* (Mason 71).

10. Bolton Brown, "Lithographic Drawing as Distinguished from Lithographic Printing," *Print Connoisseur* 2 (1921): 142; *Catalogue of an Exhibition of Original Lithographs by George Bellows* (New York: Frederick Keppel and Co., 1921), n.p. See also Bolton Brown, "Pennellism and the Pennells," with notes by Clinton Adams, *Tamarind Papers* 7 (Fall 1984): 48–83; Brown, "Lithography as a Fine Art," *American Printer* 20 (July 20, 1922): 26–29; and Brown, "Artistic Lithography by an Artist Lithographer," *International Studio* 69 (February 1920): 108–111.

11. "The World of Art: Some of the Spring Exhibitions," *New York Times Book Review and Magazine*, May 1, 1921, p. 20; Henry McBride, "News and Reviews of Art," *New York Herald*, May 15, 1921, section II, p. 11.

castile soap, and lampblack.[12] Through the employment of these crayons, Bellows' characteristically expressive lines took on an even, smooth appearance. Brown endeavored to ensure that the design as drawn on the stone be identical to the printed image. He advocated a direct method whereby all manipulation of the image was to be carried out on the stone rather than through the printing process. Brown's control over the integrity of his design extended to the limitation of edition sizes, for the stone would hold the image consistently through a limited number of impressions. Bellows heeded his advice. In 1924, he was approached about the possibility of issuing a large edition of prints for the Cleveland Print Club. Suggesting that he make two editions rather than one, Bellows noted that he had limited the edition size of his recent prints to fifty in order to maintain the quality.[13]

Perhaps because the subject matter of their prints was significantly different—Brown concentrated on landscapes—the two strong and opinionated personalities did not conflict, and the two men held each other in high esteem. Bellows made an effort to assist Brown professionally by writing on his behalf to the English artist William Nicholson, indicating that Brown was contemplating a return trip to England and sought temporary employment there; Bellows recommended him as a great lithographer. Although they had not worked together for some months preceding Bellows' death, Bellows' correspondence makes clear that he intended to continue with Brown early in 1925. He wrote on December 1, 1924: "I certainly do not want the winter to slip by without making some more lithographs with you. However, just at present I am unable to say when I should like to begin on the stone, as I have a great deal of painting which I want to do . . . But the short days of the year are certainly the worst for painting and I think I would like to do lithography at least through January and probably February." (A few weeks later he writes that their planned work session will be postponed until February and March due to several unforeseen complications.)[14] While, for his part, Brown held Bellows in high esteem, he could not forbear taking a generous share of the credit for the artist's success: "George Bellows is the most lithographic lithographer in the country . . . except me. His best pieces are by no means those huge affairs, such as prize fights, where he was largely the mere illustrator, but certain simple and utterly charming rambles on stone, more often than not with his wife or daughter or some chum as subject. . . . I did much more than print for him: I furnished him his entire set of materials, prepared exactly to suit his needs . . . The world, except for a few individuals, hasn't found it out yet, but I have revolutionized artistic lithography by my complete readjustment and invention of new materials and methods."[15] Although Brown continued to make lithographs for several months after Bellows' death, he abandoned printmaking in 1926. Brown died an impoverished and, except to a few printmakers, a largely unknown figure.[16]

The character of Bellows' more precisely rendered lithographs of the 1920s, in which he largely abandoned the broad, descriptive forms of his earlier prints, was appropriate to the more intimate, reflective subjects of his later career.

12. Bolton Brown Papers, Archives of American Art, roll 3655, frames 150–151. Brown described many such crayons, combining these ingredients (and others) in varying proportions. In his book *Lithography for Artists* (Chicago: University of Chicago Press, for the Art Institute of Chicago, 1930), pp. 20–21, he listed the components of another crayon he made specifically for Bellows as well as of a lithographic drawing ink.

13. Bellows to Theodore Sizer, March 31, 1924, Bellows Papers, Amherst College, box 1, folder 10.

14. Bellows to Nicholson, May 8, 1923, Bellows Papers, Amherst College, box 1, folder 8; Bellows to Brown, December 1 and December 15, 1924, Bellows Papers, box 1, folder 6. The complications that delayed their work included the serious illness of Bellows' half-sister in Columbus, the obligations of a one-person show scheduled to open at Durand-Ruel Gallery in February, and the installation of a window in his studio and new floors in the Bellows' New York home. See also Bellows to Griffin Herrick, December 8, 1924, regarding Bellows' disappointment in the delay (Bellows Papers, box 1, folder 8).

15. Bolton Brown, "Prints and Their Makers," *Prints* 1 (November 1930): 22, 24.

16. Adams, "Bolton Brown, Artist-Lithographer," pp. 232, 234. In his journal for 1925, Brown remarks that he had etched Bellows' stones, which implies that some lithographs were posthumously printed by Brown. See Clinton Adams, *American Lithographers 1900–1960: The Artists and Their Printers* (Albuquerque: University of New Mexico Press, 1983), p. 56.

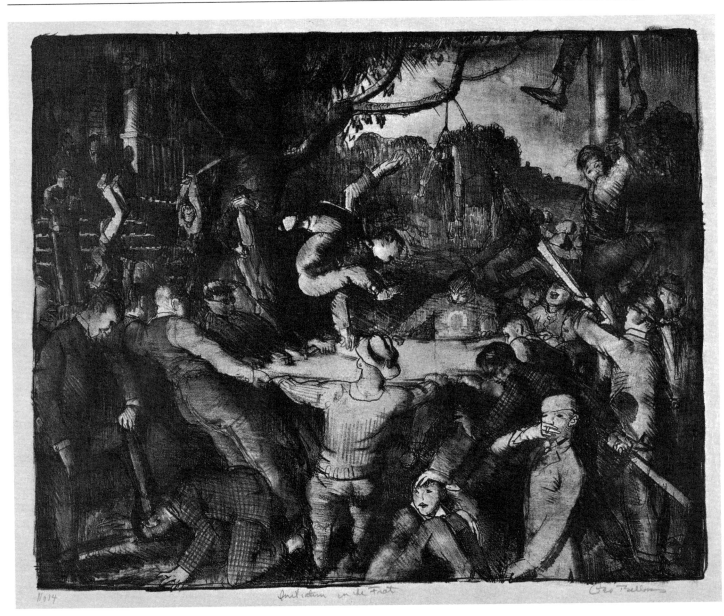

62.
Initiation in the Frat, 1917
Lithograph
10¹⁄₁₆ × 12¹¹⁄₁₆ in.
Amon Carter Museum

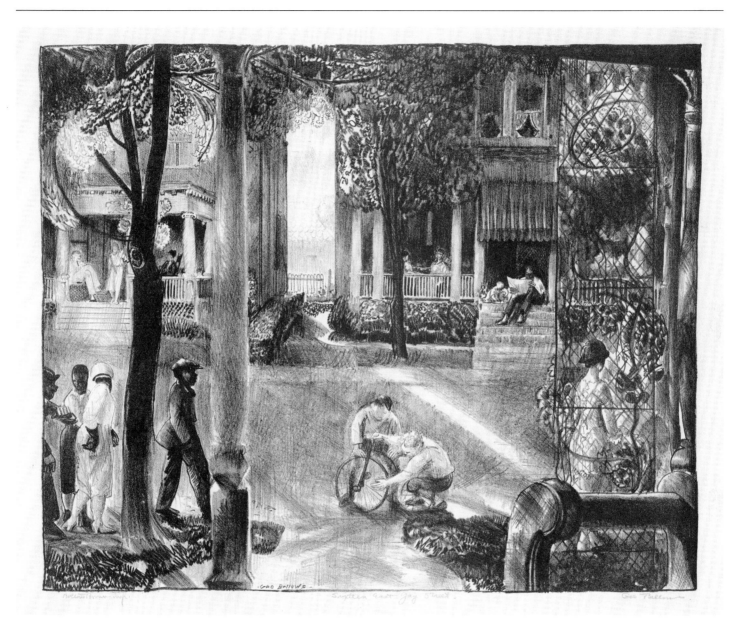

63.
Sixteen East Gay Street,
1923—24
Lithograph
9½ × 11¾ in.
Amon Carter Museum

He essayed several nostalgic portrayals of his midwestern roots, continuing a subject first treated in his 1917 lithograph *Initiation in the Frat* (fig. 62), a humorous view of collegiate antics drawn from reminiscences of Ohio State University's Beta Theta Pi fraternity. This affectionate reflection on his adolescent years was taken up again in his lithographs *Sixteen East Gay Street* (fig. 63) and *Sunday 1897* (fig. 64), two views of life in his native Columbus. Although he had lived in New York since 1904, Bellows maintained his ties with his family there, enjoying a particularly warm relationship with his mother. *Sixteen East Gay Street* portrays a scene from the perspective of a broad front porch in a neighborhood of substantial nineteenth-century homes. The architectonic framework and patterning of the scene are characteristic of the decorative quality found in Bellows' late work. *Sunday 1897* is an amusing glimpse of George's Sunday morning routine, when the tall, lanky youth was uncomfortably squeezed into the family's buggy, driven by his father. The only lithographic portrayal of the senior George Bellows, who had died in 1913, the print captures him genteelly saluting to passersby.[17] For all his fond recollections of life in Columbus, Bellows never longed to return, for he recognized the limitations of the country's conservative midsection and the lack of opportunity it offered an aspiring artist. In a letter to Henri applauding his friend's book *The Art Spirit,* Bellows noted that he wished he had read it as a boy, though it was doubtful that the book would have been allowed in the Columbus Public Library, as Balzac was not.[18] Other litho-

17. A drawing for *Sixteen East Gay Street* is located at the Boston Public Library, Print Department, and a drawing for *Sunday 1897* is in the collection of Dr. and Mrs. Harold Rifkin.

The strength of Bellows' family ties is evident in his correspondence with his mother, some of which is housed in the Bellows Papers, Amherst College.

18. Bellows to Henri, November 1923, Bellows Papers, Amherst College, box I, folder 8. Speaking of officials at Ohio State University in 1922, he remarked to his friend Joseph Taylor, a professor at that institution, that the university was a "maker of middle class minds for middle class jobs," an assessment perhaps influenced by the fact that Bellows failed to find a buyer at his alma mater for a portrait of the college president, painted some ten years earlier. (Bellows to Taylor, March 16, 1922, Bellows Papers, Amherst College, box I, folder 14.)

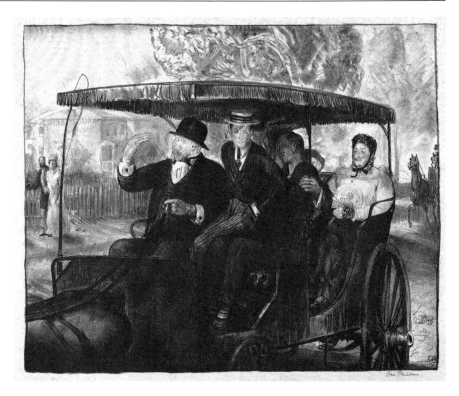

64.
Sunday 1897, 1921
Lithograph
12 × 14⅞ in.
Amon Carter Museum

66.
Evening Snow, 1921
Lithograph
7³⁄₁₆ × 9⅞ in.
Amon Carter Museum

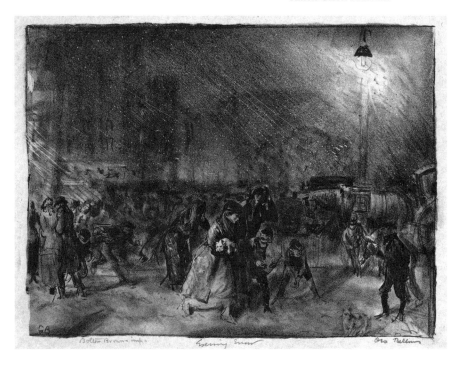

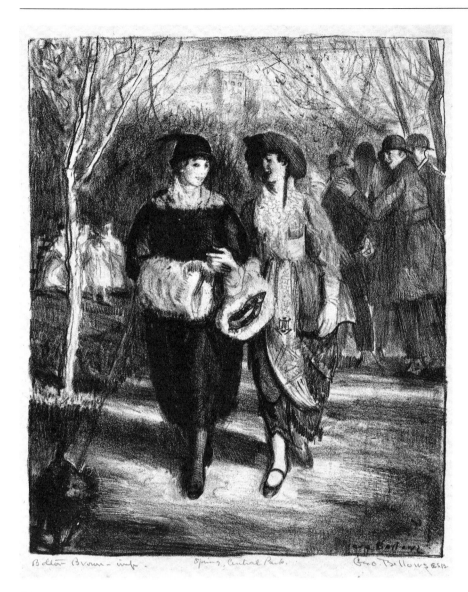

65.
Spring, Central Park, 1921
Lithograph
8⁷⁄₁₆ × 7 in.
Amon Carter Museum

graphic essays of the period state the theme of the continuity of generations, now of personal significance to George and Emma Bellows, whose daughters Anne and Jean were born in 1911 and 1915. *Married Couple* (1923), *Wedding* (1923–24), and *Auntie Mason and Her Husband* (1923–24) have a staged appearance resembling family photographs.[19]

In his lithographs of the 1920s, Bellows recorded other scenes drawn from his observations of everyday life, executing a series of outdoor genre subjects including *Spring, Central Park* (fig. 65), *Evening Snow*, one of his few nocturnal scenes (fig. 66), and *River-Front* (fig. 67). *River-Front* returns to a favorite theme of bathers in the rivers surrounding New York City; a comparison of this print with *Splinter Beach* (fig. 29), dating some seven years earlier, reveals the alteration in the aesthetic character of Bellows' prints after Brown began printing for him. The predominance of black and white extremes in *Splinter Beach* gives way to a greater tonal range in the later print, and the crisply delineated figures, which now include entire families as well as young boys, are in contrast with the more freely rendered figures of *Splinter Beach*. Although the specific subject of *River-Front* had never been treated as a lithograph, it had appeared in 1915 as a painting, *Riverfront No. 1* (fig. 68). The lithograph, made after this painting, was in turn followed by a second painted version of this subject, *Riverfront No. 2* (fig. 69), executed in April 1924. The second painting adopts the orientation of the lithograph (which reverses the original painting). The tall central structure of the 1915 painting, retained in the lithograph, is eliminated in the final oil, Bellows replacing this element with the smoke rising from the tugboat in order to provide a foil for the strong diagonal of the pier. The lithographed version of *River-Front* (possibly along with a drawing) was therefore an intermediate step in Bellows' development of the theme.

19. Mason 141, 179, and 180. Bellows identifies the female sitter in *Auntie Mason and Her Husband* ("with whom my father lived when he was building the old high school or there abouts") in a letter to Edna S. Pratt of Columbus, March 10, 1924, Bellows Papers, Amherst College, box I, folder 9.

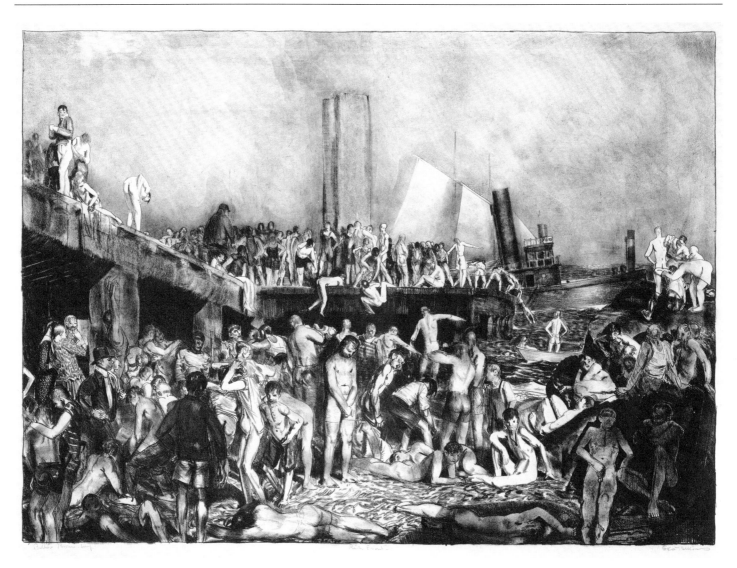

67.
River-Front, 1923–24
Lithograph
14 15/16 × 20 15/16 in.
Amon Carter Museum

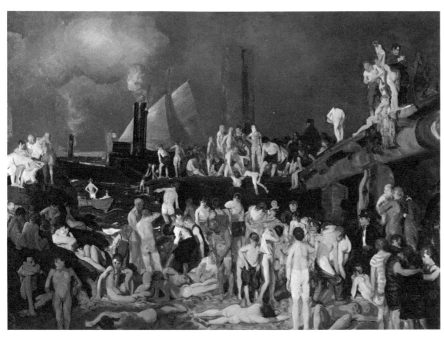

68.
Riverfront No. 1, 1915
Oil on canvas
45⅜ × 63⅛ in.
Columbus Museum of Art,
Columbus, Ohio;
Museum Purchase, Howald Fund

69.
Riverfront No. 2, 1924
Oil on canvas
45 × 63 in.
Private collection;
photograph courtesy of Hirschl
& Adler Galleries, Inc., New York

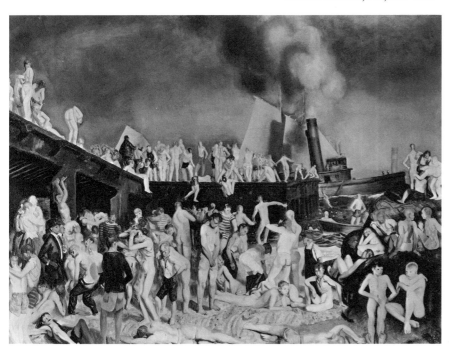

Other leisure pastimes appear in Bellows' work during this period. The lithograph *Polo Sketch* (fig. 70) takes up a theme previously essayed in three paintings and two drawings of 1910, the year he saw polo matches in Lakewood, New Jersey, and was dazzled by the spectacle and speed of the event. The lithograph, based on one of the paintings, provides a vigorous rendering of horses in motion.[20] His family's two summers in Rhode Island were recorded in a number of sketches made along the coast, which were then reworked and combined to create the lithographs *Bathing Beach* (fig. 71) and *Legs of the Sea* (fig. 72). A drawing for *Legs of the Sea* (fig. 73) shows how Bellows quickly captured the essential components of the scene, tempering the spontaneity of the drawing in the more studied and carefully composed lithograph.[21] Bellows equally enjoyed recreation outside of his family life, as attested by a series of four small prints depicting the game of billiards. In *Old Billiard Player* (fig. 74), *Indoor Athlete No. 1* (fig. 75), *Indoor Athlete No. 2* (fig. 76), and *The Pool-Player* (fig. 77), Bellows emphasized the strategy of a game he frequently played with Henri. Although their identities are no longer known, the characters in these prints were drawn from Bellows' own circle of friends.[22]

20. Bellows described his impressions of polo in a letter to Joseph Taylor, April 20, 1910, quoted in Frank Seiberling, Jr., "George Bellows, 1882–1925: His Life and Development as an Artist" (Ph.D. diss., University of Chicago, 1940), p. 240. The composition of the print is reversed from that of the painting on which it was based, *The Polo Game* (1910, private collection). Other works in the polo series are *Polo* (1910, ink wash and crayon, The Metropolitan Museum of Art); *Polo at Lakewood (Polo Field)* (1910, wash, unlocated); *Polo Scene* (1910, oil on canvas, Mrs. John Hay Whitney); and *Polo at Lakewood* (1910, oil on canvas, Columbus Museum of Art).

21. Another related drawing is located at the Boston Public Library, Print Department. *The Beach (Newport)* (private collection), a painting related to *Legs of the Sea*, was executed in June 1919 (artist's Record Book B, p. 163).

22. See the letters of Robert Henri to George Bellows, October 28, 1919, November 26, 1919, September 27, 1920, and October 21, 1924, Bellows Papers, Amherst College, box II, folder 12. In his Record Book B, p. 253, Bellows had first listed *The Pool Player* as "Murphy Playing Pool," but later crossed it out and added the title by which it is known today.

There are drawings related to both of the *Indoor Athlete* prints in the Boston Public Library, Print Department.

70.
Polo Sketch, 1921
Lithograph
8⁵⁄₁₆ × 10³⁄₈ in.
Amon Carter Museum

71.
Bathing Beach, 1921
Lithograph
8⅜ × 7 in.
Amon Carter Museum

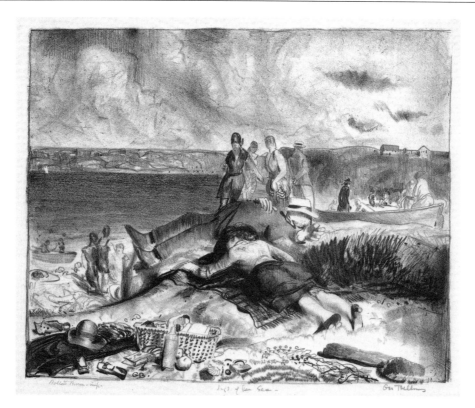

72.
Legs of the Sea, 1921
Lithograph
8⁹⁄₁₆ × 10¹¹⁄₁₆ in.
Amon Carter Museum

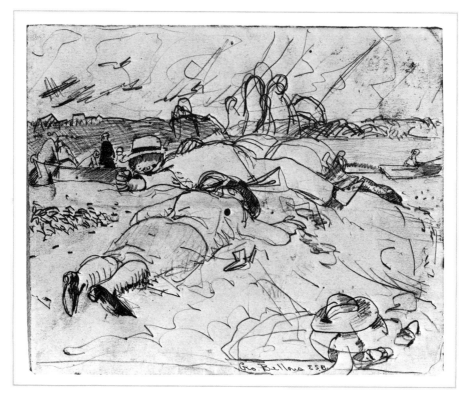

73.
Legs of the Sea, c. 1919
Graphite on paper
6⅝ × 8³⁄₁₆ in.
Boston Public Library,
Print Department;
Gift of Emma Story Bellows

74.
Old Billiard Player, 1921
Lithograph
9 × 7⁷⁄₁₆ in.
Amon Carter Museum

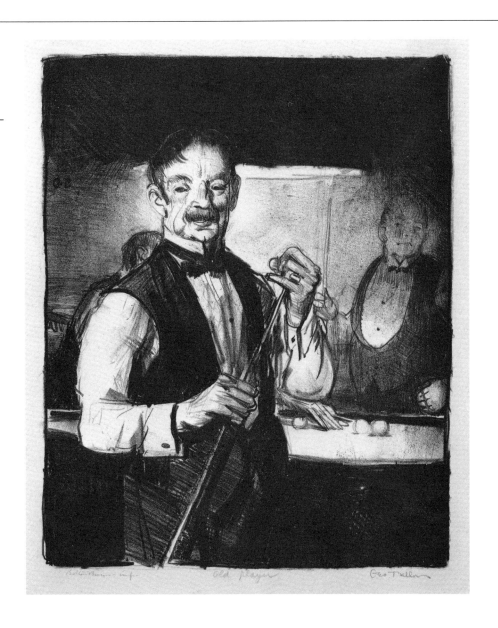

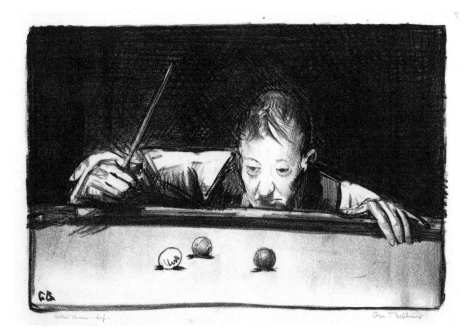

75.
Indoor Athlete No. 1, 1921
Lithograph
6½ × 9¾ in.
Amon Carter Museum

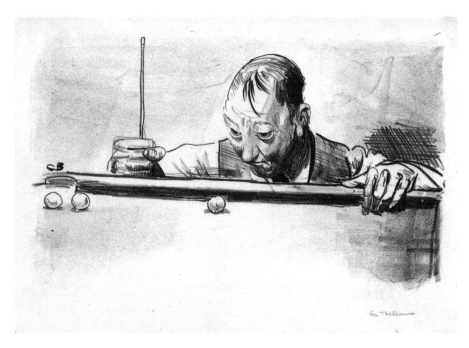

76.
Indoor Athlete No. 2, 1921
Lithograph
5¼ × 8¾ in.
Amon Carter Museum

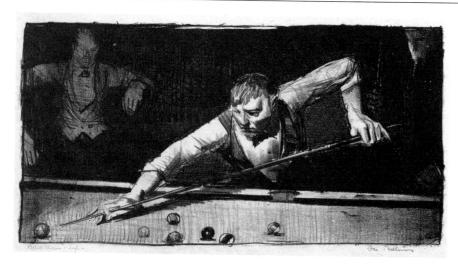

77.
The Pool-Player, 1921
Lithograph
5 × 10 1/16 in.
Amon Carter Museum

Bellows himself appears in *The Pool-Player*, in his shirt sleeves, the single overhead light recalling the male-dominated realm of the boxing prints.

Bellows' interest in boxing continued into the 1920s, and several of his boxing lithographs of the period repeat subjects taken from illustrations for the short story "The Last Ounce," the 1913 commission that had inspired several of his earliest lithographs. In 1921, he made three different lithographs based on a drawing executed for this commission entitled *Counted Out*.[23] In the same year, he produced a smaller version of his 1916 lithograph *Introducing the Champion* (fig. 33). Still another lithograph based on a drawing for "The Last Ounce" was the 1923 *Between Rounds No. 2* (fig. 114), a more refined version of a 1916 print of the same subject (fig. 34). In the later version, a combination of restrained line and delicate shading forge a smooth overall surface devoid of the harsh contrasts of the earlier print.

Bellows also explored the use of strong geometric patterns in his boxing compositions. The subjects of *The White Hope* (fig. 78) are likely Jack Johnson, a black heavyweight champion, and Jim Jeffries, known as "the white hope," in their 1910 Reno, Nevada, bout.[24] Jeffries, who lost the fight, slumps on the floor of the ring in a pose reminiscent of a classical sculpture, forming an angle of the large triangle on which the composition was based. Bellows depicts the concluding moments of the fight—while Johnson appears eager to continue, the referee, with a finely controlled gesture, gives Jeffries what may be the final count.

The nature of the sport had changed since Bellows' first treatments of boxing subjects. By the 1920s it had entered the public mainstream, generating widespread fascination and extensive press coverage.[25] In his 1921 lithograph *A Knock-Out* (fig. 79), based on a pastel of 1907

23. The lithographs are *The Last Count* (Mason 93), a unique impression, *Counted Out No. 1* (Mason 94), and *Counted Out No. 2* (Mason 95).

24. Linda Ayres, "Bellows: The Boxing Drawings," in E. A. Carmean, Jr., et al., *Bellows: The Boxing Pictures* (Washington, D. C.: National Gallery of Art, 1982), pp. 60–61.

25. E. A. Carmean, Jr., "Bellows: The Boxing Paintings," in Carmean et al., *The Boxing Pictures*, p. 36.

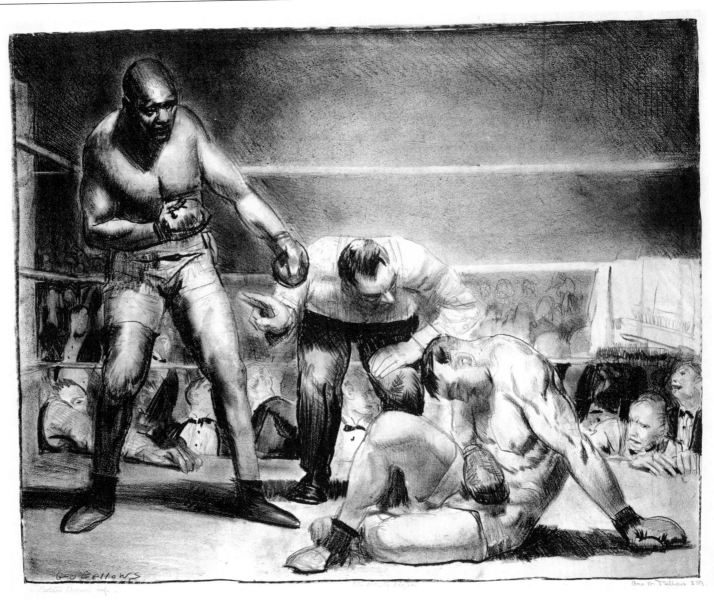

78.
The White Hope, 1921
Lithograph
15 × 18¾ in.
Amon Carter Museum

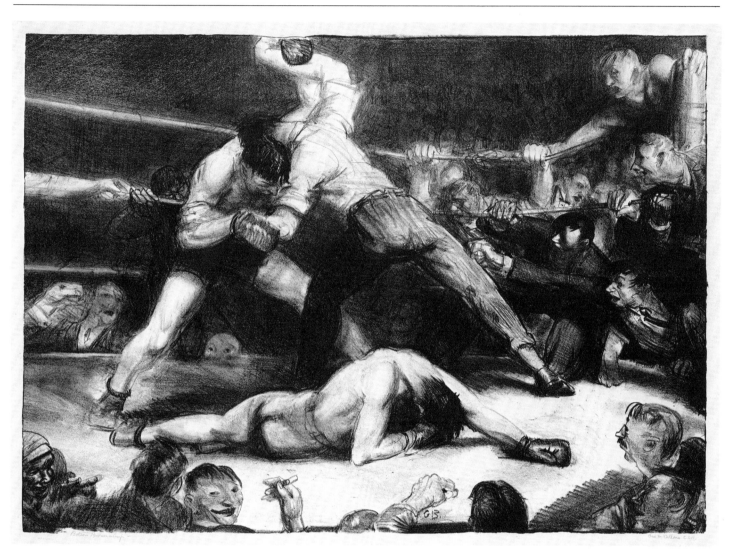

79.
A Knock-Out, 1921
Lithograph
15¼ × 21¾ in.
Amon Carter Museum

(Collection of Rita and Daniel Fraad), Bellows portrays the old back-room style of boxing—the audience participates fully in the event, climbing on the ropes as the referee intervenes to prevent the victorious boxer from striking yet another blow at his downed opponent. Such emotionally charged scenes were largely absent from Bellows' depictions of boxing events of the 1920s, when the sport was open to a larger audience.

Three of Bellows' prints from these years involved fights by boxing legend Jack Dempsey that Bellows covered for New York newspapers. On July 2, 1921, Georges Carpentier, a French pugilist, took on Dempsey in a widely publicized fight at the Polo Grounds in Jersey City, New Jersey. Bellows was commissioned by the *New York World* to cover the fight, producing two drawings (Boston Public Library, Print Department, and unlocated) and a print of it. Perhaps sensing a commercial opportunity, he deviated from his usual practice of making lithographs in New York during the winter, printing the lithograph *Introducing Georges Carpentier* (fig. 80) just a few weeks after the fight on Bolton Brown's press in Woodstock. This was also the only occasion when Brown took extensive technical notes on a Bellows print, writing several paragraphs in his diary and commenting that the edition was "printed to perfection."[26] While the drama of the fight lay in the confrontation of brute force (Dempsey) and agility and speed (Carpentier) and the eventual triumph of the former, Bellows depicts the opponents in the ring moments before the bout begins. Possibly because the picture was a commission for a newspaper, Bellows takes a reportorial approach. His crowded setting records the magnitude of an event that attracted over 80,000 fans, members of the press, and even cameramen (seen on the platform in the upper left portion of the composition).

Later, on commission from the *New York Evening Journal*, he witnessed the bout between Dempsey and the Argentine fighter Luis Firpo on September 14, 1923. An incident from his ringside experience resulted in a drawing (Metropolitan Museum of Art) and two lithographs, *Dempsey and Firpo* (fig. 117) and *Dempsey Through the Ropes* (fig. 81). Portrayed in these works is the dramatic moment after Firpo, to the astonishment of everyone present, knocked Dempsey out of the ring. This incident was of immediate interest to Bellows, as he somewhat facetiously wrote Henri: "When Dempsey was knocked through the ropes he fell in my lap. I placed him carefully back in the ring with instructions to be of good cheer." In the lithograph *Dempsey and Firpo*, however, Bellows places himself inconspicuously near the sidelines, while in *Dempsey Through the Ropes*, a version of the wider composition cut down on two sides to focus attention on the fighters, Bellows is eliminated from the scene entirely.[27]

Reflecting Bellows' search for an underlying formal order, the gestures of the fighters and referee are restrained, in contrast to Bellows' earlier boxing subjects where uncontrolled gestures dispersed the compositional focus. In a print like *A Knock-Out*, based on a very early work, the dramatic content lies in the furied interaction of the crowd and the fighters. In *Dempsey Through the Ropes* solid muscular figures fill the pictorial space, and emotions of the boxers and audience are held in check. Bellows' pictorial concerns were of more importance to him than accuracy—he was criticized for showing the right-handed Firpo landing a blow with his left. For Bellows, however, the integrity of artistic expression was of paramount importance; as he explained to Joseph Pulitzer of the *St. Louis Post-Dispatch*, who planned to repro-

26. Bolton Brown Journal, July 28 and August 3, 1921, Bolton Brown Papers, Archives of American Art, roll 3655, frames 128, 130. Although Mason (p. 140) did not record the citation, the print was listed in the artist's Record Book B, p. 259. Bellows indicated that fifty proofs of the print along with the drawing for the *New York World* were produced in July 1921. Brown's journal confirms an edition size of fifty. See also Brown, "My Ten Years in Lithography, Part II," p. 39.

27. Bellows to Robert Henri, November 1923, Bellows Papers, Amherst College, box I, folder 8. Bellows altered this version of the incident in a letter to Joseph Pulitzer: "At the fight I was sitting just back of the man in whose lap Dempsey fell and overheard Dempsey say he was feeling fine, so that's that." (Bellows to Pulitzer, April 7, 1924, Bellows Papers, Amherst College, box I, folder 9.) Bellows executed a drawing of the scene in September and an oil painting of the subject in June 1924 (Whitney Museum of American Art).

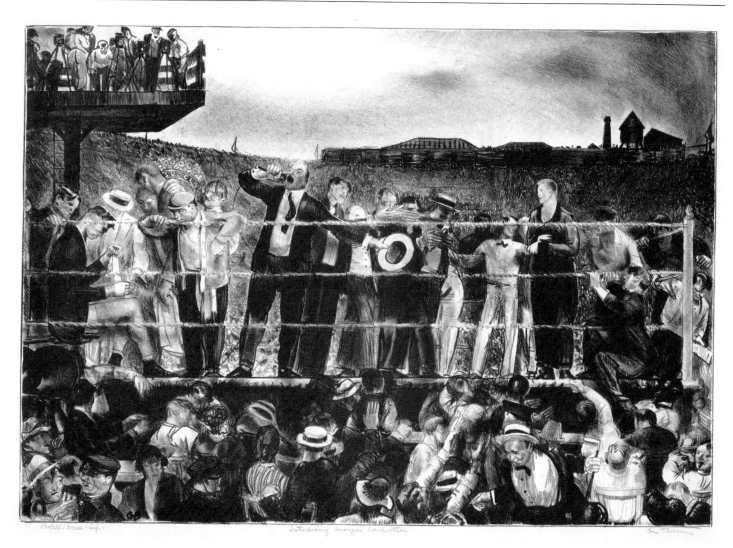

80.
*Introducing Georges
Carpentier*, 1921
Lithograph
14½ × 20¹⁵⁄₁₆ in.
Amon Carter Museum

92

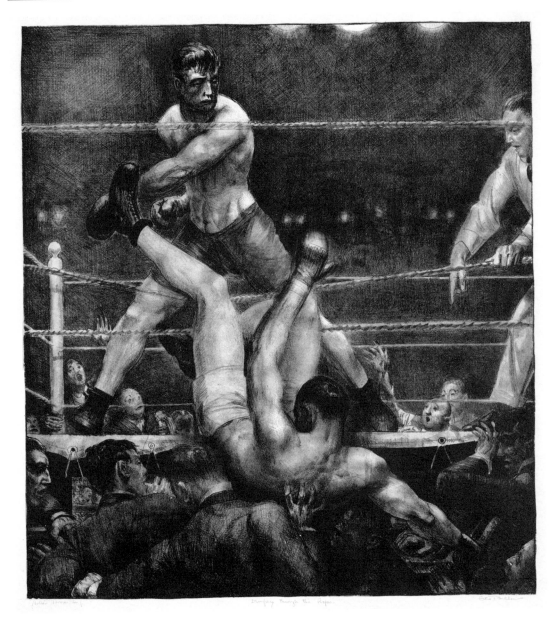

81.
Dempsey Through the Ropes,
1923–24
Lithograph
17^{13}/$_{16}$ × 16^{7}/$_{16}$ in.
Amon Carter Museum

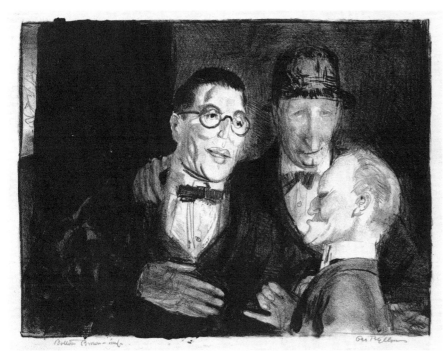

82.
Speicher, Kroll and Bellows,
1921
Lithograph
7¹³/₁₆ × 10½ in.
Amon Carter Museum

duce the Dempsey lithograph, "I have no expla-nation of Firpo's gesture other than it seemed a successful artistic invention. When I saw the fight I had no idea whether he knocked him out with his right or his left hand."[28] He suggested that he would not object if Pulitzer preferred to reverse the composition, saying that the design would be equally successful with either orientation.

In his portraits as in his boxing scenes, Bellows' lithographs parallel his work in oil, often treating the same subjects; but in both themes his lithographs create a distinctive body of work. A large proportion of Bellows' print output in the 1920s consisted of small-scale por-traits of family and friends. In 1921 alone, he produced thirty-two prints representing mem-bers of his family and his closest friends, often portraying them in group compositions. The portrait lithographs reveal Bellows' concern with the psychology of the individual rather than with the interrelationship of an entire group of figures, which dominated many of the lithographs from the 1916–18 period. Por-traiture had long fascinated Bellows. Early in his career, his oil portraits were characterized by the loosely rendered, bravura style of Henri and Frank Duveneck. His portraits of the 1920s, both in oil and in print, are less exuberant ex-pressions, for he imbues his subjects with an increasingly reflective quality.

Bellows engagingly rendered his intimate circle of friends, their everyday world typically segregated according to gender, in such prints as *Speicher, Kroll and Bellows* (fig. 82), *Elsie, Emma and Marjorie No. 1* (fig. 83), *Elsie, Emma and Marjorie No. 2* (fig. 84), and *Emma, Elsie and Speicher* (fig. 85). With the exception of *Speicher, Kroll and Bellows*—a light-hearted caricature of male camaraderie depicting Bellows and his fel-low artists, the bespectacled Eugene Speicher and the diminutive Leon Kroll—the group portraits are formally organized. In the two variations of *Elsie, Emma and Marjorie*, Elsie Speicher, Emma Bellows, and Marjorie Henri, posed in orderly fashion, are seated in the fore-ground while their husbands are engrossed in

28. Bellows to Pulitzer, April 7, 1924.

conversation behind them and do not interact with their wives. Emma and Elsie also appear in *Emma, Elsie and Speicher*, engaged in a more animated conversation while Elsie's husband, Eugene, hovers behind the sofa, maintaining a distance from their feminine concerns. The disjunctive quality of these two compositions was a result of Bellows' conception of the prints in separate parts, drawing from various figural groupings until he achieved a satisfactory composition. Bellows arrived at the final lithographed version of *Elsie, Emma and Marjorie No. 2* from a composite of three elements—the figure of Elsie, the two women on the sofa, and the men grouped in the background.[29] An earlier, less finished lithograph of the same subject served as a preliminary study for this work and was printed by Bellows in a small edition. The sketchy quality of the first version is removed in the second, where Bellows has minimized the linear passages.

Bellows also treated his friends in individual portraits, including *Elsie* (fig. 86), *Speicher Drawing* (fig. 87), and *Girl Fixing Her Hair* (fig. 88), whose attractive subject, formerly thought to be Emma Bellows, may now be identified as Marjorie Henri.[30] The Speichers, subjects of a number of Bellows lithographs, were George and Emma Bellows' closest friends. Speicher and Bellows had known each other since 1907, when they met at a YMCA basketball game. During the 1920s both families summered in Woodstock, New York. Speicher recalled his and Bellows' efforts to render likenesses of each other: "He painted my portrait and made some lithographs of me, and I painted him. The oil portraits were destroyed; we talked too much!"[31]

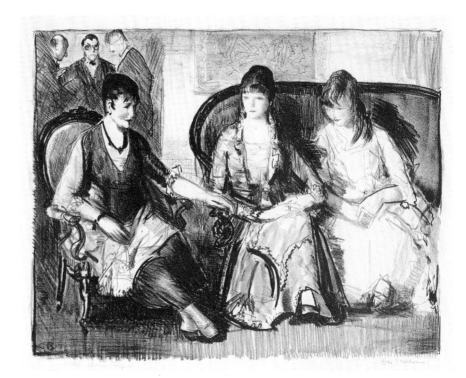

83.
Elsie, Emma and Marjorie No. 1, 1921
Lithograph
9½ × 12¼ in.
Amon Carter Museum

29. There are at least two drawings related to the second version (Art Institute of Chicago and Boston Public Library, Print Department). The figure of Elsie in *Elsie, Emma and Marjorie No. 2* also appears in the lithograph *Elsie, Figure* (1921, Mason 109).

30. Information from Jean Bellows Booth, who recalls that Marjorie was known for frequently rearranging her long hair. Interview with Linda Ayres, August 1987.

31. Eugene Speicher, "A Personal Reminiscence," in the exhibition catalogue *George Bellows: Paintings, Drawings and Prints* (Chicago: Art Institute of Chicago, 1946), p. 6.

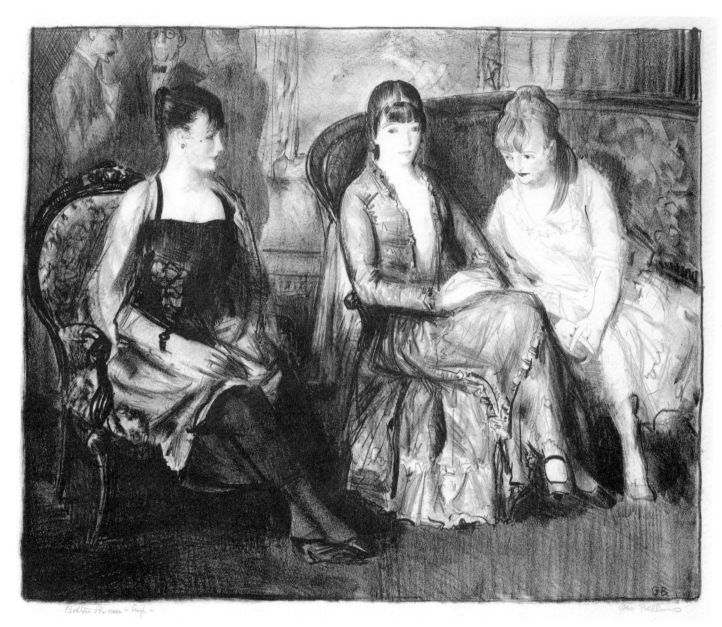

84.
Elsie, Emma and Marjorie
No. 2, 1921
Lithograph
11¼ × 13⅞ in.
Amon Carter Museum

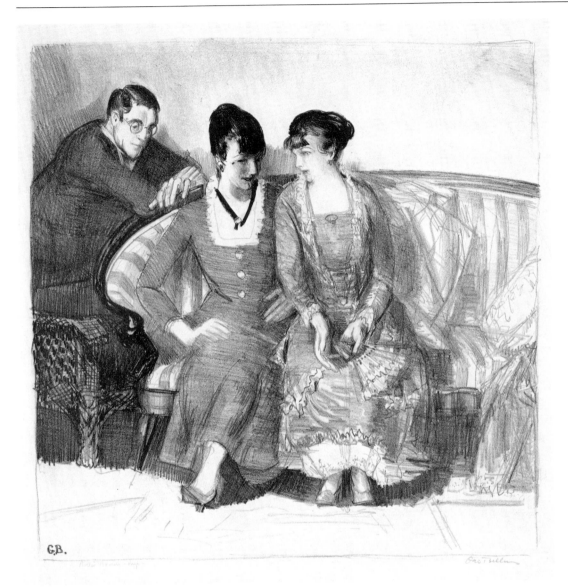

85.
Emma, Elsie and Speicher,
1921
Lithograph
11½ × 11⅝ in.
Amon Carter Museum

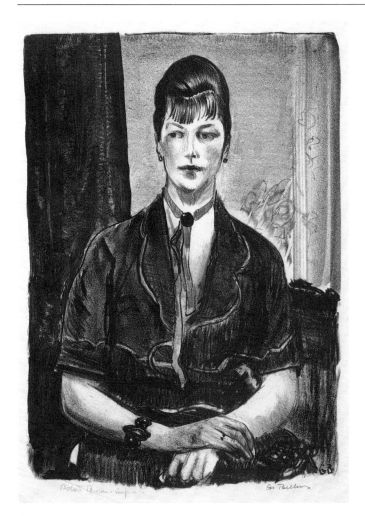

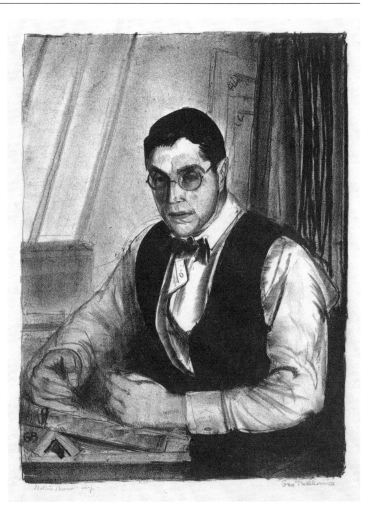

86.
Elsie, 1921
Lithograph
10�5/16 × 7½ in.
Amon Carter Museum

87.
Speicher Drawing, 1921
Lithograph
11¼ × 8⅝ in.
Amon Carter Museum

Other subjects of Bellows' portraiture included artists as well as members of the theatrical community. Sculptor Robert Ingersoll Aitken (1878–1949) was known primarily as the designer of sculpture for architectural commissions and public monuments and had made a bust of Bellows about 1910 (Columbus Museum of Art). In *Portrait of Robert Aitken No. 1* (fig. 89), one of two lithographs Bellows made of the sitter, he gives equal treatment to the strong, sculptural contours of Aitken's features and to the soft textures of his fur collar, providing an imposing likeness in this straightforward, fully realized characterization.

No one, however, was more frequently portrayed than the members of Bellows' own family, who first appeared in a lithograph in the 1916 *Mother and Children* (fig. 90).[32] He depicted them again in two 1921 prints entitled *My Family* (fig. 91). In these prints Bellows placed himself behind the sofa, a favorite prop, in a posture both approving and protective. The first version of this print, like the first version of *Elsie, Emma and Marjorie*, is a less finished interpretation of the final print, lacking the definition and detail of the second version. Other prints dating to 1921, including the group portraits, evince this tentative and delicate, almost unfinished quality, especially apparent in the features of Bellows' sitters. *My Family No. 2* is ordered around a series of curvilinear forms—Emma's arms, the back of the sofa, and the rocker and arm of the chair in which Anne sits. The composition has a balanced geometric framework—the three females comprise a pyramidal shape and, together with Bellows' figure and the dark drapery to the left, create a large X. With equal deliberation, Bellows employed the figures' glances to echo the sweeping motion of the curvilinear elements and set up a subtle psychological interaction— Anne commands the attention of Emma and Jean and she continues the direction of their glances by gazing out of the picture plane.

It was also in 1921 that Bellows embarked on a series of bust-length portraits. Some of the more formal among them, like the Aitken por-

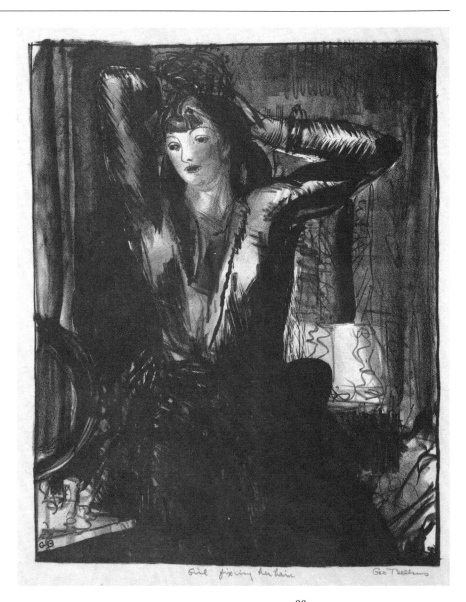

88.
Girl Fixing Her Hair,
1923–24
Lithograph
8¾ × 7 in.
Amon Carter Museum

32. The print is related to two unfinished oils, *My Family* (1916, National Gallery of Art, Washington, D. C.) and *Study of Emma and Her Children* (1917, Museum of Fine Arts, Boston).

89.
*Portrait of Robert Aitken
No. 1*, 1921
Lithograph
13⅝ × 11⁵⁄₁₆ in.
Amon Carter Museum

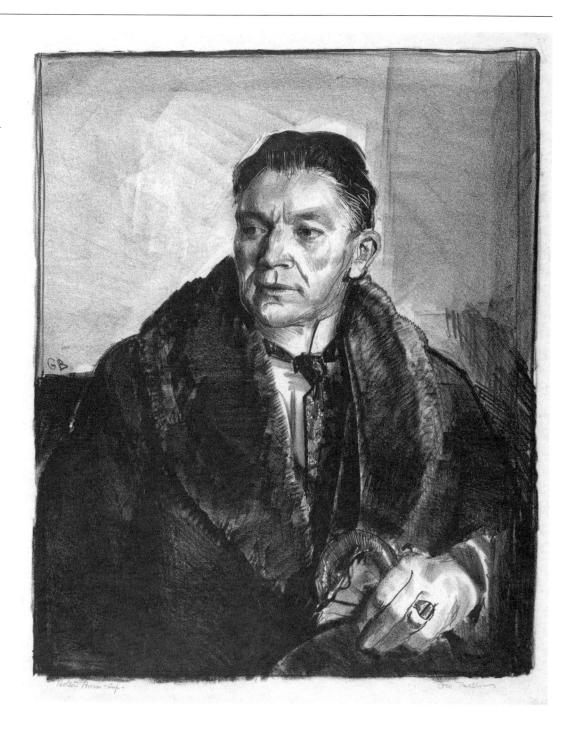

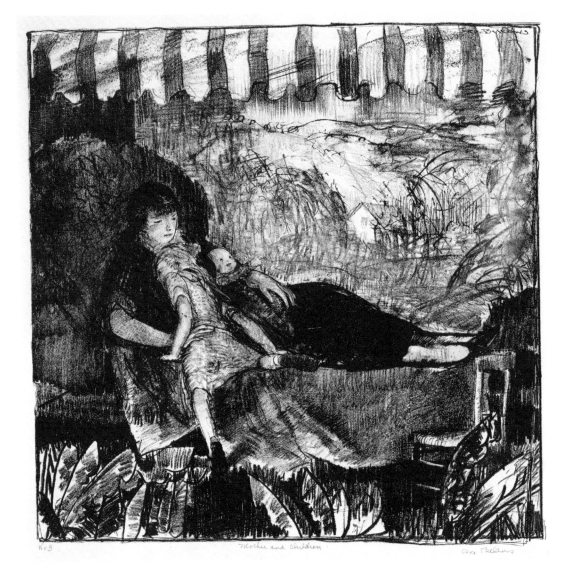

No 3 Mother and Children. Geo Bellows

90.
Mother and Children, 1916
Lithograph
11 3/16 × 11 3/8 in.
Amon Carter Museum
ALSO FIG. 142

My Family No. 2, 1921
Lithograph
10³⁄₁₆ × 8 in.
Amon Carter Museum

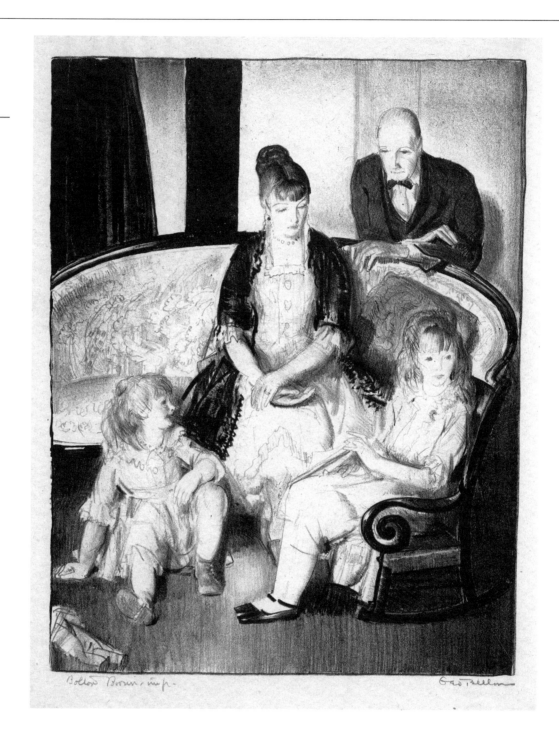

92.
Self-Portrait, 1921
Lithograph
10⁷/₁₆ × 7⁷/₈ in.
Amon Carter Museum

93.
Lady with a Fan, 1921
Lithograph
11¼ × 8¼ in.
Amon Carter Museum

trait, were probably commissioned works. Many were portraits of friends, some of whom he socialized with in Woodstock and may have sketched there, executing the lithographs during the winter in New York. Among the first in this format was his own *Self-Portrait* (fig. 92), possibly conceived as a pair with the similarly scaled *Speicher Drawing* (fig. 87). Bellows depicts himself looking at his reflection in a mirror, his image encircled by the scalloped molding of the frame. He wears his signature bow tie and draws on a lithography stone with one hand, holding a cigarette in the other. Smoking was a habit he attempted to conquer, as he humorously told his friends Charles and Mildred Rosen: "Also all winter I have been making evasive gestures at cigarettes usually with the left hand and lighting them with the right."[33]

Bellows' distinctive character and boisterous personality were accepted by his wife, Emma (c. 1884–1959), whom he portrayed in 1921 in the lithograph *Lady with a Fan* (fig. 93). A woman of independent spirit, Emma is portrayed seated in the frontal pose employed by Bellows in oil portraits of the period. As in his paintings, Bellows delighted in the frilly voluminous fabric, drawn freely in a quivery, descriptive line. Two years later Emma was again the subject of a lithograph, *Plaid Shawl* (fig. 94), her pensive, slightly weary gaze and her relaxed, increasingly natural pose indicative of changes wrought by the passage of time. Bellows' good-natured comments to the Rosens about a year after the lithograph was made succinctly echo this transformation: "Emma is wearing her knot a little lower and her bang a little higher and her figure a little rounder."[34]

Bellows' most enduring achievement among his lithographed portraits is the series depicting his daughters, Anne, named after Bellows' mother, Anna, and Jean, whose name was a tribute to the Bellows' friendship with Eugene Speicher. Sensitive portrayals of his growing children, the lithographs testify to Bellows' ability to transcend literal depictions, achieving

33. Bellows to Charles and Mildred Rosen, April 20, 1924, Charles Rosen Papers, Archives of American Art, roll 1033, frame 523.

34. Ibid., frame 524.

94.
Plaid Shawl, 1923
Lithograph
13⅝₁₆ × 9⅝ in.
Amon Carter Museum

95.
Anne in a Spotted Dress, 1921
Lithograph
11 × 8⅞ in.
Amon Carter Museum

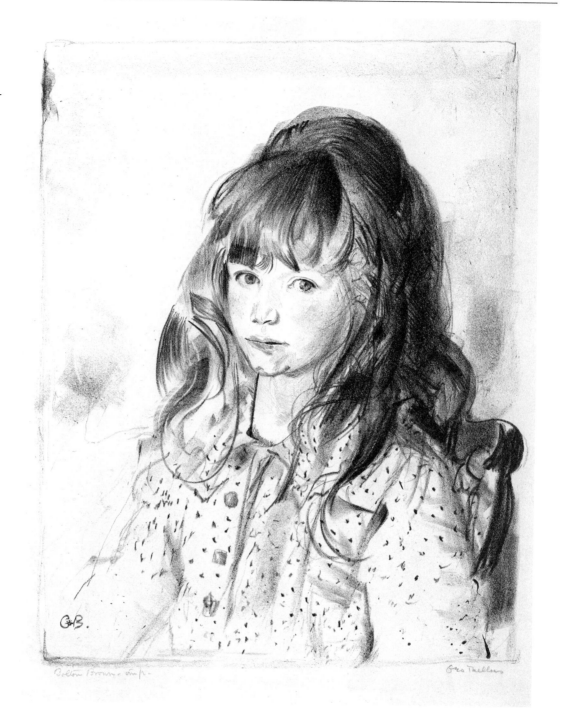

106

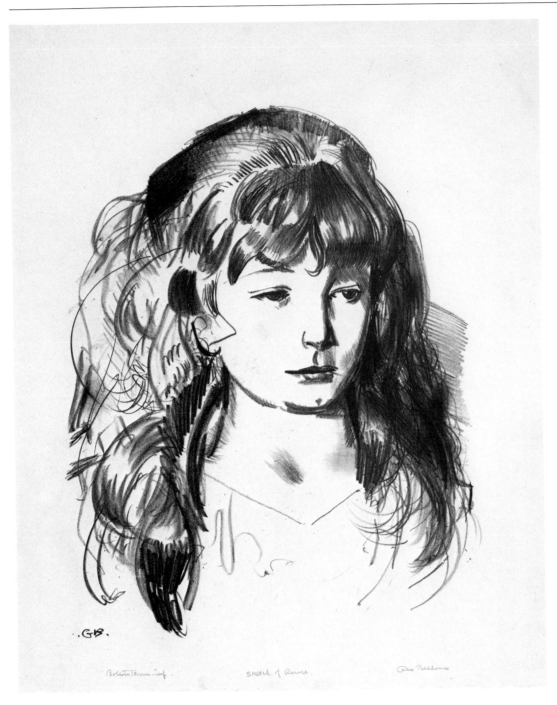

.G.

96.
Sketch of Anne, 1923–24
Lithograph
10 × 7¾ in. (irreg.)
Amon Carter Museum

97.
Anne in a Black Hat,
1923–24
Lithograph
14¼ × 12 in. (irreg.)
Amon Carter Museum

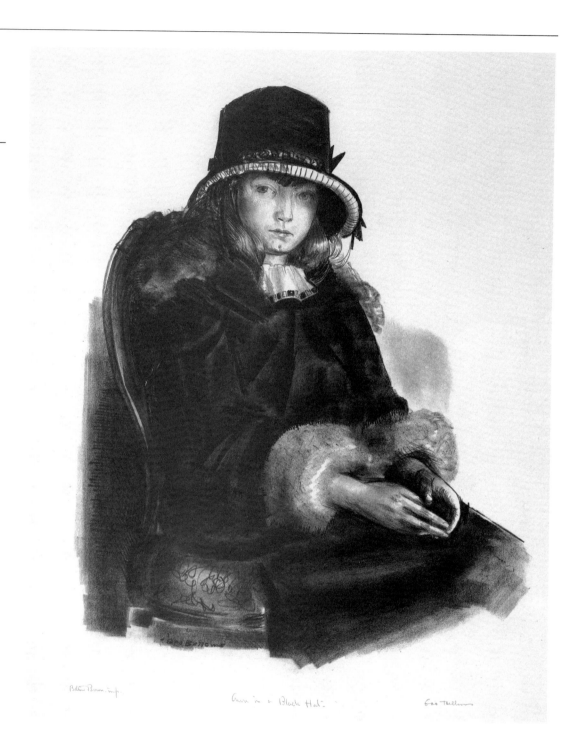

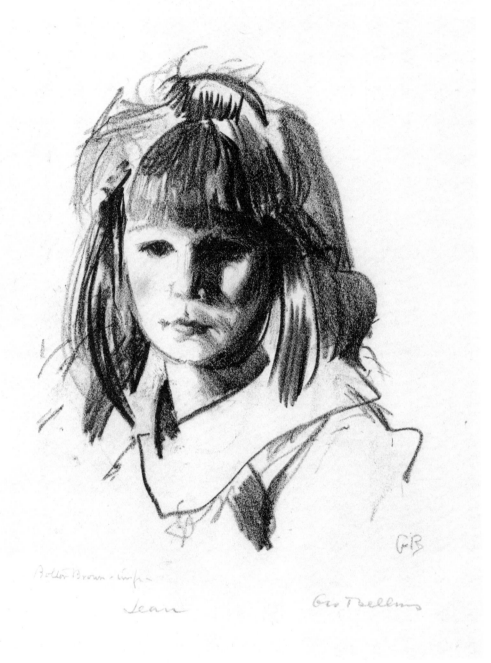

Boller Brown Impr

Jean Geo T Bellows

99.
Jean 1923, 1923
Lithograph
9¼ × 7 in.
Amon Carter Museum

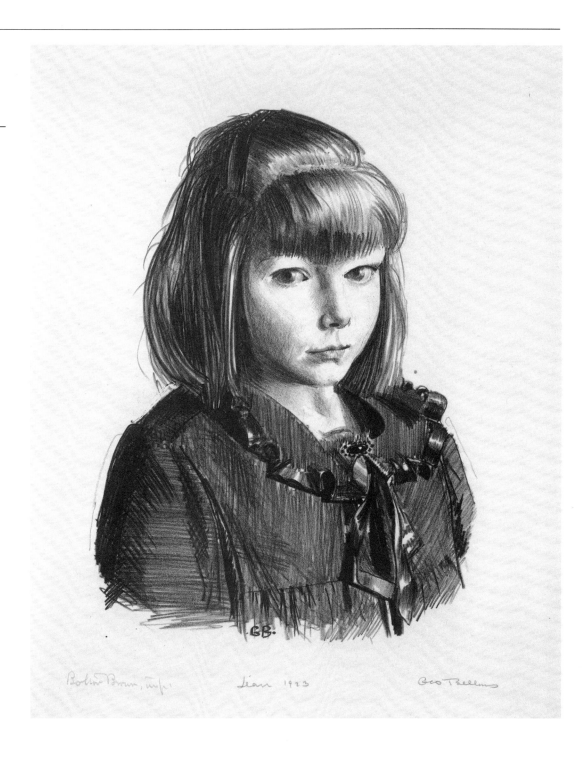

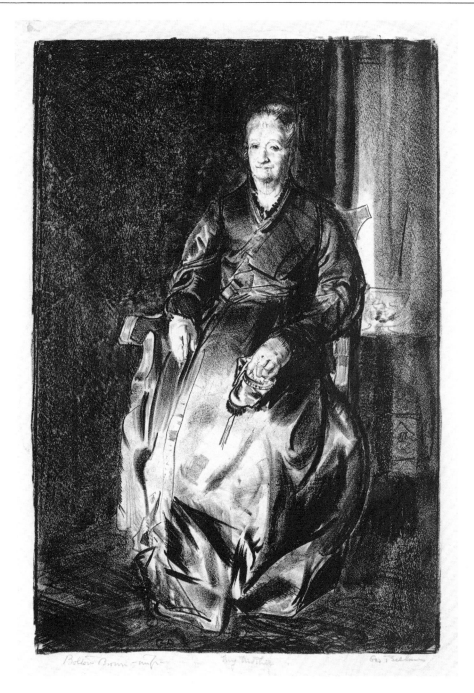

100.
Study of My Mother No. 2,
1921
Lithograph
11⅜ × 7⅞ in.
Amon Carter Museum

insightful portraits of character. Like the work of Thomas Eakins, whom Bellows greatly admired, Bellows' portraits have an introspective, penetrating quality that fixes the sitter's salient characteristics, especially vivid in those subjects close to the artist.[35] In the portraits of his daughters he conveys not only the essence of childhood but the pleasure he took in fatherhood, his daughters' visages a warm reflection of their relationship.

Anne and Jean were the subjects of numerous quickly rendered drawings in which Bellows caught their likenesses in a few simple strokes. For the drawings, Bellows employed the same rich black crayon he used in making lithographs. Anne, who was thirteen when her father died, evolves in the prints from the young girl of *Anne in a Spotted Dress* of 1921 (fig. 95) to the more mature *Sketch of Anne* (1923–24, fig. 96), the innocent gaze of the girl supplanted by the pensive look of a young adolescent. In the later print Bellows' treatment is increasingly abstract, a lively interplay of line and void defining Anne's cascading locks. Bellows' later prints expanded his range not only of expressive line, but of the rich textures he achieved through lithography. All three female members of the Bellows household were depicted in lithographs attired in their Sunday-best black hats. In *Anne in a Black Hat* (fig. 97), Bellows lavished attention on the tactility of the fabric and fur, subtly modulating the intense black to achieve creamy textures. This method contrasts with his earlier technique of describing denser passages in the prints through the application of tusche to the stone.

In the five prints Bellows devoted to his younger daughter, Jean makes an equally revealing passage through childhood. In the print *Jean 1921 No. 1* (fig. 98), Bellows delineates her five-year-old likeness with a loose, expressive application of the crayon. In a later print, *Jean 1923* (fig. 99), the sitter engages the viewer with her knowing, yet still innocent, glance.

This print is more tightly rendered, the lines of Jean's hair, dress, and features more deliberately placed.

Like the drawings, many of the portrait lithographs are linked to oil portraits executed during the same period. For example, Bellows indicated in his record book that the print *Sketch of Anne* was a study for a painting, apparently never executed. A friend of the family recalled that Bellows considered doing a lithograph of her sister from a painting (unlocated). To another sitter, Lilla Kalman, Bellows wrote that he was having difficulty with her portrait, and wished to take it to the country with him, adding, "I also hope that some time you will let me make a lithograph of you."[36] Some of the portrait lithographs were executed nearly concurrently with the related oils. The two lithographs of his mother, Anna Bellows (c. 1838–1923), executed in the first three months of 1921 (fig. 100), relate to two paintings, one from March 1921 and the second from the fall of that year. The lithographs resemble most closely the first painting although they are not identical to either, sharing the composition of the figure in the earlier oil but with less elaborate background. The print likely served, as did the drawn studies of Anna's figure, as a means to arrive at a posture Bellows liked; the second and more finished print corrects the minor compositional problems of the first, such as the placement of the figure's hands and the tilt of her head.[37] A tall and heavyset woman, Anna Bellows fills the chair in which she is seated, the artist conveying a sense of her girth by emphasizing the highlights of the voluminous folds of her satin dress. His mother's

35. Bellows and Eakins, who had died in 1916, were the subjects of a joint exhibition in February 1921 at New York's Ferargil Galleries.

36. Artist's Record Book C, p. 9 (where the print is called "Anne's Head"); Jacqueline Hudson to Charles Morgan, September 21, 1966, Charles Morgan Papers, Amherst College Archives, box XIII, folder 10; Bellows to Lilla Kalman, May 10, 1924, Bellows Papers, Amherst College, box I, folder 8.

37. An earlier oil of 1919, *Grandma Bellows*, a three-quarter-length portrait, is in the collection of the Oklahoma Art Center. Besides the paintings, *Portrait of My Mother* (March 1921, Art Institute of Chicago) and *Portrait of My Mother, No. 1* (September 1921, Columbus Museum of Art), there are at least two drawings related to the series (Art Institute of Chicago and the collection of Dr. and Mrs. Harold Rifkin). Anna's figure also appears in the painting *Elinor, Jean and Anna* (1920, Albright-Knox Art Gallery).

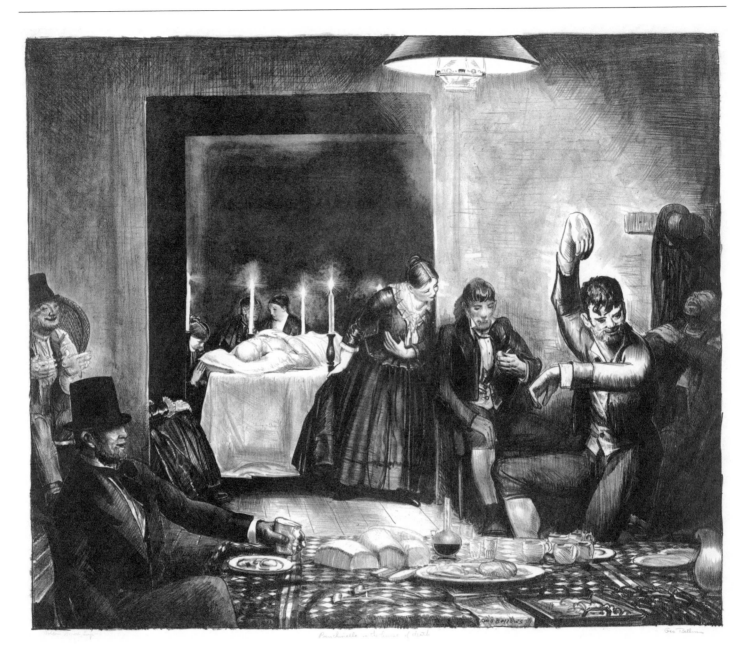

101.
*Punchinello in the House
of Death*, 1923
Lithograph
16 × 19⅜ in.
Amon Carter Museum

ample appearance must have suggested Eakins' ecclesiastical portraits, for Anna's pose is identical to that of Eakins' *Archbishop William Henry Elder* (1903, Cincinnati Art Museum)—Eakins' portrayal of dignity and age finding a parallel in Bellows' affectionate look at his mother.

While Bellows excelled in his depictions of the real world, between 1922 and 1924 he produced a series of lithographs for entirely imaginary narratives. He was commissioned to provide a large number of drawings for H. G. Wells' novel *Men Like Gods* and for Irish writer Donn Byrne's novel *The Wind Bloweth*, serialized in *Hearst's International Magazine* and *Century Magazine* respectively. For many of his earliest lithographs Bellows had drawn on his magazine illustrations for source material. In the 1920s, lithographs sometimes fulfilled the commission itself, and Bellows encouraged their publication. In a letter to the English artist William Nicholson, who had requested a drawing to publish in his magazine *The Owl*, Bellows indicated that while his recent drawings were done on commission and therefore had already been published, "I have, however, a series of new lithographs, one or two of which I would be glad to send you for publication . . ."[38] In other cases the lithographs were produced shortly after the drawings for the illustrations, changing the drawings only slightly.

Bellows, whose subject matter, except for the war series, had been drawn almost exclusively from his own experiences, enthusiastically met the challenge of depicting scenes from an author's imagination. Bellows' creative process was described by a contemporary writer: "His method of illustrating a story is to read it through, 'freezing' in his memory, as it were, the pictures that are conjured in his imagination. If a story lacks pictorial value, some abstract thought in it may still furnish the germ of a picture."[39] Friends and family recall that Bellows was an inveterate reader, and these commissions for fictional works appealed to his untapped romantic sensibilities, providing the

opportunity to treat more substantial works of fiction than his earlier magazine illustrations for short stories had offered.[40]

In 1922 Bellows received the substantial sum of $1,400 to provide illustrations for Donn Byrne's *The Wind Bloweth*. Fifteen illustrations appeared in *Century Magazine* from April to September, eight of which were included in the book version published the same year. Four of the drawings, *Punchinello in the House of Death* (fig. 101), *Allan Donn Puts to Sea* (fig. 102), *The Irish Fair*, and *The Journey of Youth*, were also made into lithographs in 1923 and 1924.[41]

Recounting the romantic adventures of an Irish mariner and set in an imaginary realm of the nineteenth century, the tale is replete with elements of Irish folklore and legend, an attractive quality for Bellows whose friend Henri had traveled to Ireland and had painted landscapes and portraits of Irish "characters." Bellows' association with Irishman John Butler Yeats, whose *Essays Irish and American* were published in 1919, provided additional familiarity with a culture he never witnessed firsthand. Bellows' continuing interest in Irish affairs is evidenced by a drawing and lithograph he made of the leader of the Irish independence movement, Eamon De Valera, who traveled to the United States in 1919 to raise support for the Irish cause. The lithograph, *Appeal to the People* (1923–24),

38. Bellows to William Nicholson, May 8, 1923, Bellows Papers, Amherst College, box I, folder 8.

39. Louis H. Frohman, "Bellows as an Illustrator," *International Studio* 78 (February 1924): 422–423.

40. See the reminiscences of Anne Bellows Kearney, Charles Chubb, Fred Cornell, and Emma Bellows in Seiberling, "George Bellows," pp. 232, 183, 188, 227.

41. The artist's record books indicate that *Irish Fair, Punchinello in the House of Death*, and *Allan Donn Puts to Sea* were printed between January and June of 1923 (Record Book B, pp. 294–295), while *The Journey of Youth* was printed in the winter of 1923–24 (Record Book C, p. 9). The drawing *The Journey of Youth* was reproduced in the April 1922 issue, p. 807; *Punchinello in the House of Death* in the May 1922 issue, p. 101; *Allan Donn Puts to Sea* in August 1922, p. 618; and *Irish Fair* in September 1922, p. 765. *The Journey of Youth* and *Allan Donn Puts to Sea* were omitted when the story was published in book form by the Century Company in 1922. Bellows' payment for the illustrations is recorded in his Account Book, n.p. An oil version of *The Journey of Youth* is in the collection of Bellows' grandson, Philip Kearney.

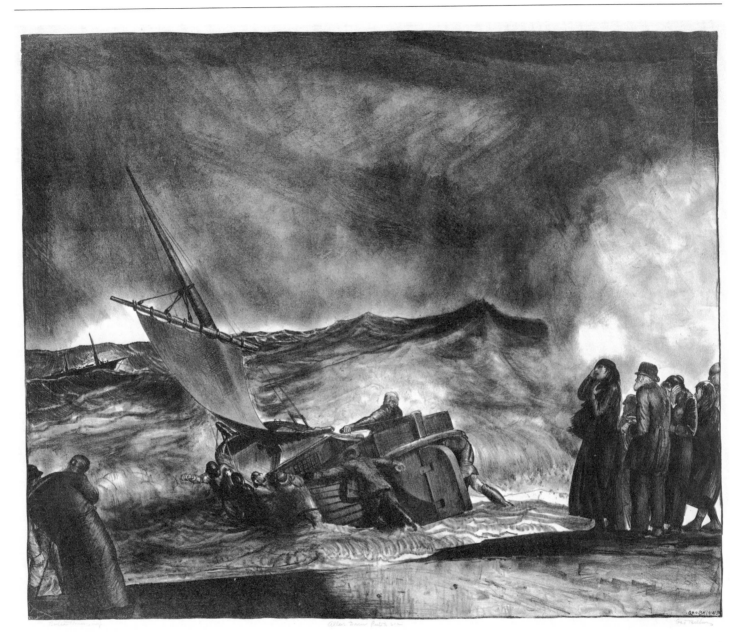

102.
Allan Donn Puts to Sea, 1923
Lithograph
15¹¹⁄₁₆ × 19¼ in.
Amon Carter Museum

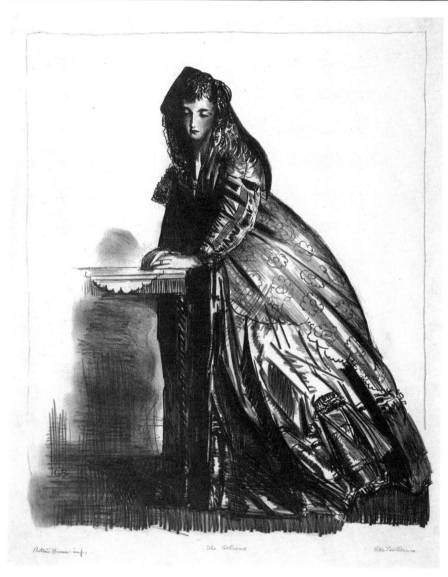

103.
The Actress, 1923—24
Lithograph
13¼ × 11¹⁄₁₆ in.
Amon Carter Museum

is one of the few Bellows did in the 1920s that contains political commentary.[42]

Bellows' most successful prints in the *Wind Bloweth* series illustrate events with moral significance, reflecting the tone of the story. For his illustrations Bellows selected key narrative developments, involving the loves of protagonist Shane Campbell, son of a Gaelic poet, and his worldwide peregrinations in search of truth and the meaning of life. In *Punchinello in the House of Death*, Campbell appears seated against a wall, attending a wake for his wife, the first of several women who enter his life in the course of the novel. A young man of twenty-one years, he suffers the indignities of women's gossip and the merrymaking of the feasting "mourners"—the "punchinello" of the title, a commentary on the grotesque irony of the situation.[43] In the print, Bellows follows the details of the narrative closely and returns to his earlier employment of character types to represent male Irishmen, bestowing upon them what he considered to be peculiarly Irish features.

Allan Donn Puts to Sea, in contrast, represents a tumultuous seascape, the only print Bellows executed that approximates the breadth and mood of his numerous marine paintings. Bellows took one element of the composition from an earlier source; the dory and the surrounding figures appear in the painting *Big Dory* (1913, New Britain Museum of American Art).[44] The scene represents the moment when Donn, a sailor and Shane Campbell's uncle, though it meant certain death, set out to sea alone to rescue a stranded schooner, visible on the left side of the print. Bellows' imagination dramatically recreated the scene—the woman left behind, huddled with others on the shore, set against

42. This lithograph (Mason 167) was based on a newspaper photograph, which entered the collection of the Boston Public Library, Print Department with the related drawing.

On Henri's interest in Ireland, see William Innes Homer, *Robert Henri and His Circle* (Ithaca: Cornell University Press, 1969), p. 249.

43. Donn Byrne (pseud.), *The Wind Bloweth* (New York: The Century Co., 1922), pp. 69—70. A related drawing is in the Boston Public Library, Print Department.

44. The scene is described in Byrne, *The Wind Bloweth*, pp. 268—270. The drawing for the print is in the collection of the Albright-Knox Art Gallery. Although in the novel the character's name is spelled "Alan," Bellows misspelled it in inscribing his lithographs.

the turbulent sea and stormy sky that reinforce the futility of the mission.

Although he was critical of some of his own drawings for this commission, noting that the "drawings in [the] first issue are the poorest,"[45] the novel's nineteenth-century setting stimulated his interest in historical costume. During this period Bellows made numerous drawings of Victorian dress, including the lithograph *The Actress* (fig. 103), a subject probably inspired by one of the novel's characters, a former thespian. The *Wind Bloweth* commission also provided the impetus to explore the elderly Irish type, later developed in the lithographs *Irish Grandmother* and *Old Irish Woman* in which Bellows captured the sweet, wizened features of age.[46]

While *The Wind Bloweth* offered an opportunity to exercise a romanticized concept of a foreign culture, a commission to illustrate H. G. Wells' novel *Men Like Gods* posed the challenge of realizing a purely fantastic world. Bellows' account book indicates that he was paid handsomely—$1,200 in 1922 and $3,800 in 1923 for twenty-five drawings, of which twenty-one were published in *Hearst's International Magazine* between November 1922 and June 1923, each issue averaging about three illustrations. Six of the drawings for these illustrations, as well as the four that were not published, were transferred to lithographic stone and printed in 1923.[47] In selecting those drawings to be copied

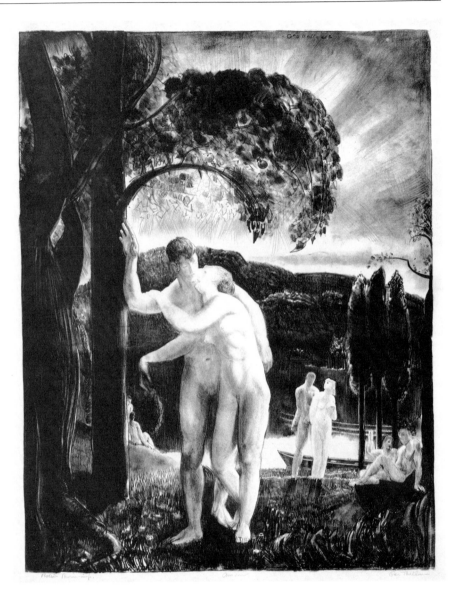

104.
Amour, 1923
Lithograph
17 13/16 × 14 1/16 in.
Amon Carter Museum

45. Bellows to Joseph Taylor, March 16, 1922, Bellows Papers, Amherst College, box I, folder 14. Two of the drawings in the first installment were used by Century in the book, and the third was copied by Bellows in his lithograph *The Journey of Youth* (Mason 150).

46. Mason 155 and 156. A number of drawings depicting Irish types are in the collection of the National Gallery of Art, Washington, D. C.

47. Morgan erroneously states that Bellows made twenty-seven drawings for the Wells story and that the artist earned $3,800 for the entire assignment (*George Bellows*, p. 258). The artist's Record Book B, p. 294, lists all the lithographs related to this series except *The Battle* under "January–June 1923"; *The Battle* is listed in Record Book C, p. 9 under "Winter 1923–4." The illustrations for the serialized novel that relate to lithographs are: *The Christ of the Wheel*, December 1922, p. 42; *Amour*, February 1923, p. 47; *The Battle*, March 1923, p. 41; *The Garden of Growth* and *The Return to Life*, April 1923, pp. 56, 60; and *The Crowd*, May 1923, p. 88. The lithographs based on illustrations for the project that were never published are *Lychnis and Her Sons* (Mason 163), *The Lovers That Passed Him By* (Mason 164), *Farewell to Utopia* (Mason 165), and *Final Instructions* (Mason 166).

as lithographs, Bellows chose episodes occurring at intervals throughout the story, thus ensuring that a cross-section of the narrative would be represented—suggesting that he regarded the lithographs as a set. The fact that four of the lithographs were based on illustrations the magazine elected not to reproduce suggests a difference of opinion on the part of Bellows and the publisher. In May 1923, before the serial had concluded, Bellows wrote to H. G. Wells in London, noting that he had been working on the illustrations for the author's story; having learned that Wells was interested in seeing the originals, Bellows sent him some, apparently hoping to have them included in the forthcoming book version of the novel (a hope that remained unrealized): "I have had amazing pleasure in trying to follow the course of your thought and in seeing what effect it had upon my own imagination in the process of my own work. If you find in any of these proofs a particular one which you are particularly interested in I shall be glad to send you a still further present of a lithograph of that proof if such happens to be made by lithographic process and is therefore available. Most of these drawings are original paper drawings and in some cases I have created them on stone and therefore have multiple proofs." Bellows then indicates his displeasure with the publisher: "I am sorry that the publishing world will probably not find it to its advantage to put these drawings with your text in a way that I , as an artist, and possibly you, as an author, might most like to see it done, at least I so hope that this may be your point of view upon seeing my work. They are, of course, full of all sorts of faults but I have tried like the devil to make them do the finest thing I am capable of."[48]

Wells' narrative dealt with a group of Englishmen who unexpectedly find themselves transported to a utopian world. These individuals, who symbolize Wells' view of the flawed society of contemporary England—the dogmatic clergyman and the duplicitous politician among them—in their quest for domination declare war upon the Utopians. The lone dissenter is the narrator, Mr. Barnstaple, who finds in the advances of Utopia—population control, the absence of war, and an economic system based on credit and trust rather than currency—a socialized society superior to his own. Abandoning his compatriots, Barnstaple befriends the Utopians. The moral underpinnings of the story undoubtedly appealed to Bellows, who found a subject that conformed to his belief that "the great illustrator must be interested in the noble order of form, the noble order of light, and the noble order of sensation."[49]

Although he had drawn upon classical sources in previous works, Bellows here employed classical form systematically to impart noble qualities to his idealized subjects.[50] In *Amour* (fig. 104) he depicts the natural world of Utopia, which Barnstaple found enchantingly beautiful, with glowing rays suggesting a sun-filled, idyllic place. The rays bear little physical relation to the rest of the composition, casting a decorative pattern against the orderly forms of the landscape. For Wells the citizens of Utopia, who wore no clothing, embodied the perfection of form, providing Bellows with the opportunity to render many nude figures. A number of these are based on classical prototypes, such as the figures in *The Battle* (fig. 105), a confrontation between the Utopians and Barnstaple's fellow Englishmen, whose intertwined postures echo those of the Greek marble *Laocoon* (Vatican Museums, Rome). While a sculptural source for these figures may have endowed them with a muscular appearance, the majority of the figures in the *Men Like Gods* series, like those in *Amour*, have an elastic, limp quality—Bellows' attempt to suggest their otherworldliness.

Because it was based on an imaginary realm, Bellows explored other sources suggested by the narrative; he expands a brief passage in the novel concerning one of the civilization's ancient martyrs into an image with Christian overtones. In *The Christ of the Wheel* (fig. 106) he equated the Utopian prophet with Christ, giving form to Wells' description: "This prophet in Utopia had died very painfully, but not upon

48. Bellows to H. G. Wells, May 8, 1923, Bellows Papers, Amherst College, box I, folder 15.

49. Frohman, "Bellows as an Illustrator," p. 423.

50. E. A. Carmean, Jr., "Bellows: The Boxing Paintings," p. 33, notes Bellows' affinity for classical forms.

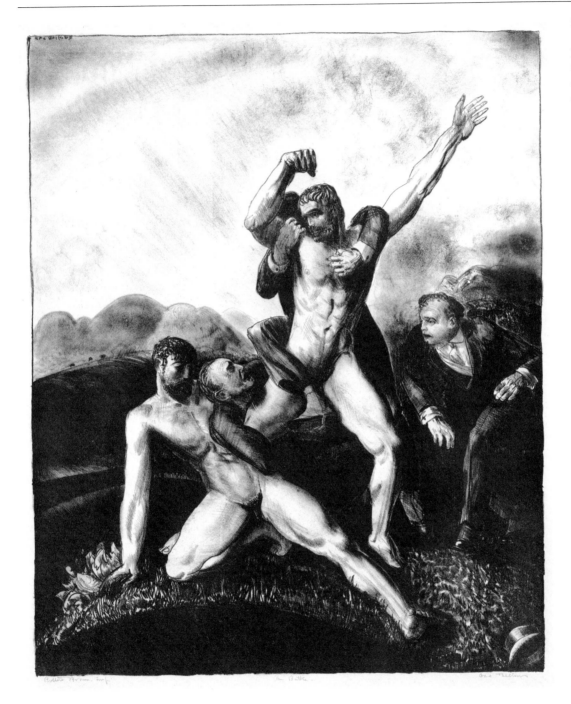

105.
The Battle, 1923–24
Lithograph
15¾ × 13 in.
Amon Carter Museum

106.
The Christ of the Wheel, 1923
Lithograph
17¹⁵/₁₆ × 14¹³/₁₆ in.
Amon Carter Museum

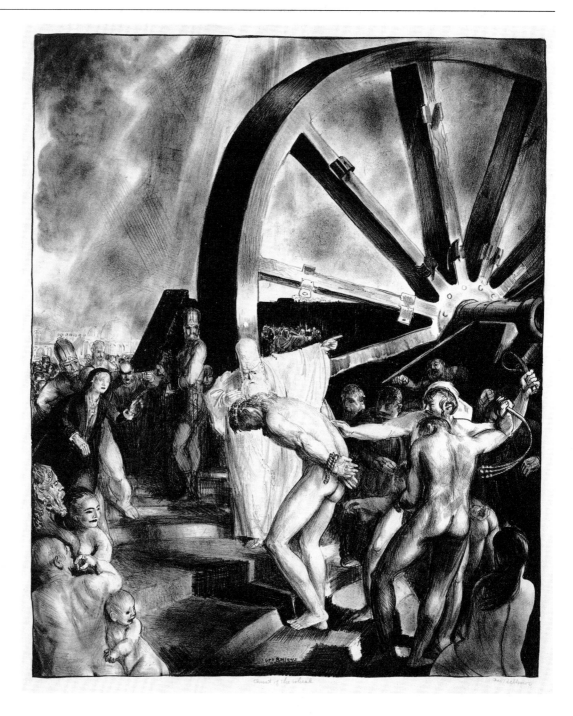

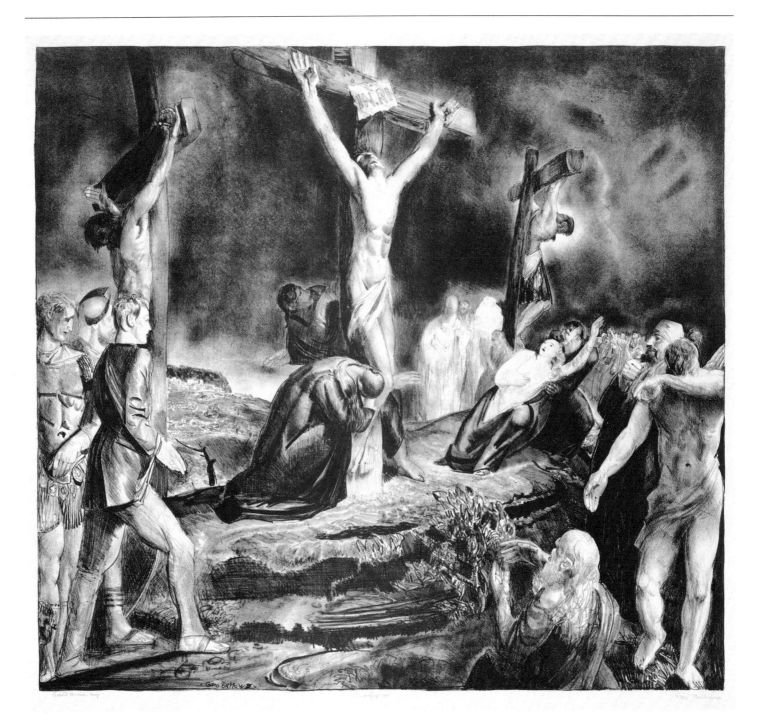

107.
Crucifixion of Christ, 1923
Lithograph
18⅝ × 20⅝ in.
Amon Carter Museum

108.
The Law Is Too Slow, 1923
Lithograph
17 15/16 × 14 1/2 in.
Amon Carter Museum

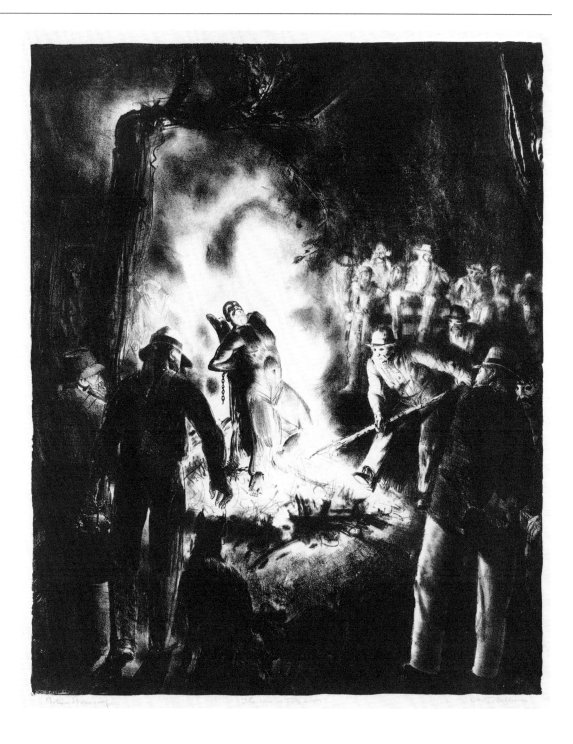

the cross. He had been tortured in some way and then been fastened upon a slowly turning wheel until he died. There flashed upon Mr. Barnstaple a picture of a solitary looking, pale-faced figure, beaten and bleeding in the midst of a jostling sun-bit crowd which filled a narrow high-walled street."[51]

Bellows employed the stylistic formulas of the *Men Like Gods* series in other commissioned works calling for scenes drawn from the imagination. The lithograph *Crucifixion of Christ* (fig. 107) was based on a drawing of 1922 that accompanied "I Saw Him Crucified," a short story by Arthur Conan Doyle published in *Hearst's International Magazine*. To a traditionally composed scene of the Crucifixion, Bellows adds the narrative element of the soldier at the left, the eyewitness in Doyle's story. Like the *Men Like Gods* lithographs, the print features elongated figures and an evocative, surreal landscape. Following the lithograph, Bellows painted an oil of the subject that received extensive critical and popular attention.[52]

During the 1920s prints played a growing role in Bellows' commissioned work. In 1923 a lithograph was chosen over the related drawing to illustrate Mary Johnston's story "Nemesis" for *Century Magazine*. The lithograph, *The Law Is Too Slow* (fig. 108), is a vivid portrayal of a lynching in this fictional tale of racial intolerance in the South, a timely issue during the 1920s, a period of recurring racial violence. The guilt or innocence of the man, who was accused of murdering a white woman, is not resolved in the narrative, the story focusing on the lawless nature of lynching and the eventual downfall of the crime's perpetrators. Bellows chose to emphasize the more horrific aspect of this passage: "One of the four men lighted the pile. . . . The

cane blazed up, and the night turned red and horribly loud—like hell."[53] Although he also executed a drawing of the same subject (Boston Public Library, Print Department), it was the lithograph that was reproduced in the article, perhaps because the print surpasses the drawing in theatricality with a dense, black background that obscures all detail.

Bellows' predilection for a more graphic expression in commissioned works is also evident in another lithographic image, *The Drunk*, executed for the February 1924 *Good Housekeeping*.[54] The first version of the image (see Appendix A), based on a drawing, was subtly altered in the second version to heighten the theatricality of the drunken man's rampage (fig. 109). The woman to his left is now bare-breasted, and the children's expression more terrified as they recoil in horror from their father; the two women, forming a dynamic composition with the drunken man, try to restrain him. It was this second lithograph, the more dramatic of the two, that was reproduced in the magazine. The illustration accompanied an article by Mabel Potter Daggett, "Why We Prohibit," written in praise of the Volstead Prohibition Act, outlining from the woman's perspective the evils of drink and its insidious influence on the family.

Bellows exploited the properties of the lithographic crayon to more lyrical ends in the majority of his later lithographs; between 1921 and 1924 he produced thirteen lithographs of the female nude. The period saw a renewed interest in the nude figure in Bellows' oils, drawings, and lithographs.[55] One series of lithographs, printed in 1921, depicts a nude model seated cross-legged on a bed. *Evening, Nude on Bed* (fig. 110) is one of three versions of the subject.

51. H. G. Wells, "Men Like Gods," *Hearst's International Magazine* (December 1922): 42.

52. Bellows lists the commission in his Account Book for 1922. Doyle's story appeared in *Hearst's International Magazine* 42 (October 1922): 5ff. The oil painting (Lutheran Brotherhood Insurance, Minneapolis) was executed in October 1923 (artist's Record Book C, p. 5). A related drawing is in the collection of the Westmoreland County Museum of Art, Greensburg, Pennsylvania.

53. *Century* 106 (May 1923): 8.

54. The related drawing is in the collection of the Addison Gallery of American Art, Phillips Academy, Andover, Massachusetts. It is recorded in the artist's Record Book C, p. 8. The two lithographic versions of *The Drunk* are listed in the artist's Record Book C, p. 9, the first in an edition of 35, the second in an edition of 50, for the winter of 1923–24.

55. See for example the oils *Nude with Fan* (1920, North Carolina Museum of Art, Raleigh) and *Nude with Red Hair* (1920, National Gallery of Art, Washington, D. C.).

109.
The Drunk No. 2, 1923–24
Lithograph
15¾ × 13 in.
Amon Carter Museum
ALSO FIG. 184

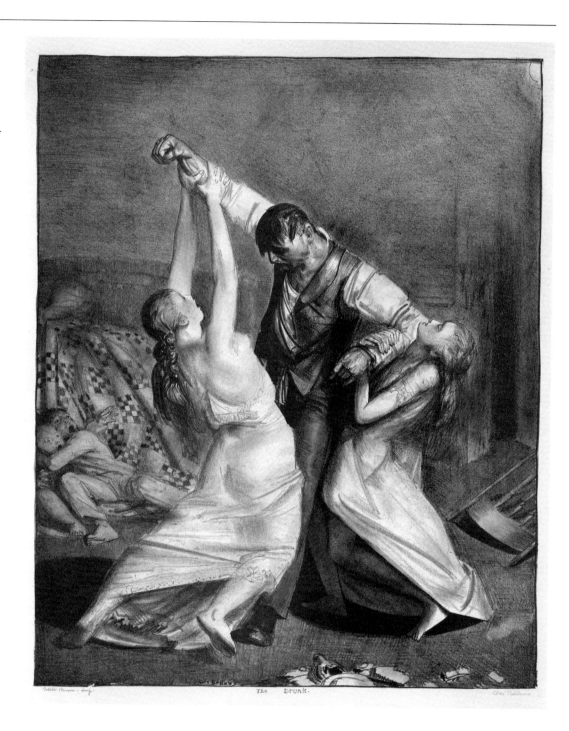

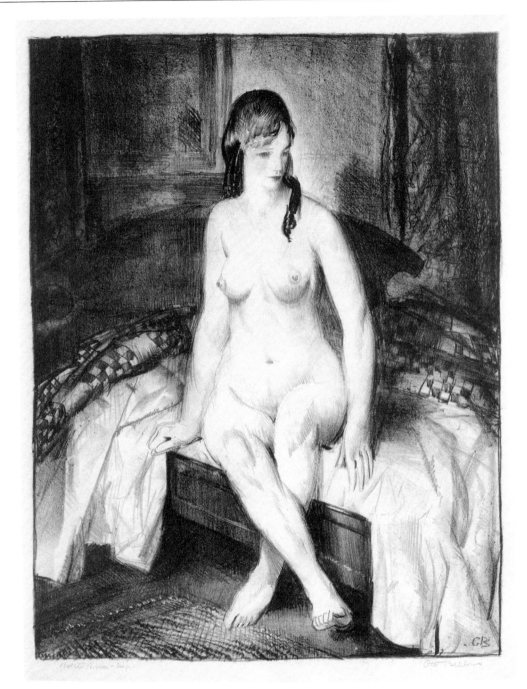

110.
Evening, Nude on Bed, 1921
Lithograph
12⅜ × 9⅝ in.
Amon Carter Museum

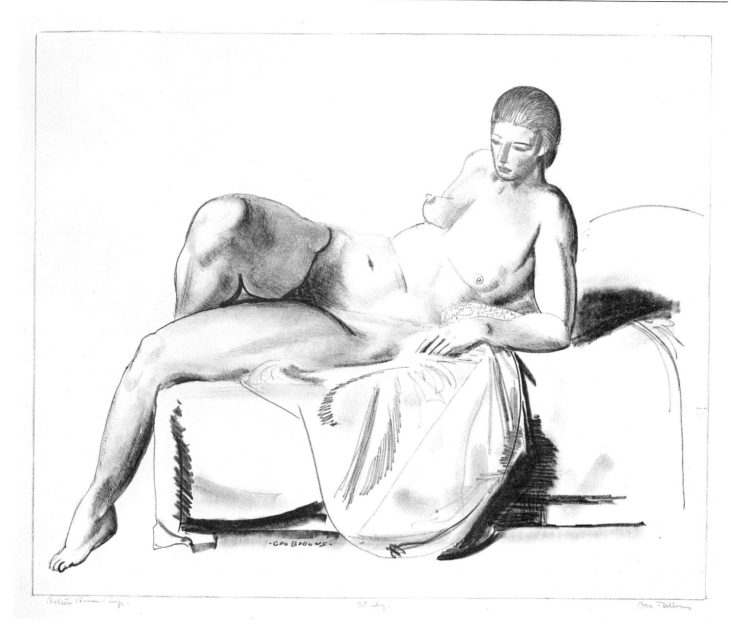

Boltón Brown imp. · Study· · Geo Bellows·

III.
*Nude Study, Classic on a
Couch*, 1923–24
Lithograph
10 1/16 × 12 1/2 in.
Amon Carter Museum

In each, Bellows employed a hard crayon point to make the line describing the languid, serpentine form of the nude, a shape that is echoed in the curving lock of hair that falls over the subject's shoulder. The figure is set against a patterned quilt and a bed set at an oblique angle to show off its distinctive curved footboard, a combination of favorite props that appears in numerous lithographs, including *The Drunk* and all three versions of *Reducing*.

Among his last lithographic essays, executed in the winter of 1923–24, were a series of eight nudes that Bellows inscribed simply "Study." In such prints as *Nude Study, Classic on a Couch* (fig. 111), *Nude Study, Woman Kneeling on a Pillow* (fig. 112), and *Nude Study, Girl Standing on One Foot* (fig. 113), the artist achieved a controlled simplicity, approaching his subjects in a direct and straightforward manner. Bellows' economic use of line emphasizes the sinuous curves of the figures' silhouettes against a background minimally suggested, if at all, by a few props. Here, as in many of his later prints, the paper works harmoniously with the medium, no longer obscured by densely filled compositions. Some of the nude studies, such as *Nude Study, Classic on a Couch*, based on Michelangelo's sculpture *Dawn* for the tomb of Lorenzo de Medici, have a monumental presence despite their small format; the figure's organically rendered legs and elongated torso contrast with the stylized features of the head.[56]

As in his nude drawings, many of which relate to the 1923–24 series, Bellows employs in these lithographs a judicious use of shading, the sharp, dark outline giving way to a soft, silvery modeling of form.[57] In *Nude Study, Woman*

56. Michelangelo's sculpture is in the Medici Chapel, San Lorenzo, Florence. For Bellows' use of this source, see Seiberling, "George Bellows," p. 157.

57. Compare for example the lithographs *Nude Study, Woman Lying on a Pillow* (Mason 177), *Nude Study, Girl Standing with Hand Raised to Mouth* (Mason 173), and *Nude Study, Girl Sitting on Flowered Cushion* (Mason 172) and their related drawings in the collections of Yale University Art Gallery, Boston Public Library, Print Department, and the Columbus Museum of Art, respectively.

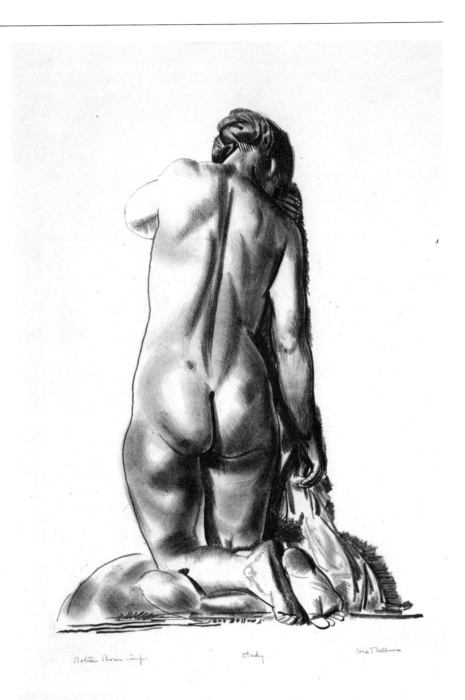

112.
Nude Study, Woman Kneeling on a Pillow,
1923–24
Lithograph
9⅜ × 7 in. (irreg.)
Amon Carter Museum

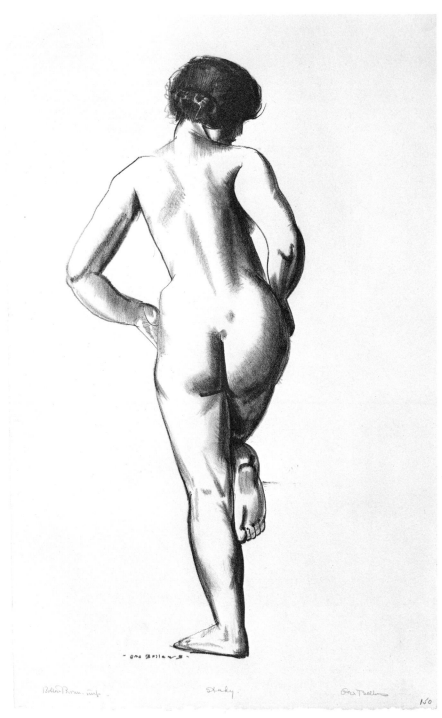

113.
Nude Study, Girl Standing on One Foot, 1923–24
Lithograph
12 1/16 × 4 15/16 in.
Amon Carter Museum

Kneeling on a Pillow, Bellows varies his spare technique by rubbing ink onto portions of the stone, imparting a delicate modeling to the figure.

The nude and portrait series were the last Bellows would undertake in the lithographic medium, but his productive final years and his projected collaboration with Bolton Brown indicate that equally sustained efforts would have followed. In the wake of his death, his prints were immediately recognized as a significant part of the artist's legacy. In 1927 Emma Bellows published a catalogue raisonné of the lithographs; it sold out quickly, prompting a second edition.[58] Bellows' prints were featured not only in exhibitions devoted to his own work but in print installations such as the one at the Philadelphia Sesqui-Centennial International Exposition in 1926, where Bellows was represented by fifty-three lithographs, more than twice as many as any other lithographer. The Century of Progress Exhibition in 1933 at the Art Institute of Chicago featured Bellows' lithographs, along with the prints of Whistler and a few other Americans, some living, in a section devoted primarily to European master printmakers.[59] Although this exhibition placed Bellows at the close of a worthy tradition (the exhibition included separate galleries for "modern prints"), his prints look forward as well—to a rich body of twentieth-century American lithographs by printmakers who followed him in exploiting the inherent qualities of the medium. More than any other contemporary printmaker Bellows grappled with the life of his time, in which he was an enthusiastic participant, and saw beyond it to the human condition.

58. Emma Bellows to Leon and Viette Kroll, January 14, 1928, Charles Morgan Papers, Amherst College, box XIII, folder 2.

59. See the catalogues *Paintings, Sculpture and Prints in the Department of Fine Arts Sesqui-Centennial International Exposition* (Philadelphia: n.p., 1926) and *A Century of Progress Exhibition of Prints* (Chicago: Art Institute of Chicago, 1933).

George Bellows, 1924
Photograph by Alfred Cohn,
Stowall Studios, Woodstock, New
York
Courtesy of George Wesley Bellows
Papers,
Amherst College Library,
Amherst, Massachusetts

A Critical History of Bellows' Lithographs [1]

1. In selecting criticism for this essay, I have concentrated on reviews of exhibitions held during Bellows' lifetime. Some quotations refer to his art as a whole and describe paintings and drawings as well as prints; it is not always a simple matter to separate the comments about the various media in which he worked. However, I have sought chiefly to cite comments directly related to Bellows' lithographs. The study focuses on several major critics, primarily Royal Cortissoz of the *New York Tribune*, Henry McBride of the *New York Sun* (and briefly, the *New York Herald*), Elizabeth (or Elisabeth) Luther Cary of the *New York Times*, Helen Appleton Read of the *Brooklyn Daily Eagle*, and Forbes Watson of the *New York Post* and the *World*. New York critics are featured because that is the city in which Bellows lived and pursued his career and in which most of the exhibitions of his work were held.

The titles of works referred to by the critics have been standardized to the lithographs' current titles in order to avoid confusion.

Few artists have enjoyed such favorable press as George Bellows. He did not lack for exhibition opportunities, whether at commercial galleries, museums, or art associations, nor for patrons, nor especially for notice in the newspapers and art journals of the day. By the time he began to make lithographs, in 1916, he already had a comfortable income and established reputation. An article in *Current Literature* in 1912 outlined Bellows' "enviable and even unique" position: he was elected at a young age to the National Academy of Design, his paintings had won prizes and been purchased by the Metropolitan Museum of Art, the Pennsylvania Academy of the Fine Arts, and other leading institutions, and he had exhibited his work in Venice and Germany. In 1914, James Gibbons Huneker, the lively and influential art critic who supported the group of New York realists known as The Eight, announced that "Bellows is no longer a coming man; he has 'arrived' . . ." Writing in the same year, Forbes Watson called Bellows "one of the most powerful personalities in American art." [2]

He was certainly among the most active. Bellows taught at the Art Students League, he was a founding member of such organizations as the New Society of Artists and the Society of Painter-Gravers, and he worked tirelessly to organize exhibitions to promote the work of his fellow artists. He was seen as a kingpin in the exhibition world and a fearless supporter of American art. For the Painter-Gravers' first annual show in 1917, George Bellows was not only a financial backer but designed the newly built galleries, admired by critics for their tasteful furnishings, beautiful lighting, and delicate coloration that showed the prints to advantage. Bellows sought to carry out the organization's purpose of generating interest in prints, raising standards in the field, and making art more accessible to the public. At least once, Bellows presented a public lecture on the art of lithography and gave a printmaking demonstration (in connection with the 1923 New Society exhibition) to help the public better understand this newly revived medium. [3]

2. "George Bellows, An Artist with 'Red Blood,'" *Current Literature* 53 (September 1912): 342; James Gibbons Huneker, "The Seven Arts," *Puck* 75 (April 18, 1914), quoted in Arnold T. Schwab, ed., *Americans in the Arts, 1890–1920: Critiques by James Gibbons Huneker* (New York: AMS Press, 1985), p. 454; Forbes Watson, *New York Post*, January 24, 1914.

Huneker (1857–1921) contributed to many journals. In 1900 he joined the *New York Sun*, reviewing music, drama, and art, and in 1906 became that art-oriented newspaper's art critic. He wrote "The Seven Arts" column for *Puck* in 1914–16 before returning to the *Sun*. He was music critic for the *New York Times* in 1918–19 and for the *World* in 1919–20. Huneker liked the work of Cézanne, Matisse, and Munch, but also championed the American painters known as The Eight. As early as 1910, Huneker felt that George Bellows was a great talent.

The journalist and editor Forbes Watson's (1880–1960) reviews for the *Post* were unsigned between 1911 and 1917. His column, "Reviews and Notes of Current Events in Art," appeared in the *World* from the early 1920s until 1927. Watson was editor of *Arts* from 1923 to 1931, and he wrote for other journals such as *Arts & Decoration* and *Magazine of Art*. Watson supported the arts of his time and hoped to make them more accessible to the public. See Peninah R. Y. Petruck, *American Art Criticism: 1910–1939* (New York: Garland Publishing, 1981), esp. pp. 134–174. In an address entitled "George Bellows—The Boy Wonder of American Painting" delivered in 1945 at the National Gallery of Art, Watson discussed his relationship with Bellows, whom he knew for about twenty years. The critic stated that he enjoyed talking and arguing with Bellows, who fought "without rancor." The typescript for this lecture is on microfilm at the Archives of American Art, Smithsonian Institution, Washington, D. C., Forbes Watson Papers, D54, frames 1346–1369.

3. Forbes Watson, "George Bellows," *World*, January 11, 1925, p. 10E, dubbed him a kingpin, and Henry McBride, "Bellows and His Critics," *Arts* 8 (November 1925): 292, recognized his support of American art.

McBride (1867–1960) succeeded James Huneker as the art critic for the *Sun*, for which he worked from 1913 to 1950 (his articles from about 1913 to 1915 were unsigned). He also wrote for the *New York Herald* in the 1920s and contributed to *Creative Art* and to the *Dial*, in which his monthly essay appeared from 1920 to 1929. Known as the "dean of American art critics," McBride was trained as a painter and was a teacher and arts administrator. He often traveled abroad and was cosmopolitan in outlook. He championed modernism—both European and American—in his informal and humorous columns. He advocated the work of Marin, Nadelman, Demuth, Hartley, and Lachaise, among others. Like The Eight, he found the National Academy of Design and its jury system too conservative and favored the founding of the Society of Independent Artists and similar groups. See *The Flow of Art: Essays and Criticisms of Henry McBride* (New York: Atheneum Publishers, 1975); Petruck, *American Art Criticism*, esp. pp. 91–131; and Sanford Schwartz, *The Art Presence* (New York: Horizon Press, 1982), pp. 207–210.

The first Painter-Gravers show traveled to Rochester, Buffalo, Cleveland, Cincinnati, Pittsburgh, Toledo, Milwaukee, and Detroit and was supplemented by lectures and publications on printmaking. Bellows served on the Board of Governors of the organization.

On the printmaking demonstration at Anderson Galleries, see "Give Art Demonstration," *New York Times*, January 23, 1923, p. 4, and Margaret Breuning, *New York Evening Post*, January 20, 1923, p. 12. There was so much interest that 100 people had to be turned away, and the lithographs, at the reduced price of $5.00, were quickly sold.

Bellows showed his prints more frequently as his career progressed—he exhibited groups of prints at least annually between 1916 and 1925—and his work received increasing coverage in the press, especially during the 1920s. Exhibitions devoted solely to his prints were held in 1918, 1919, and each year from 1921 through 1925. And whenever George Bellows' prints were on view the press covered the event, for, as the *New York Times* critic wrote, a Bellows exhibition "cannot fail to excite interest."[4] If he participated in a group exhibition, the critics often singled out his lithographs for praise and wrote more about his work than that of others in the show. When he had a one-man show the review was often the lead story on the arts page, accompanied by an illustration of his work.

Often critics judged Bellows' lithographs to be his best work, believing that his "ultimate place as an artist would rest upon them." His prints were commonly held to be the finest made in America, or as good as anything of their kind. The *Boston Evening Transcript* went so far as to say that no artist, even when one "considers Daumier or Garvarni *[sic]* or some of the Englishmen, has carried lithography to a greater height. In beauty of tone, silvery grays and velvety even blacks, it is unexcelled." Frank Crowninshield, Bellows' friend and editor of *Vanity Fair*, believed that no one could be compared to Bellows as a "master of the lithographic stone," and many agreed.[5]

Not all critics were positive in their comments, and there seems to be no discernible evolution in the criticism of Bellows' lithographic work between 1916 and 1925; indeed, critics often changed their minds about Bellows from exhibition to exhibition. Bellows was occasionally criticized for lack of subtlety, grace, and charm, for technical crudeness, and for his reliance on dynamic symmetry, the set of compositional formulas based on geometry espoused by Jay Hambidge and used increasingly by Bellows after 1917. But, as *New York Sun* critic Henry McBride observed, "nothing that he produced was innocuous."[6] Everyone had an opinion on George Bellows and his work—he was perhaps the most talked-about artist in America in the early twentieth century—a fact that accounts for the vast wealth of contemporary criticism available for the present study.

A chronological survey of the exhibitions that included Bellows' prints during his lifetime gives an indication of his increasing activity in the field. (A list of exhibitions in which Bellows' prints appeared between 1916 and 1925 is in Appendix B.) When Bellows first exhibited his prints, at New York's Frederick Keppel & Company in 1916 in a show comprised primarily of the work of nineteenth-century European lithographers, his work did not receive widespread attention in the art reviews. Nonetheless, the *New York Times* critic noticed that Bellows captured "character," while Forbes Watson of the *New York Evening Post Saturday Magazine* thought Bellows' "good specimens" were "forceful and humorous" and showed that

4. Elizabeth Luther Cary, "George Bellows' Work on Exhibition," *New York Times*, November 10, 1918, section 4, p. 4. A prolific writer, Cary (1867–1936) saw herself as an objective commentator on art, from ancient to modern. She designed, wrote, edited, and published a monthly art magazine, the *Scrip* (1905–08), and in 1908 joined the *Times* as its art critic, a post she held until her death. She contributed articles to *Camera Work* and wrote books on Luks, Daumier, Whistler, and the writers Henry James, Emerson, Browning, and Tennyson. See Arlene Olson, *Art Critics and the Avant-Garde: New York, 1900–1913* (Ann Arbor: UMI Research Press, 1980), pp. 57–65; *Cyclopedia of Photographic Artists & Innovators* (New York: Macmillan, 1983), p. 104; and Peter Hastings Falk, ed., *Who Was Who in American Art* (Madison, Conn.: Sound View Press, 1984), p. 104.

5. "Bellows, Noted Artist, Is Dead," *New York Sun*, January 8, 1925; H.P., "George Bellows," *Boston Evening Transcript*, January 9, 1925; Frank Crowninshield, "An Ap-

preciation of the Life and Work of George Bellows," *Art News* 23 (January 17, 1925): 6. See also Florence Davies, "Bellows' Lithographs Show a Vigorous Touch," *Detroit News*, April 5, 1925, part 2, p. 19.

Crowninshield (1872–1947) served as one of the pallbearers at Bellows' funeral. From 1914 to 1935 he was editor of *Vanity Fair*. Previously he had published the *Bookman* (1895–1900), was assistant editor of *Metropolitan Magazine* (1900–02) and *Munsey's Magazine* (1903–07), and served as art editor of *Century Magazine* (1910–13). See *Who Was Who in America*, vol. 2 (Chicago: Marquis Who's Who, Inc., 1975), pp. 137–138.

6. McBride, "Bellows and His Critics," p. 292.

he was in "perfect sympathy with his medium."[7] Bellows' affinity to the lithographic process and its expressive possibilities were traits that would be commented upon throughout his printmaking career. Also in 1916, Bellows' prints began to appear in *Arts & Decoration* and *Vanity Fair* (which in 1921 would nominate Bellows to its Hall of Fame because of his mastery of the graphic arts).

A one-man show of Bellows' work at the Milch Gallery in 1917 drew additional praise for the lithographs, a "field in which Mr. Bellows's humor and trenchant draughtsmanship have gained for him a place all his own." Gustav Kobbe, the music, drama, and art critic of the *New York Herald*, found the prints to be "enough to make one giddy . . . the abiding joy of the show." And Henry McBride reported that a crowd began to form the moment that the lithographs were installed: "There is something about almost everything this artist does that arrests the idle glance." One indication of the precocious Bellows' stature in the world of American printmakers was the attention given to him during the first annual Painter-Gravers' exhibition that year. Although the show consisted primarily of etchings, and Bellows' prints numbered only six out of the 198 on view, the critics (who devoted long reviews to the show) gave his work special praise. The *New York Sun* commented, "Mr. Bellows is doing some of his best work nowadays in his lithographs."[8] This is especially noteworthy given the fact that Bellows had been making prints for only a year.

The first show to focus solely on Bellows' prints, held at Keppel in the fall of 1918, naturally garnered the most notice to date in the press. Reviews appeared in the *New York Times, New York Evening Post*, and *New York Herald*. The show was also covered by the *Christian Science Monitor*, whose critic felt that Bellows' experiments in this "rapid and responsive" medium were highly successful and "rich in unsuspected possibilities."[9] The popularity of Bellows' prints outside of New York was proven when most of the lithographs from the Keppel show traveled in early 1919 to the Doll & Richards Gallery in Boston and Albert Roullier Art Galleries in Chicago. They were enthusiastically received in both cities.

By 1920 Bellows' prints were selling extremely well across the country. In a letter to his dealer, Marie Sterner, he indicated that many galleries were carrying impressions of *A Stag at Sharkey's* (fig. 38): Milch, Kraushaar, Keppel, and Brown-Robertson in New York; George E. Gage in Cleveland; Carper in Detroit; Carson Pirie Scott and J.M. Young in Chicago; Noonan-Kocian Gallery in St. Louis; Smalley, McPherson in Kansas City; The Print Room in San Francisco; and Louis Thomas in Sèvres, France. During 1920 Bellows continued to exhibit his prints actively, and extensive articles on his prints appeared in progressive magazines like the *New Republic*.[10]

7. "Sketches and Prints in Many Exhibitions," *New York Times Magazine*, May 14, 1916, p. 18; Forbes Watson, "At the Art Galleries," *New York Evening Post Saturday Magazine*, May 6, 1916, p. 12. The *Times* review cites many of the artists involved and lists the seven lithographs by Bellows, presumably the first he had exhibited: *Artists' Evening, In the Park, Between Rounds No. 1, Splinter Beach, Business-Men's Class, Introducing the Champion*, and *Prayer Meeting*.

8. Forbes Watson, "At the Art Galleries," *New York Evening Post Saturday Magazine*, March 17, 1917, p. 9; Gustav Kobbe, *New York Herald*, March 18, 1917, section 3, p. 10; Henry McBride, "News and Comment in the World of Art," *New York Sun*, March 18, 1917, section 5, p. 10; probably McBride, "Painter-Gravers Display Their Art," *New York Sun*, April 2, 1917. Besides writing for the *Herald*, Kobbe (1857–1918) was a founder of *Lotos Magazine*. See *Who Was Who in American Art*, p. 345.

9. "Lithographs and War Zone Graphics," *Christian Science Monitor*, November 18, 1918, p. 14.

10. George Bellows to Marie Sterner, November 2, 1920, Marie Sterner Papers, Archives of American Art, roll 1265, frame 35; Babette Deutsch, "A Superb Ironist," *New Republic*, July 21, 1920, p. 220. Founded in 1914, the *New Republic* was a voice of progressivism and cultural nationalism. Its chief editor, Walter Lippmann, felt that art should give human insights. See Arthur Frank Wertheim, *The New York Little Renaissance: Iconoclasm, Modernism, and Nationalism in American Culture, 1908–1917* (New York: New York University Press, 1976), pp. xii, 167, 169, 171.

According to his account book, titled "Sales and Proffesional [sic] Income" (manuscript in possession of Jean Bellows Booth), Bellows also sold his lithographs to the Print Club (Philadelphia), Purnell Company (Baltimore), George W. Smith, Hill Tollertin, Rochester Gallery, Milwaukee Art Institute, Mary Smith, New York Public Library, Del Monte (California), Leon Kroll, Albert Roullier, Colnaghi & Orback, Senator Brandegree, Mr. Travis, Chester Dale, Ray Greenleaf, Bradley (?), Jesse Loose, and Knoedler's. After 1920 the list of print patrons continued to increase and included (in addition to those already mentioned): Doll & Richards, Weyhe Gallery, M. Guillaume,

In 1921 Bellows was included in the "First Retrospective Exhibition of American Art," a show that included paintings, sculpture, drawings, and prints by three hundred artists beginning chronologically with Copley, Stuart, and West. The *Detroit News* reported that the "most compelling forces" in the exhibition were probably Rockwell Kent and George Bellows, the latter of whom was represented by several paintings and sixteen "fine lithographs in his vigorous style." That same year, Bellows' lithographs were also the subject of a large exhibition at Keppel—reviewed at length by such New York papers as the *Times, Post, Herald*, and *Sun*—and a group of his prints was added to Bellows' one-man show at Montross Gallery. The critic for the *New York Sun* observed that the room of lithographs "completes the record of Mr. Bellows's recent work" and that they were "even more characteristic of this artist than his characteristic paintings."[11] Bellows' name and art remained before the public for much of 1921. In addition to the three exhibitions already mentioned, a long article on Bellows in *Arts & Decoration*, based on an interview with the artist, depicted a young iconoclast who won every honor while breaking from tradition. The *American Art Student* published Bellows' article "What Dynamic Symmetry Means to Me," and *Vanity Fair* used Bellows' *Introducing the Cham-pion* (fig. 33) to illustrate an article on the Dempsey-Carpentier fight.[12]

Bellows' name appeared in 1922 in articles in the *Arts, Art in America*, and *Literary Digest*, and he was the subject of a substantial article by Holger Cahill in *Shadowland* as well.[13] Due partly to the four months Bellows spent working on his Woodstock, New York, house, he produced only one lithograph that year, though Washington's Corcoran Gallery of Art held an exhibition of his lithographs in 1922. The following year Bellows sent a show of his lithographs to his hometown of Columbus, Ohio, where they were admired for depicting "life in its ultimate . . . [with] a range most diverse." The most extensive article written on Bellows in 1923 was by Helen Appleton Read, the art critic for the *Brooklyn Daily Eagle*, who did a full-page feature story on Bellows' versatility. While Read acknowledged that Bellows was known foremost as a landscape and portrait painter, she felt that "he does amazingly interesting things in the field of lithography. To say he is our foremost lithographer needs not a single qualifying adjective, since he combines with an individual and expert manipulation of the stone the charm of a personal and always

Marie Sterner, Mrs. Montgomery Hare, Auerbach Levy, Pennsylvania Academy of the Fine Arts, Walter Richter, Montross Gallery, Ignatio Zulouaga, Carnegie Institute, F. Knight, Z.L. White (Columbus, Ohio), Woodstock Art Association, Mrs. Cassell, Devett Welsh Gallery (Philadelphia), Crosby Gaige, Society of Illustrators, New Society, Knopf, Mrs. Gordon Abbott, Rehn Gallery, Harley Perkins, Herb Roth, Mrs. H.T. Webster, Gerald Brooks, Otto Wierner (or Williams), and Print Rooms (Los Angeles).

Although the account book lists a gallery called Robinson & Brown in New York, he most likely was referring to Brown-Robertson.

Although there is a reference (in *The Index of Twentieth Century Artists, 1933–1937* [New York: Arno Press, 1970], p. 119) to an exhibition of "Monotypes by Ross Moffett & Lithographs by George Bellows," held at Carson Pirie Scott in June 1920, a perusal of Chicago newspapers of this period did not reveal notice or reviews of the show.

11. J. Streatfield, "American Art," *Detroit News*, May 22, 1921; *New York Sun*, December 17, 1921, p. 9. The *New York Herald*, April 24, 1921, gives the number of artists represented in the "First Retrospective Exhibition."

12. Estelle Ries, "The Relation of Art to Every-day Things," *Arts & Decoration* 15 (July 1921): 158–160; George Bellows, "What Dynamic Symmetry Means to Me," *American Art Student* 3 (June 1921): 5–7; *Vanity Fair* 16 (September 1921): 68.

13. See Mary Fanton Roberts, "Mrs. Roberts' Department," *Arts* 2 (January 1922): 222–224; Catherine Beach Ely, "The Modern Tendency in Henri, Sloan and Bellows," *Art in America* 10 (April 1922): 132–143; "How Art Has Gone to the Dogs," *Literary Digest* 73 (June 1922): 34–35; Edgar Holger Cahill, "George Bellows," *Shadowland* 6 (July 1922): 11, 61.

Mary Fanton Roberts (1871–1956) and her husband, Bill, were frequent associates of Bellows. She was a staff writer for the *Herald, Tribune, Journal*, and *Sun*, the editor of *Demorest Magazine* and *New Idea Woman's Magazine*, on the editorial staff of *Woman's Home Companion*, and managing editor of the *Craftsman*. Roberts founded and edited *Touchstone* and *Decorative Arts Magazine* and edited *Arts & Decoration* for seventeen years. In 1921, when *Touchstone* merged with *Arts*, she wrote a monthly column for the latter periodical. See *Who Was Who in America*, vol. 3 (Chicago: Marquis—Who's Who, 1960), p. 732.

enlivening point of view." She also lauded his "impeccable draftsmanship."[14]

The last year of Bellows' life was a high-water mark for him as far as exhibitions and the press were concerned. As the *New York Post*'s Margaret Breuning observed, it would have been difficult to escape Bellows in New York in early 1924, for, as the artist himself said, he was "'all over the place.'" Not only was his controversial painting, *The Crucifixion*, the sensation of the New Society of Artists exhibition (the critics mentioned his prints in the show as well), but he had two prints in the Society of Illustrators exhibition, and Rehn Gallery gave him a one-man show— his first in New York since the Montross exhibition in late 1921—which was the subject of several reviews. In addition, a large exhibition of his lithographs at Marie Sterner's gallery generated even more comment in the press. Henry McBride considered it by far the best of the three Bellows exhibitions on view, and Breuning concurred that the lithographs made a "distinguished showing."[15]

Vanity Fair, illustrating *Between Rounds No. 2* (fig. 114) in its March 1924 issue, described Bellows as having "assumed major proportions as a figure in American art" and called attention to his prints. His lithographs were also discussed in articles in the *Christian Science Monitor* and *International Studio* and most prominently in a lengthy discourse in *Print Connoisseur* by Frank Weitenkampf, the distinguished print curator, who felt that Bellows was "in his prime and is yet ripening."[16]

Bellows' early death in January 1925 produced an outpouring of tributes, testimony to his stature in the art community. The many obituaries stressed the fact that the life of this artist, who was ever experimenting despite early success, had ended before his work was done. They mourned the passing of this driving force in the early twentieth-century art world, the "loss of that spirit as well as of his technical brilliance." However, these articles also listed the many contributions he had made in his short career. Newspapers printed not only obituaries but

14. For the Columbus exhibition, see H.E. Cherrington, "Palette and Brush," *Columbus Dispatch*, February 18, 1923, p. 11. The exhibition was held at the Z.L. White Department Store.

Read's feature story was "George Bellows—Artist of Versatility," *Brooklyn Daily Eagle*, October 28, 1923 [date uncertain], p. 20. Read (1887–1974) was the art critic for the *Eagle* from 1922 to 1938. She also served as associate art editor of *Vogue* (1923–31) and later was director of Portraits, Inc. See *Who's Who in American Art* (New York & London: Jaques Cattell Press/ R. R. Bowker Company, 1973), p. 600.

15. Margaret Breuning, "Two Shows by Bellows at the Same Time," *New York Evening Post*, February 16, 1924, p. 13; Henry McBride, "Dempsey-Firpo Lithograph Attracts Art Collectors," *New York Herald*, February 17, 1924, section 7, p. 13; Breuning, "Two Shows by Bellows at the Same Time," p. 13. Breuning was the author of a number of books on artists, including Mary Cassatt and Maurice Prendergast.

Helen Appleton Read, "News and Views on Current Art," *Brooklyn Daily Eagle*, January 6, 1924, reported that Bellows entered lithographic portraits of his daughters, Anne and Jean, in the New Society show. She lamented the fact that *The Crucifixion* was so large that there was not much room left for Bellows' lithographs (each artist was allotted nine feet of wall space). The *New York Times*, February 17, 1924, also mentions the two Bellows prints in the New Society show and two in the Illustrators show at The Art Center. On the Rehn show, see Read, "The Versatility of George Bellows," *Brooklyn Daily Eagle*, February 3, 1924, p. 2B. She reported that the room of lithographs and drawings was constantly changing because they were sold almost as soon as they were hung.

16. *Vanity Fair* 22 (March 1924): 24; "New Bellows Lithographs," *Christian Science Monitor*, February 27, 1924; M.O., "The Art of George Bellows," *Christian Science Monitor*, July 7, 1924; Ralph Flint, "Bellows and His Art," *International Studio* 81 (May 1925): 79; and Frank Weitenkampf, "George W. Bellows, Lithographer," *Print Connoisseur* 4 (July 1924): 225–235. The last article ends with a list of Bellows' lithographs by date, giving dimensions and edition sizes. Weitenkampf (1866–1962) was curator of prints at the New York Public Library and the author of *American Graphic Art* (New York: Macmillan, 1924).

17. The quotation is from "George Bellows," editorial, *New York Tribune*, January 9, 1925, p. 14. Among the other tributes were Flint, "Bellows and His Art," and Royal Cortissoz, "George Bellows and His Americanism," *Scribner's Magazine* 78 (October 1925): 443.

The obituaries and accounts of the funeral include "G. W. Bellows Dies in His 43d Year," January 9, 1925, p. 17, "George Bellows," January 10, 1925, p. 12, and "Artists at Bellows Bier," January 11, 1925, section 2, p. 5, all in the *New York Times*; "Bellows, Noted Artist Is Dead," January 8, 1925, "George Bellows," January 9, 1925, and Henry McBride, "Bellow's [*sic*] Death Is Great Blow," January 10, 1925, p. 7, all in the *New York Sun*; Forbes Watson, "George Bellows" and "George Bellows, Noted Artist, Dies," January 9, 1925, pp. 12, 20, and "George Bellows," January 11, 1925, p. 10E, all in the *World*; "George Bellows" and "George W. Bellows, Noted Painter, 42, Dies in Hospital," January 9, 1925, pp. 14, 15, and "Throng Attends Rites for George Bellows, Painter," January 11, 1925, all in the *New York Herald Tribune*. See also H.P., "George Bellows," *Nation* 120 (January 21, 1925): 60; "Art World Mourns Death of Bellows," *Art News* 23 (January 17, 1925): 6.

editorials on Bellows and his work and accounts of his funeral at the Church of the Ascension in Manhattan, attended by throngs of people from the art world.[17]

The dean of the art critics, Henry McBride, called for a memorial exhibition, and, although this was held in the fall (surprisingly early), a number of other exhibitions of Bellows' work appeared even earlier, beginning with a previously scheduled show of his paintings at Durand-Ruel. This was followed by a large exhibition of his lithographs and drawings at Frederick Keppel that, as one reviewer put it, heightened "our sense of what was lost to American art" when Bellows died. *Vanity Fair* reproduced some of Bellows' prints in two of its summer issues and predicted that Bellows would rank, "for many years to come, as our chief American lithographer," citing his humor, his "passion for truth and reality," the variety of emotions his work exhibited, and his mastery of draftsmanship as some of the reasons for his prominence. Noting his wide-ranging appeal, the author stated that "no American painter, working in black and white, at any period in our history, has more powerfully touched the imagination of the people than Mr. Bellows—not only of the connoisseurs, critics and collectors, but of the populace at large."[18]

Bellows' prints outnumbered those by others in a group print show at the National Arts Club (New York) in 1925 and commanded some of the highest prices. The *New York Evening Post* cited his prints as the feature of the show, and the *New York Herald* noted the special recognition given Bellows' work. Bellows' prints were also shown at the Detroit Institute of Arts in an exhibition that surveyed his career and illustrated "his strong appeal, his directness of expression and vigorous presentation, as well as . . . technical mastery." Emma Bellows lent a group of prints to a show at the Columbus (Ohio) Gallery of Fine Arts, and the Women's City Club of New

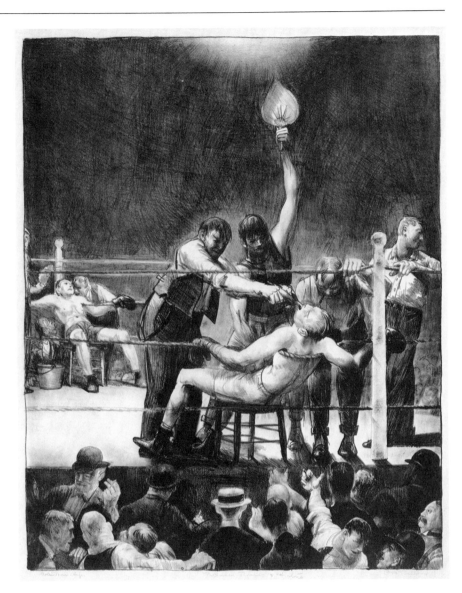

114.
Between Rounds No. 2, 1923
Lithograph
18¼ × 14¾ in.
Amon Carter Museum

18. Henry McBride, "Bellow's [*sic*] Death Is Great Blow," p. 7; unidentified clipping, "Lithographs by Bellows and Etchings by Rembrandt," New York Public Library artist files (microfilm); *Vanity Fair* 24 (July 1925): 31, and 24 (August 1925): 40.

York and the Boston Art Club both showed Bellows' lithographs in 1925. A review in the *Boston Evening Transcript* demonstrates the high praise accorded the prints. The critic observed Bellows' variety of moods and subject, his careful draftsmanship, and his ability to delineate character (and caricature), resulting in "more than sheer power, in many cases more than art." His work, the writer continued, had the "quality of a Daumier, and the humor of Twain. Bellows strikes a high note in his lithographs and sticks to it, faltering only occasionally." [19]

By the time an exhibition of a nearly complete set of Bellows' lithographs and a few of his paintings opened at Marie Sterner's gallery in the fall of 1925, the lithographs had grown particularly valuable; some, like *A Stag at Sharkey's*, were already out of print. And the much-heralded memorial exhibition at the Metropolitan Museum of Art, assembled by Bellows' friends and colleagues Robert Henri and Eugene Speicher in cooperation with Emma Bellows and the Metropolitan's curator Bryson Burroughs, was a great success. It was the largest exhibition of his work thus far and its importance was underscored, as critic Margaret Breuning stated, by the fact that the prestigious museum had staged memorial shows for only nine American artists. Lithographs were well represented in the exhibition and drew high praise in the press. Henry McBride, for one, believed that the prints were a greater indication of Bellows' power than his paintings. "Looking

about among his contemporaries," Ralph Flint wrote, "fails to reveal his like or equal." [20]

What were the reasons for George Bellows' broad appeal? One major factor is suggested by Frank Seiberling's comment that Bellows seemed "conservative to the conservative, and modern to the liberal." Indeed, this is borne out in comments by many contemporary critics, such as the anonymous reviewer in a 1919 *Arts & Decoration* issue who wrote: "George Bellows is one of the few American artists of our own day who seems successfully to bridge the chasm between the conservative and the radical in art. He is a member of the Academy. His pictures possess the conservative and traditional virtues. At the same time this artist has kept an open mind in all matters of freedom in art." As Helen Appleton Read of the *Brooklyn Daily Eagle* observed the dichotomy, he was a "shatterer of academic tradition," yet he continued to win prizes from the conservative Academy. He participated in the Armory Show, which featured the most avant-garde painting America had seen up to that point, and was a leader of such independent groups as the New Society of Artists who rebelled against the Academy's jury system. Although Henry McBride did not accept Bellows as a modernist as some others did (to McBride, Bellows was more like the "Sargent of the East Side"), he saw the artist as the "bad boy of the Academy," revered by a whole younger

19. Margaret Breuning, "Bellows Lithographs," *New York Evening Post*, April 18, 1925, magazine section, p. 11; Royal Cortissoz, "Random Impressions in Current Exhibitions," *New York Herald Tribune*, April 12, 1925, p. 20; "Museum Notes," *Bulletin of the Detroit Institute of Arts* 6 (April 1925): 77; C.C.C., "Sermons, Ironies, Humors in Bellows's Lithograph," *Boston Evening Transcript*, October 10, 1925.

For a review of the Columbus show, see John McNulty, "George Bellows, the Artist with a Punch," *Columbus Citizen*, October 7, 1925, p. 13. He reported that this marked the first time that a large number of Bellows' works had been shown in that city. The exhibition's dates are listed as October 4–25, but the October 24 issue of the *Columbus Dispatch* indicates that the show was extended for four days. My gratitude to Linda Fisher at the Columbus Museum of Art for her assistance in tracking down these citations. Thus far no reviews of the Women's City Club (New York) exhibition have come to light.

20. Margaret Breuning, "Metropolitan Arranges Bellows Memorial," *New York Evening Post*, October 10, 1925, magazine section, p. 7; Henry McBride, "Art Season Starts Vigorously," *New York Sun*, October 17, 1925, p. 4; Ralph Flint, "The Bellows Memorial Exhibition," *Christian Science Monitor*, October 19, 1925, p. 6. McBride had earlier commented that the prints in the 1924 New Society show proved "how much more the artist he is in lithography than when he wields the brush" ("George Bellows's Crucifixion Is Sensation of the Exhibition," *New York Herald Tribune*, January 6, 1924).

On the Marie Sterner show see "Mrs. Sterner Has a Bellows Show," *Art News* 24 (October 17, 1925): 2, which also reports the sale of *Stag* prints. On the Metropolitan exhibition, see also "Exhibit Honors George Bellows, Native Painter," *New York Herald Tribune*, October 13, 1925, p. 13, which reported that over 2,000 invited guests, all leaders in the field of art, came to see the exhibition on the day prior to its public opening. The exhibition later traveled to a number of American cities.

generation as the "Ajax who was to defy for their benefit the too conservative traditions of the older school."[21] It is a remarkable testimony to Bellows' affable personality and artistic integrity that he could successfully be an active academician and an active independent at the same time.

Although on the whole Bellows fared well with the press, the two writers who found most fault with his work were Henry McBride and Royal Cortissoz, who favored the most modernist and conservative artistic camps, respectively. Critics who could be considered moderates in the modernist-conservative controversy— Forbes Watson, Helen Appleton Read, Margaret Breuning, Elizabeth Luther Cary, Mary Fanton Roberts, and Frank Crowninshield— were more frequently positive in their assessments of Bellows.

An ardent champion of modern art, Henry McBride was probably the most vocal and frequent critic of Bellows' work, although he certainly acknowledged the artist's popular appeal and discussed what he felt were the positive aspects of the lithographs. Not surprisingly, the man who early recognized the talents of such modernists as Georgia O'Keeffe, Charles

Demuth, John Marin, and Marsden Hartley favored those of Bellows' lithographs that "approach nearest to abstract art." He did not like those with overcrowded compositions or lithographs in which Bellows' satire was heavy-handed. Typical of McBride's informal, witty prose is a passage from his review of Bellows' 1917 Milch Gallery show: "Mr. Bellow's *[sic]* muse rides a recalcitrant steed. Sometimes she is jolted terribly, sometimes actually flung to the ground and trampled in the dust. But muses, like able horsemen, love a spirited nag. There is no reason why Mr. Bellows should discharge his muse. She has plenty of time even yet in which to make a Garrison finish." Reviewing the second annual Painter-Gravers show (incongruously held the same year as the first annual), McBride criticized *The Shower Bath* (fig. 115) for being a "very gross affair. It is not alone that the bathers are beefy . . . but that all the touches in the lithograph are heavy and ponderous." He found *The Life Class No. 1* (fig. 116) to be "filled with extravagant movement" and not well thought out. In his reviews, McBride often took the tone of a chastising teacher, proclaiming that he felt the artist could do better. When he felt Bellows improved, he did not fail to mention it, as in his 1921 article "Bellows's Progress in Lithography": "These lithographs," McBride observed, " . . . represent Mr. Bellows's best work." Although McBride felt his prints still could not be compared to those of the French printmakers, he admitted that they would "have their significance for us and will serve until an American Forain, Garvarni *[sic]*, Guys or Daumier appears." The early 1920s marked a turning point in McBride's opinion of Bellows. In 1924, McBride wrote that, in lithography, Bellows' "uncertain muse seems to feel more at home and to move about . . . with greater ease and more frequent success" than in any other medium. "One is tempted to put this production at the head of the American black and white work of the period," he continued, and he acknowledged that it was certainly the most popular with the public. McBride announced himself an admirer of Bellows' work, despite the fact

21. Frank Seiberling, Jr., "George Bellows, 1882–1925: His Life and Development as an Artist" (Ph.D. diss., University of Chicago, 1948), p. 46; "Bellows in Chicago," *Arts & Decoration* 12 (November 15, 1919): 10; Helen Appleton Read, "The George Bellows Memorial Exhibition," *Brooklyn Daily Eagle*, October 11, 1925, p. 8C; Henry McBride, "Bellows and His Critics," *Arts* 8 (November 1925): 292; McBride, "George Bellows," editorial, *New York Sun*, January 9, 1925.

Read and Watson often took note of the fact that conservatives and radicals alike accepted Bellows. See Read, "George Bellows—Artist of Versatility," *Brooklyn Daily Eagle*, October 28, 1923 [date uncertain], p. 12, and Watson, "George Bellows," *New York Evening Post Illustrated Magazine*, around November 1913, p. 9.

In its editorial "George Bellows," 120 (January 21, 1925): 60, the *Nation* preferred the opinion that Bellows passed as an "artistic radical" but commanded the admiration of the "average, plain, conservative American" as well. Another critic recognized Bellows for having bombed "the reactionaries from their trenches," winning benefits for thousands of young artists. Unidentified clipping from a 1925 *New Yorker*, pp. 21–22.

The New Society of Artists was comprised predominantly of painters of the Ashcan School rather than the modernists. Its first exhibition was held in New York in November 1919.

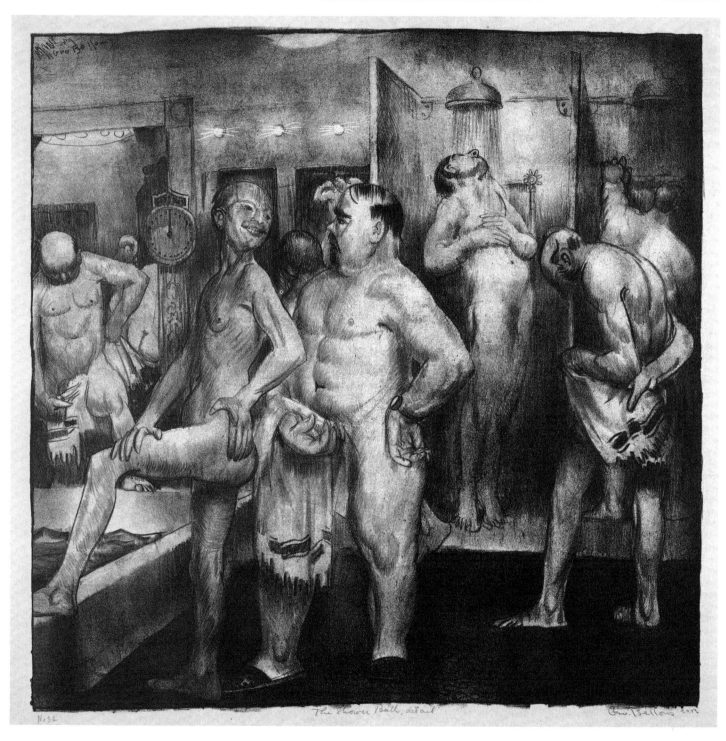

115.
The Shower Bath, 1917
Lithograph
15⅞ × 16⅜ in.
Amon Carter Museum
ALSO FIG. 165

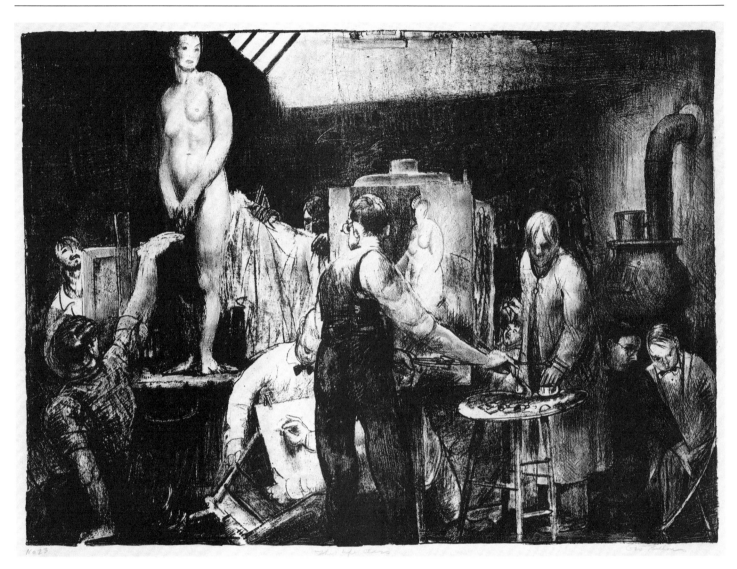

116.
The Life Class No. 1, 1917
Lithograph
13⅞ × 19⅜ in.
Amon Carter Museum
ALSO FIG. 160.

that he was sometimes "obliged to wave aside certain awkwardnesses and confusions before arriving at the part that pleases." He called *Dempsey and Firpo* (fig. 117), for example, a "wonderful souvenir of a historic occasion" and recommended it to collectors, despite finding fault with Bellows' "cursed rules of Hambidge," the compositional formulas that were anathema to McBride's modernist sensibilities. McBride mellowed even more in the years after the artist's death, proclaiming Bellows America's best lithographer in 1927 and writing a laudatory introduction to the catalogue of the Smithsonian Institution's traveling exhibition of Bellows' prints and drawings in 1957.[22]

Royal Cortissoz, the critic for the *New York Tribune*, was at the other end of the artistic spectrum from Henry McBride. A self-proclaimed conservative and traditionalist with a vision more of the nineteenth century than the twentieth, Cortissoz admired craftsmanship and good drawing above all else in art. For him, the purpose of art was the creation of beauty, and he reserved his highest praise for the prettiness and charm of the group known as The Ten. The man who revered Thomas Wilmer Dewing's visions of ethereal female figures in idyllic landscapes and Childe Hassam's delicate depictions of sun-dappled seaside gardens would not necessarily appreciate Bellows' relatively dark, somber work with its sometimes grotesque figures and biting satire. Cortissoz, indeed, felt that the New York realists like Bellows suffered from an "excess of personality."[23] In 1917 he perceived Bellows as recording "rather drab facts with sufficient force, if not with any aesthetic charm whatever." And although Cortissoz' 1923 book *American Artists* pictured Bellows as a lithographer of remarkable power and technical virtuosity (Cortissoz admired his rich blacks, nuances of tone, and the craftsman's mastery in Bellows' studies of children), he found the artist too dedicated to prosaic subjects for his liking. He cited *Reducing* (figs. 16–17, 61) as representative of Bellows' taste: "It is the mere ugliness of form, an ugliness unredeemed by beauty or drawing or style, which repels. Life, as Bellows sees it, is singularly barren of charm."[24]

A more moderate point of view was posed by Helen Appleton Read, an art historian and critic for the *Brooklyn Daily Eagle* who had studied with Robert Henri and William Merritt Chase. To Cortissoz' comment that Bellows saw life devoid of charm, Read countered that, while Bellows did not depict a pretty, superficial charm as did Dewing, he had the ability to put "romance, sturdy or lyrical as the case requires, . . . into reality," as revealed in his prints in the 1924 Rehn Gallery show, and she considered the 1925 Keppel show to be the outstanding event of the week "among the moderns."[25]

22. Henry McBride, "News and Comment in the World of Art," *New York Sun*, March 18, 1917, section 5, p. 10 (first two quotations); "News and Comment in the World of Art," *New York Sun*, December 16, 1917, section 5, p. 12; "Bellows's Progress in Lithography," *New York Herald*, May 15, 1921; "Dempsey-Firpo Lithograph Attracts Art Collectors," *New York Herald*, February 17, 1924, section 7, p. 13; "Fame of George Bellows," *New York Sun*, November 11 or 12, 1927; Introduction to *George Bellows: Prints and Drawings* (Washington, D. C.: Smithsonian Institution, 1957–58), pp. 8–10.

Bellows and McBride had one public argument in 1920, played out on the arts page of the *New York Sun*. Bellows took issue with McBride's statement (January 11, 1920, magazine section, p. 12) that cast aspersions on the permanency of the pigments Bellows used in his paintings. Bellows replied with a stern letter to the editor that was printed prominently, at the artist's request, in the arts section of the Sunday edition, two weeks later (January 25, 1920, magazine section, p. 12). It was accompanied by McBride's apology and retraction.

23. This description of Cortissoz' attitude is from Olson, *Art Critics and the Avant-Garde*, p. 32. Royal Cortissoz (1869–1948) did not particularly admire The Eight or any of the modernists. Cortissoz was prolific, writing for various magazines and newspapers (he worked for the *New York Tribune* from 1891 to 1948; his articles were unsigned until 1901), and he wrote a number of books, including *American Artists* (New York: Charles Scribner's Sons, 1923) and *The Painter's Craft* (New York: Charles Scribner's Sons, 1925). On Cortissoz, see Olson, *Art Critics and the Avant-Garde*, pp. 19–32, and the critic's own comments in *American Artists*, esp. pp. 3, 17–19, 22.

24. Royal Cortissoz, "The Personal Accent in American Art Today," unidentified clipping reviewing the first annual Painter-Gravers show (bound with exhibition catalogues for the Painter-Gravers of America, New York Public Library); Cortissoz, *American Artists*, p. 178.

25. Helen Appleton Read, "The Versatility of George Bellows," *Brooklyn Daily Eagle*, February 3, 1924; Read, "Few but Diverse Exhibitions Mark Easter Season," *Brooklyn Daily Eagle*, March 29, 1925, p. 2B.

Like Read, Forbes Watson, critic for the *Post* and *World* and editor of the *Arts*, stood somewhere between the extremes represented by Cortissoz and McBride. He liked the less radical work of the American, as opposed to European, modernists, and favored Robert Henri and The Eight particularly. Though his articles were not as entertaining as McBride's, they were more straightforward appraisals. Watson felt from the beginning that Bellows showed great promise. He was an admirer of most of Bellows' prints, but especially liked the studies of his family and close friends as well as the scenes of city life. Watson also found Bellows a personable man and enjoyed talking and arguing with him about art as they watched Bolton Brown print lithographs in the artist's studio.[26]

Elizabeth Luther Cary of the *New York Times*, a collector of fine prints, also avoided the extremist camps and considered herself an objective commentator and apostle of "good taste." She found in certain of Bellows' prints a lack of self-discipline but in reviewing the 1921 Keppel show, for instance, hailed Bellows as a modernist talent.[27]

Two personal acquaintances of George Bellows, Mary Fanton Roberts and Frank Crowninshield, could probably not have had the same degree of objectivity as other writers. Crowninshield's *Vanity Fair* often reproduced Bellows' work, and Crowninshield himself contributed the introduction to the Metropolitan Museum's memorial exhibition catalogue, in which he stated that "as a lithographer, Bellows had no equal in this country." He felt that the medium was particularly suited to Bellows' nature, which derived "a pleasurable thrill from the feeling of the crayon on the stone," and credited him for his role in bringing lithography back into popular favor. Roberts, an editor and writer for many newspapers and periodicals,

and her husband Bill (editor of *Literary Digest*) appear to have belonged to an inner circle that often gathered at Henri's studio to study and discuss the artists' most recent work. Her long, personal appreciation of Bellows in *Arts & Decoration* is indicative of her deep admiration for the man and his work. In it she praised Bellows' lithographs as being "the best that have been done in this country."[28]

━━━━━

Another frequent topic in Bellows criticism is the quality of his art, his technical brilliance and versatility. Critics found him to be particularly sympathetic to the black and white medium, one who "found in the practice of his profession irresistible pleasures." Bellows was frequently cited as the most expert lithographer in America. Many writers took note of the brilliant, rich, velvety blacks he achieved. From the first lithographs, "Bellows confessed himself a lover of blacks—deep and velvety or luminous and tenuous," as one critic wrote. Henry McBride described Bellows' prints as the "blackest black-and-whites on earth," blacker than the "middle of a barrel of tar at midnight" and "blacker than black." But he also noted Bellows' ability to enable those blacks to take on "mystery and color." Even if, as McBride asserted, Bellows' draftsmanship was faulty and his range of expression limited, he achieved those rich blacks and distributed them effectively. "As a lithographer this is the best thing he does." Although the praise accorded the prints' technical achievements increased after 1920, when Bolton Brown began to print the lithographs (the critics often citing the excellent printing and brilliant plates), it was noted as early as 1918 that Bellows had al-

26. See Forbes Watson, "Vivid Black and Whites by Bellows," *World*, March 29, 1925, p. 5M. On watching Bolton Brown pull lithographs, see Forbes Watson Papers, Archives of American Art, D54, frame 1347.

27. "Bellows's Lithographs," *New York Times*, March 29, 1925, and "The World of Art," *New York Times Book Review and Magazine*, May 1, 1921, p. 20. Although these reviews are unsigned, they are presumed to have been written by Cary, the art critic for the *Times* during this period.

28. Frank Crowninshield, Introduction to *Memorial Exhibition of the Work of George Bellows* (New York: Metropolitan Museum of Art, 1925), p. 19; Mary Fanton Roberts, "George Bellows—An Appreciation," *Arts & Decoration* 23 (October 1925): 40. Roberts earlier rose to Bellows' defense and took exception to Hamilton Easter Field's comments (*Arts*, November 1921) in an article in the January 1922 issue of *Arts*. Bellows often wrote notes of gratitude to critics who wrote flattering articles about his work. See an undated letter in the Mary Fanton Roberts Papers, Archives of American Art, D162, frame 750, and an undated letter to Forbes Watson in the Forbes Watson Papers, Archives of American Art, D54, frame 1345.

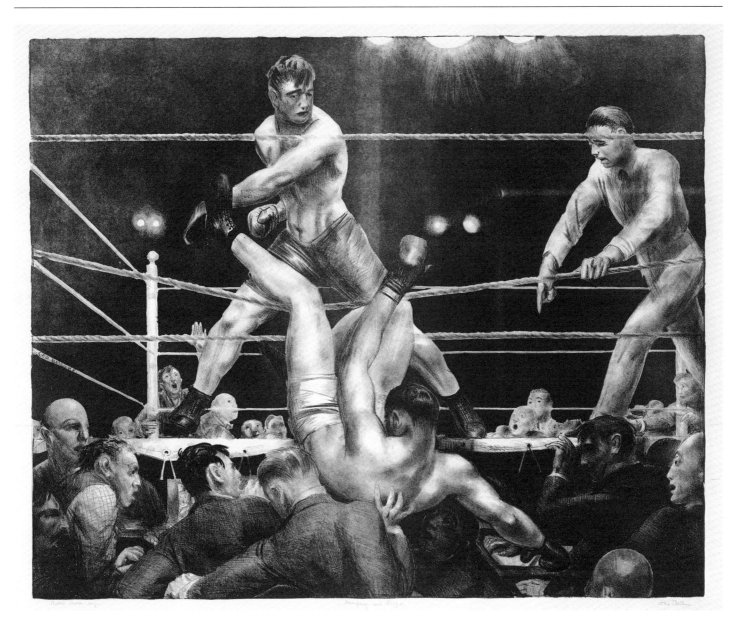

117.
Dempsey and Firpo, 1923–24
Lithograph
18⅛ × 22⅜ in.
Amon Carter Museum

ready mastered the technical secrets to "melt the lithographic heart of stone."[29]

Bellows drew directly on stone, as several critics remarked when praising his fine draftsmanship. One writer observed: "His stroke is powerful, confident. . . . It is, moreover, as pure as it is potent. There are no inadequate touches." Although Henry McBride and others sometimes censured the artist for his faulty draftsmanship, Forbes Watson deemed his drawing brilliant, and Elizabeth Luther Cary admired its assertiveness. She also found every plate a "handsome arrangement without any indication . . . of mathematical computation," despite Bellows' allegiance to Hambidge's rules of composition.[30]

Bellows' prints were anything but timid, and critics, such as the reviewer for the *New York Evening Post*, waxed enthusiastic about "the most opulent contrasts of warm blacks and sharp dazzling whites. They clang like a gong." But others admired their more subtle aspects, "his handling of grays, of all those delicate halftones and fleeting modulation which make the stone a source of aesthetic joy."[31] Starting from

prints that were "merely drawings on the stone," according to Helen Appleton Read, Bellows was able to extract from lithography the fullest expressive possibilities. The *Christian Science Monitor* critic felt that none of lithography's practitioners had a "greater feeling for its supple possibilities and dusky depths of tone than Mr. Bellows. . . . He hits the . . . lithographic crayon on the head with very constant accuracy and keeps his line speeding along with fresh impetus." Frank Weitenkampf praised Bellows' "richly and finely contrasted tones, well considered composition . . . , engrossing disposition of lines." Other critics lauded the astonishingly rich tones, "gradations . . . from silvery grays to blacks that pass into each other by imperceptible transitions . . . luminous whites that radiate light and . . . velvety blacks that seem to be of impenetrable depth and softness." Critics also noted his ability, through a manipulation of tones, to suggest color in his prints.[32]

However, some critics found Bellows' forcefulness, particularly in the earlier prints, to be overbearing and not at all subtle. According to Henry McBride, Bellows, in *Artists Judging Works of Art* (fig. 49), "wields a lumbering stick where he should have employed the rapier." The subjects "might just as well be longshoremen in the midst of a carouse. . . . One's sympathies go, in consequence, where they shouldn't, to the art juries." A critic for the *New York Evening*

29. Forbes Watson, "Vivid Black and Whites by Bellows," p. 5M; Watson (?), "A Bellows Memorial," *Arts* 7 (May 1925): 284; Henry McBride, "Art Season Starts Vigorously," *New York Sun*, October 17, 1925, p. 4; McBride, "Bellows Lithographs on View," *New York Sun*, March 28, 1925, p. 13; McBride, "Bellows's Progress in Lithography," *New York Herald*, May 15, 1921; "Lithographs and War Zone Graphics," *Christian Science Monitor*, November 18, 1918, p. 14.

30. Unidentified clipping, "Lithographs by Bellows and Etchings by Rembrandt," New York Public Library artist files (microfilm); Watson, "Vivid Black and Whites by Bellows," p. 5M; Elizabeth Luther Cary, "Lithographs," *New York Times*, February 17, 1924. Other comments on Bellows' draftsmanship include Lena McCauley, "Among the Dealers," *Chicago Evening Post*, January 14, 1919, p. 7 (noting that his prints were drawn directly on stone and pulled in his own shop on his own press); and McBride, "Bellows's Progress in Lithography." See also Babette Deutsch, "A Superb Ironist," *New Republic*, July 21, 1920, p. 220; and Guy Pène du Bois, *New York Evening Post*, October 26, 1918, p. 7.

31. *New York Evening Post*, December 17, 1921; Cortissoz, *American Artists*, p. 177. Similar opinions can be found in Margaret Breuning, "Two Shows by Bellows at the Same Time," *New York Evening Post*, February 16, 1924, p. 13; "Lithographs and War Zone Graphics," p. 14; Helen Appleton Read, "George Bellows—Artist of Versatility," *Brooklyn Daily Eagle*, October 28, 1923 [date uncertain], p. 20; and Holger Cahill, "Adventures in Lithography," *New York Herald Tribune*, November 27, 1927, section 7, p. 1.

32. Helen Appleton Read, "Lithographs by George Bellows," *Brooklyn Daily Eagle*, February 17, 1924, p. 2B; "New Bellows Lithographs," *Christian Science Monitor*, February 27, 1924; Frank Weitenkampf, "George W. Bellows, Lithographer," *Print Connoisseur* 4 (July 1924): 226; "Lithographs by George Bellows Grouped for Exhibition," *New York Evening Post*, March 28, 1925, section 5, p. 11; Read, "George Bellows—Artist of Versatility," p. 12. Read observed that lithography appeals to painters since it is the most colorful of the graphic arts. Similarly Holger Cahill, "Adventures in Lithography," p. 2, stated that Bellows in *The Irish Fair* and *Evening Snow* suggested color with a range of values that couldn't be achieved in another medium. Gustav Kobbe, *New York Herald*, November 17, 1918, section 3, p. 8, noted that *Base Hospital* revealed how Bellows succeeded in "getting color out of his black and white."

Rockwell Kent praised the "incomparable silver delicacy and the deep, black velvet richness of the prints"; see Kent, "George W. Bellows: His Lithography," *Bookman*, February 1928, p. 677. Holger Cahill admired the subtlety and range of grays in Bellows' prints ("Adventures in Lithography," p. 1).

Post struck a similar chord when he wrote that the "robustness of the humor" in *The Shower Bath* "may militate against the force of the truth it contains. These actions are well observed, these figures monstrous."[33]

Bellows' compositions also came under occasional attack. McBride criticized *The Sawdust Trail* (fig. 42) for having an overcrowded and confusing design. Frederick James Gregg found *Murder of Edith Cavell* (fig. 56) to be overcrowded, with certain parts suffering from overemphasis. He found the sprawling soldiers in the courtyard distracting, thereby complicating a "deeply tragic situation by taking away its simplicity." And Elizabeth Luther Cary felt that Bellows was sometimes so intent on depicting character that he failed to depict anatomy truthfully, as in *Elsie Reading to Emma No. 2* (fig. 118), the prize fights (figs. 33–36, 38, 78–81, 114, 117, 121), and the nude studies (figs. 110–113), although she also saw this as a modernist tendency.[34]

———

The characteristic most commonly noticed by critics was Bellows' wide variety of subject matter, "a latitude and longitude that none of his contemporaries in the United States can lay claim to." Bellows was versatile, always experimenting and therefore seldom redundant or boring. He saw material for his art everywhere. As Henry McBride put it, he "ran the gamut of possible subjects with a gusto that knew no obstacles." His work presented satire, sensitive portraits, the tragedies of war, the action of the prize ring, scenes of daily life in New York. Helen Appleton Read wrote, in an article entitled "George Bellows—Artist of Versatility,"

that the public was amazed at Bellows' ability to shift from a prize fight scene to the crucifixion. He was an artist who could not be pigeonholed. In a later article Read again stressed versatility, inviting those who thought the artist's work too harsh and powerful and lacking in tenderness and charm to study the pictures of his children.[35]

Bellows' versatility is perhaps best demonstrated by the diverse prints that critics singled out for praise. The lists of exceptional or favorite examples among the artist's work frequently included *Prayer Meeting* (figs. 39–40), *Artists' Evening* (fig. 51), *The Studio* (fig. 119), *The Sawdust Trail*, the portrait studies of the artist's family (figs. 90–91, 93–100), and *Murder of Edith Cavell*, a print often praised both for its technical brilliance and for its dramatic subject. *Edith Cavell* was considered the most powerful print in the war series, admired not only for its effective dark-light contrasts but for the many details that vivified the scene. It was deemed the masterpiece of the 1923 show in Columbus, while Cortissoz cited its "great richness of color" as a reason for its popularity.[36]

Many critics liked the prints that depicted life in New York City, a theme in vogue in the early twentieth century. *Solitude* (fig. 19), showing couples courting in Central Park on a spring evening, and *The Street* (fig. 11), depicting a summer's day on the crowded Lower East Side, were admired among the early prints, as was

33. Henry McBride, "News and Comment in the World of Art," *New York Sun*, March 18, 1917, section 5, p. 10; "Art Notes," *New York Evening Post*, December 19, 1917, p. 13.

34. Henry McBride, "News and Comment in the World of Art," *New York Sun*, March 18, 1917, section 5, p. 10; Frederick James Gregg, "Lithographs of War by George Bellows," *New York Herald*, November 17, 1918, section 3, p. 4; Elizabeth Luther Cary(?), "The World of Art," *New York Times Book Review and Magazine*, May 1, 1921, p. 20. Frank Weitenkampf, on the other hand, liked satirical prints such as *Business-Men's Bath* in which Bellows distorted form in the cause of caricature; see "George W. Bellows, Lithographer," p. 231.

35. Ralph Flint, "George Bellows' New York Show," *Christian Science Monitor*, February 11, 1924; Henry McBride, "Bellows and His Critics," *Arts* 8 (November 1925): 292; Helen Appleton Read, "George Bellows—Artist of Versatility," p. 12; Read, "The Versatility of George Bellows," *Brooklyn Daily Eagle*, February 3, 1924, p. 2B. Another critic had earlier noted Bellows' ability to go from the robust vitality of the fight scenes to the ironic humor of *The Sawdust Trail*, the satire of *Artists' Evening*, or the romance of *Solitude*: see "Lithographs and War Zone Graphics," *Christian Science Monitor*, November 18, 1918, p. 14.

36. See Marguerite Williams, "Horrors of the War Depicted by Artist," *Chicago Daily News*, January 15, 1919, p. 13; Lena McCauley, "Among the Dealers," *Chicago Evening Post*, January 14, 1919, p. 7; McCauley, "George Bellows, N.A.," *Chicago Evening Post*, January 7, 1919, p. 4; H. E. Cherrington, "Palette and Brush," *Columbus Dispatch*, February 18, 1923, p. 11; and Cortissoz, *American Artists*, p. 178.

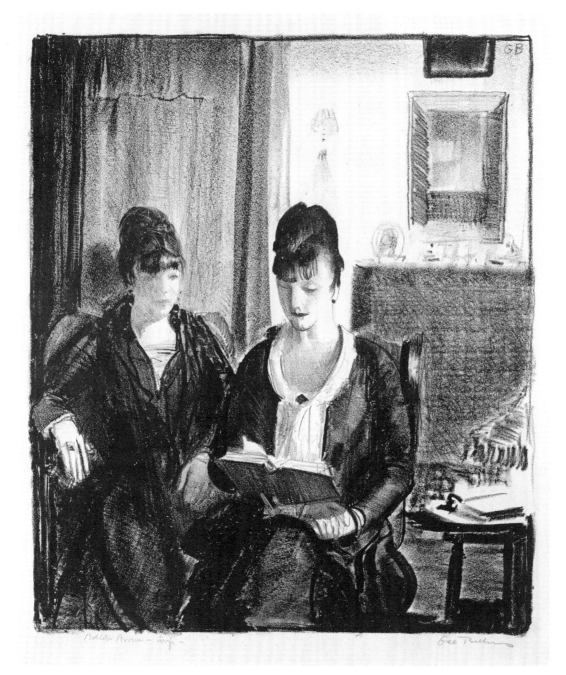

118.
Elsie Reading to Emma No. 2,
1921
Lithograph
9 11/16 × 8 3/8 in.
Amon Carter Museum

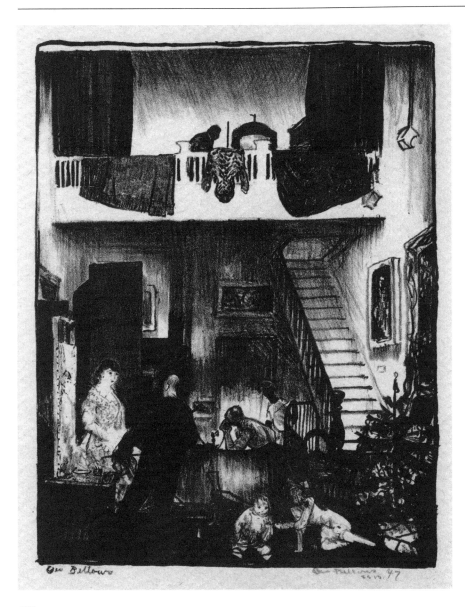

119.
The Studio, 1916
Lithograph
5½ × 4⁵⁄₁₆ in.
Amon Carter Museum

Splinter Beach (fig. 29), with its "river rats" bathing under the Brooklyn Bridge. A later re-working of the theme, *River-Front* (fig. 67), also captured the public's imagination. The joys of city life were balanced by its hazards, as Bellows depicted in his popular print *The Hold-Up* (fig. 120), praised for its Dickensian spirit. Bellows' prints of New York, it was said, were "shudderingly true" to their time.[37]

Another highly praised group was that of scenes of the artist's family and friends. *Artists' Evening*, showing artists and writers at their favorite watering hole, Petitpas, provided, as one critic wrote, the "scent of food and cigarettes and the flavor of the chatter. . . . Atmosphere and characterization, these are the things . . . which do Bellows' work." Another favorite was *The Studio*, with its charming depiction of the artist and his family at home (complete with printing press and printer on the balcony). And the many sensitive portraits of Emma, Anne, and Jean held great appeal for the critics and public alike. It was here, Frank Weitenkampf observed, that "interest in the job and in the personality are harmoniously blended."[38]

The most controversial group of prints were those involving satire and irony. To modern

37. Cary (?), "The World of Art," p. 20.
38. Babette Deutsch, "A Superb Ironist," *New Republic*, July 21, 1920, p. 221; Weitenkampf, "George W. Bellows, Lithographer," pp. 232, 235. Weitenkampf praised the small-scale, straightforward prints depicting single figures or small groups. In such prints as *Artists' Evening, Four Friends, Reducing, The Drunk*, and *Old Billiard Player*, as well as a group of nude studies, he wrote, one gets "the directest, simplest expression of Bellows in relation to the world around him." He also liked the directness of *Dance in a Madhouse* and *Prayer Meeting*.

A critic for the *New York Evening Post* similarly admired prints with personal references, like *Sunday 1897, Artists' Evening*, and *Reducing*, citing *Reducing* as one of Bellows' best and most facetious efforts. See "Among the Art Galleries," *New York Evening Post*, May 7, 1921.

Helen Appleton Read and Margaret Breuning delighted in portraits of Bellows' children. See Read, *Brooklyn Daily Eagle*, February 3, 1924, and Breuning, "Two Shows by Bellows at the Same Time," *New York Evening Post*, February 16, 1924, pp. 13–14. Breuning described the portraits of his children as having "exquisite gradations of tone, nuance of gray . . . all in a lusciousness of tone."

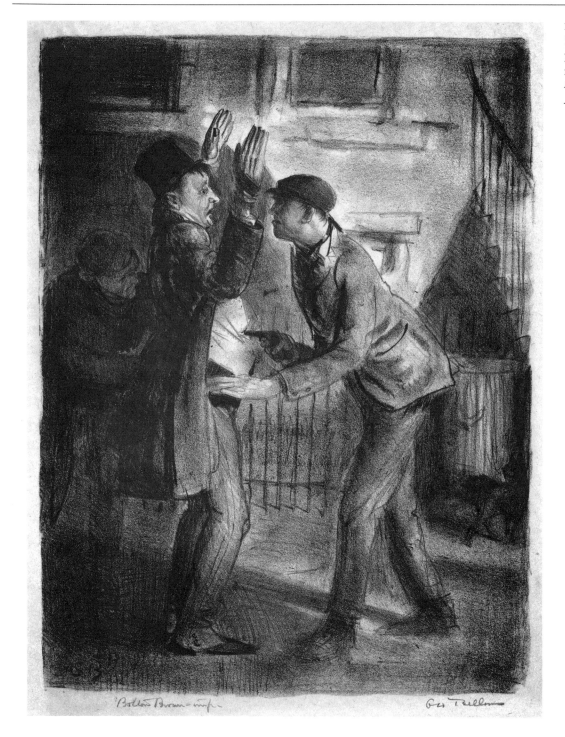

'Bolton Brown—imp. Geo. Bellows

120.
The Hold-Up, 1921
Lithograph
11 × 8½ in.
Amon Carter Museum

viewers these perhaps epitomize Bellows' work, but there was no unanimity regarding their importance during his lifetime. A 1920 article in the liberal journal *New Republic* focused on Bellows' eloquent use of irony—a trait the author found typical of American art in general and the chief weapon of Bellows in particular. *Reducing*, she wrote, was "worthy of Degas." Frequently Henry McBride found fault with Bellows' more satirical work. To him, *Reducing* did not exhibit much humor or character, *Prayer Meeting* wasn't funny, *The Sawdust Trail* was overcrowded, and *The Shower Bath* was too ponderous.[39] But, to most critics, caricature and satire were among Bellows' strong suits. The prints mentioned above, along with such incisive commentaries as *Business-Men's Class* (fig. 14) and *Dance in a Madhouse* (fig. 27), were among the hallmarks of his work.

The boxing prints were the object of much critical acclaim. *Between Rounds, Dempsey and Firpo*, and *Introducing John L. Sullivan* (fig. 121) all got their share of praise, but it was *A Stag at Sharkey's* that was cited most frequently as Bellows' lithographic masterpiece. The boxing prints drew attention as soon as they were exhibited, no doubt due to the novelty of their subject matter, which was noted by Cary, among others. Henry McBride liked the "sheer dynamics" of the prize fight scenes in general and cited *Preliminaries* (fig. 36) and *Between Rounds No. 1* (fig. 34) for their "interesting blacks nicely distributed" and for the "play of lights and shadow nicely done." He praised *A Stag at Sharkey's* ("the best match this artist has staged") for vigorous drawing and brilliant blacks. For McBride, *Stag* remained a favorite throughout the years, a "rhapsody of enthusiasm for the drama of pugilism" and directly in line with Bellows' temperament, which likes "to do everything with a smash." A writer for the *Arts* (probably Forbes Watson) considered it the high-water mark of Bellows' work, and Marguerite Williams of the *Chicago Daily News*

thought it was the finest print in terms of draftsmanship.[40]

────

Forbes Watson furnished a clue to another factor in Bellows' popularity: "People of the most divergent viewpoints respond to the dynamic force of his personality." Writers described Bellows' art in terms that also described the man himself, who was known to be an excellent athlete. Virility, energy, dynamism, swaggering gusto, power, vitality, exuberance, boldness, robustness, and force were some of the qualities frequently remarked upon. His lithographs could be "seen without a magnifying glass." His art, like that of the prize fighters he depicted so well, had punch. "Bang" was almost his middle name, one critic observed: "Bellows loved force and forceful doings, and even in his portraits he meant to hit you hard." He was a "man's man." His art was a highly personal one, and critics responded to that. *Arts & Decoration* saw in the prints "the spirit of independence, of self-reliance, that dominates the man, and that has been at the bottom of his success."[41]

Certainly there were some critics, as noted earlier, who found his forcefulness too coarse,

39. Deutsch, "A Superb Ironist," p. 220; Henry McBride, "News and Comment in the World of Art," *New York Sun*, March 18, 1917, section 5, p. 10.

40. Elizabeth Luther Cary, "Painter-Gravers of America Exhibit Prints," *New York Times*, April 1, 1917, p. 12; Henry McBride, "Bellows's Progress in Lithography," *New York Herald*, May 15, 1921; McBride, "News and Comment in the World of Art," *New York Sun*, March 18, 1917, section 5, p. 10; McBride, "Painter-Gravers Display Their Art," *New York Sun*, April 2, 1917; McBride, "Bellows Lithographs on View," *New York Sun*, March 28, 1925, p. 13; McBride, "Bellows's Progress in Lithography"; Forbes Watson (?), "A Bellows Memorial," *Arts* 7 (May 1925): 284, 286; Marguerite Williams, "Horrors of the War Depicted by Artist," *Chicago Daily News*, January 15, 1919, p. 13.

41. Forbes Watson, "George Bellows," *New York Post Illustrated Magazine*, around November 1913, p. 9; Watson, "At the Art Galleries," *New York Evening Post Magazine*, March 31, 1917, p. 11; Henry McBride, "Art Season Starts Vigorously," *New York Sun*, October 17, 1925, p. 4; McBride, "Bellows Lithographs on View," p. 13; L.M., "The Bellows Memorial Exhibition," *American Magazine of Art* 16 (December 1925): 657; Estelle Ries, "The Relation of Art to Every-day Things," *Arts & Decoration* 15 (July 1921): 158.

It was noted in the press that Bellows was a baseball player. His boxing prints were successful, it was reported, because he was "capable of putting on the gloves himself." (*Vanity Fair* 7 [October 1916]: 74.)

particularly in his forays into satire and irony. Henry McBride criticized *Artists Judging Works of Art* for that reason, yet he liked the scenes of the Billy Sunday campaign "in which comedy sinks into rough farce, . . . the vein Mr. Bellows works best." Frank Jewett Mather, reviewing the catalogue of Bellows' prints published in 1927, observed a "bluntness of vision" and lack of finesse that he felt detracted from the work. The artist and critic Guy Pène du Bois summed up Bellows' lack of delicacy and grace: "The man has never been intrigued by the elusive subtility. He has ever manoevered his large hands toward the production of large effects. He has almost without variation sought to attain that virtue so much vaunted here—punch." Pène du Bois felt that Bellows shared the public's weakness for a "Hearstian play upon the sensational" in his prints. "Thus he talks as if the world were almost deaf or draws as if it were near-sighted. . . . He will not prick us with the point of his sword . . . but slap us, and not tenderly, with the relentless flat of it." As examples, the critic pointed out the broadened humor in *Reducing*, the accentuated dignity in *Edith Cavell*, and the number of props in *The Cigarette* (fig. 55).[42]

But other writers overlooked Bellows' occasional lack of grace and charm: "He is a real man, with 'pep' enough for half-a-dozen. His lithographs will live." The *Christian Science Monitor* saw the satiric value of the prints, "swift messengers of the draftsman's brittle wit or an impish and twinkling-eyed appreciation of personal idiosyncracies. Delicacy is absent nor is subtle differentiation to be desired in work which is more akin to Steinlen than the graceful Gavarni, yet whose joyousness precludes the personal and bitter invective of Forain. Behind each line stands Bellows, derisive, condemnatory or deeply understanding, but never disinterested. . . . The work of this artist is filled with a just and kindly understanding of humanity. . . . The art of George Bellows will remain a

document of his day enwrapped in beauty of design."[43]

Several reviewers pointed out Bellows' forte as a social commentator. The *Christian Science Monitor* critic felt that Bellows' prints proved him to be a "true peripatetic philosopher, a contemporaneous historiographer, a serio-comic sociologist on stone." Cary compared Bellows' love of city scenes and frank observation to the work of the English printmaker and satirist William Hogarth. But Bellows, she wrote, "outdoes the Georgian lustiness of appetite for broad humor. His 'Reducing' . . . is funny, precisely as the Flemish grotesques showing the antics of the very fat and the very thin were funny to their public." She found *Introducing John L. Sullivan* to be rewarding due to the artist's keen observation of "types," a sentiment echoed by Gustav Kobbe: "You can hear the unction of the introducer's voice and you expect to hear the introduced one respond with a speech winding up with 'I remain yours truly, John L. Sullivan.'" Kobbe also admired character studies such as *The Sawdust Trail* and *Business-Men's Class*. Cary recognized the talent of a true caricaturist in *The Sawdust Trail*, in which he used "sarcastic humor over the frailties of the human constitution" and interpreted the "barbaric character of the whole scene." *Dance in a Madhouse* she found to be another remarkable performance of subtle observation, showing the "pathetic people whirling about in a harmony the flow of which carries with it a myriad of small discords. Each individual seems fighting . . . against the prevailing rhythm while yielding to it." *Vanity Fair* hailed *Between Rounds No. 2* as a "vigorous and accurate piece of character realization." Helen Appleton Read considered "Bellows' 'Comedie Humaine' . . . a clear-eyed version of actuality . . . ; he is an observer who stands a little apart." Forbes Watson wrote that Bellows "took rank . . . as the most vigorous recorder of important and until then neglected aspects of contemporary life." His satirical tendencies, seen especially in his early

42. McBride, "Bellows's Progress in Lithography"; Frank J. Mather, "In Black and White," *Saturday Review of Literature*, unidentified clipping from 1927 (New York Public Library artist file); Guy Pène du Bois, "In and About the Art Galleries," *New York Evening Post*, October 26, 1918, p. 7.

43. W.H.D., "Huns Depicted Vividly," *Boston Evening Transcript*, January 13, 1919; M.O., "The Art of George Bellows," *Christian Science Monitor*, July 7, 1924.

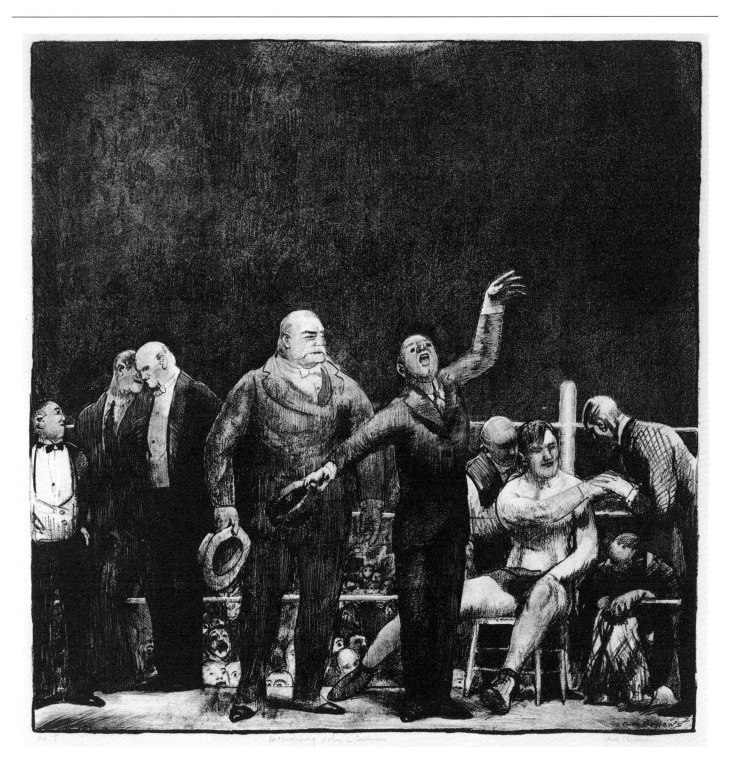

121.
Introducing John L. Sullivan,
1916
Lithograph
21⅝ × 20½ in.
Amon Carter Museum

work, were gradually absorbed into larger and broader interests, Watson felt. The *American Art Student* considered Bellows preeminent as a satirist, interpreting both humor and pathos.[44]

━━━━━━━

Finally, reviews frequently stressed Bellows' Americanism, their chauvinistic comments reflecting the cultural nationalism of the time. Critics vigorously promoted art and literature that reflected American life and values, calling for a new indigenous culture expressive of the current generation. This was a period of social radicalism, political isolationism, and revolt against the more conservative, genteel traditions of the nineteenth century. New York City, itself the symbol of modernism, was the center of this movement, urban America now serving as inspiration for artists and writers as rural America had in the previous century. Critics admired the artists who painted and interpreted the native urban scene, and few did so with more humor and understanding than George Bellows. In this respect he was often compared to a writer greatly admired by the cultural nationalists, Walt Whitman. Like Whitman, Bellows exuded an insistent Americanism, characterized by energy, bravado, gusto at the expense of grace, and a democratic spirit in his interest in commonplace subjects. Another important precedent was Mark Twain, with whom Bellows shared a certain robustness and humor, evident especially in his lithographs. Edmund Wilson, writing in the *New Republic*, cited Bellows as a spokesman for his time, much as Carl Sandburg, Leo Ornstein, Sinclair Lewis,

H. L. Mencken, and Eugene O'Neill were in their respective fields.[45]

Bellows was absorbed in American life, as the cultural nationalists felt artists must be, and intimately knew its values. Holger Cahill credited Bellows' deep native roots (calling him "an American of the Americans") for his success, since they gave him the "familiarity of the satirist, the man who can be critical about the object of his affection." Bellows was called "thoroughly American," "distinctively American," "American to the core." Anyone who studied his art didn't have to ask whether he had studied abroad, Forbes Watson wrote. Bellows was a "strong native talent." The fact that he had never been abroad was seen as an advantage—something to be worn as a badge of honor—and is mentioned again and again in discussions of his art. Helen Appleton Read felt that Bellows best interpreted twentieth-century America; "so completely American was he in his spirit that he stands alone as being the only significant figure in American art who never visited Europe." Here, Read wrote, is an artist who is proof that American art is not a poor imitation of European art, an artist who is wholly Ameri-

━━━━━━━

44. "Lithographs and War Zone Graphics," *Christian Science Monitor*, November 18, 1918, p. 14; Elizabeth Luther Cary, "Painter-Gravers of America Exhibit Prints," *New York Times Magazine*, April 1, 1917, p. 12; Cary, "George Bellows' Work on Exhibition," *New York Times*, November 10, 1918, section 4, p. 4; Gustav Kobbe, *New York Herald*, March 18, 1917, section 3, p. 10; Cary, "George Bellows' Work on Exhibition," p. 4; *Vanity Fair* 22 (March 1924): 24; Helen Appleton Read, "George Bellows—Artist of Versatility," *Brooklyn Daily Eagle*, October 28, 1923 [date uncertain], p. 20; probably Forbes Watson, "A Bellows Memorial," *Arts* 7 (May 1925): 284, 286; and Freeman H. Hubbard, "George Wesley Bellows Takes His Place with the Old Masters," *American Art Student* 9 (October 1925): 21.

45. Edmund Wilson, "George Bellows," *New Republic*, October 28, 1925, p. 255. Crowninshield, Introduction to *Memorial Exhibition*, p. 16, compared Bellows to Whitman; C.C.C., "Sermons, Ironies, Humors in Bellows's Lithograph," *Boston Evening Transcript*, October 10, 1925, compared him to Twain.

On the cultural nationalism of Bellows' time, see Wertheim, *The New York Little Renaissance*, esp. pp. 167–206. Wertheim lists four groups active during the little renaissance (pp. xi–xii): the radical group of writers and artists affiliated with the *Masses* (John Reed and Max Eastman) and The Eight (John Sloan and Robert Henri); the more conservative apolitical iconoclasts like H. L. Mencken and Willard Huntington Wright on the staff of *Smart Set*; the cultural nationalists like Van Wyck Brooks, Waldo Frank, and Walter Lippmann who worked for the *Seven Arts* and the liberal *New Republic*, who called for a new indigenous culture; and the Stieglitz circle of modernists who experimented with new artistic forms.

Although Wertheim called Bellows a cultural nationalist, an interview with the artist in 1920 sheds interesting light on his feelings about Americanism: "Bellows is sick and tired of those who want to nationalize our art, to Americanize it. . . . Nor can he tolerate the critic that truckles to these sentiments, that drivels and drools about the 'sturdy Americanism' in the work of this or that painter." (Ameen Rihan, "Luks and Bellows: American Painting, Part III," *International Studio* 71 [August 1920]: xxiii.)

can, "not only in ancestry and bringing up, but in the quality of his imagination and point of view." His Americanism, she felt, prevented Bellows from "insisting upon the macabre or the perverse" and caused him to distrust the "bizarre and the erotic." To the *Nation*, Bellows interpreted the "vast energy, the seething turmoil of the American scene." "Native force, energy, courage and initiative" plus an ability to express "American life, with its exuberances, its humors, its vulgarities and its vitality" were traits observed by Forbes Watson. Royal Cortissoz devoted an article in *Scribner's* to Bellows and his Americanism, considering it one of the artist's most outstanding traits. And Frank Crowninshield also stressed Bellows' American inspiration; in his work "the stalk, roots and fibre of America found a sincere and inspired expression." Bellows, he felt, embodied the geography and democracy of America.[46]

The effusive praise accorded Bellows' series of lithographs (figs. 53–58, 122, 124) depicting the widely reported German war atrocities in Belgium sprang, in part, from nationalism. The shocking subject matter of cruelty and torture is so vividly presented that it is difficult to look at the lithographs even today. Their impact on viewers during World War I must have been immeasurably greater. In 1918 *American Art News* called them "brutal, full of horror, but reeking with truth, which adds to their poignancy." These pictures shocked, but were "full of strange beauty" and "conceived in bigness of vision that is rare and inspiring." Charles Dana Gibson wanted to send them to Washington, hoping they would hang in the room where

peace terms were discussed, adding: "It is [a] pity these pictures were not made when the war started." Frederick James Gregg recognized the powerful propagandistic value of the prints, reflecting as they clearly did the "personal and passionate indignation at the deeds of our defeated enemy. They are thus capable of serving a good purpose . . . when many of our people are inclined to show a maudlin pity for the Prussians, who are behaving themselves only because they are more or less impotent for evil." *Vanity Fair* illustrated some of the lithographs to show how American artists were "helping out at the wheel" and cited the effective use of *Gott Strafe* (fig. 122) in the Fourth Liberty Loan drive. In later years a different opinion of the war lithographs emerged. A writer for the *Arts* (probably Forbes Watson) considered them, with the exception of *Murder of Edith Cavell*, to be as "ill-judged in their appeal to the passion of hatred as anything produced in America's most hysterical war years," and Holger Cahill called them mannerist.[47]

Bellows became known for depicting the "stuff of our national life";[48] his dominating influence was America and its people, the critics said, and his ability to capture everyday subjects was repeatedly mentioned in the press. Paradoxically, though, the same critics frequently compared him to various European artists. Perhaps the critics' campaign to make George Bellows an "old master" was a way to stake America's claim to high art. Daumier was the artist to whom Bellows was most often linked due

46. Edgar Holger Cahill, "George Bellows," *Shadowland* 6 (July 1922): 11, 61; Forbes Watson, "George Bellows, Noted Artist, Dies," editorial, *World*, January 9, 1925, p. 10E; Helen Appleton Read, "Bellows' Last Year's Work; Review of His Career," *Brooklyn Daily Eagle*, February 8, 1925, p. 2B; Read, "George Bellows—Artist of Versatility," p. 12; Read, "The George Bellows Memorial Exhibition," *Brooklyn Daily Eagle*, October 11, 1925, p. 8C; "George Bellows," editorial, *Nation* 102 (January 21, 1925): 60; Forbes Watson, "George Bellows," *World*, January 11, 1925, p. 10E; Royal Cortissoz, "George Bellows and His Americanism," *Scribner's Magazine* 78 (October 1925): 440; Frank Crowninshield, "An Appreciation of the Life and Work of George Bellows," *Art News* 23 (January 17, 1925): 6; Crowninshield, Introduction to *Memorial Exhibition*, p. 13.

47. D. Cotton, "Newport (R.I.)," *American Art News* 16 (September 14, 1918): 3; Charles Dana Gibson to George Bellows, August 27, 1918, George Wesley Bellows Papers, Amherst College Library, quoted in Charles Morgan, *George Bellows: Painter of America* (New York: Reynal & Company, 1965), p. 220; Frederick James Gregg, "Lithographs of War by George Bellows," *New York Herald*, November 17, 1918, section 3, p. 4; "The Hun: Lithographs by George Bellows," *Vanity Fair* 11 (November 1918): 36–37; probably Forbes Watson, "A Bellows Memorial," *Arts* 7 (May 1925): 286; Holger Cahill, "Adventures in Lithography," *New York Herald Tribune*, November 27, 1927, section 7, p. 2.

Gibson was writing in his capacity as Chairman of the Committee on Public Information, Division of Pictorial Publicity for New York City.

48. "George Bellows," editorial, *New York Tribune*, January 9, 1925, p. 14.

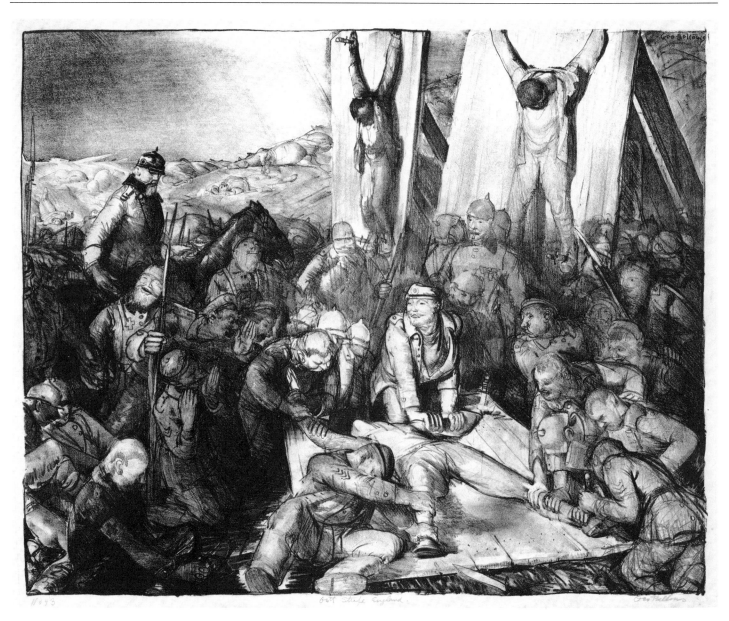

122.
Gott Strafe, 1918
Lithograph
15³/₁₆ × 19 in.
Amon Carter Museum
ALSO FIG. 171

123.
The Garden of Growth, 1923
Lithograph
18 1/16 × 14 9/16 in.
Amon Carter Museum

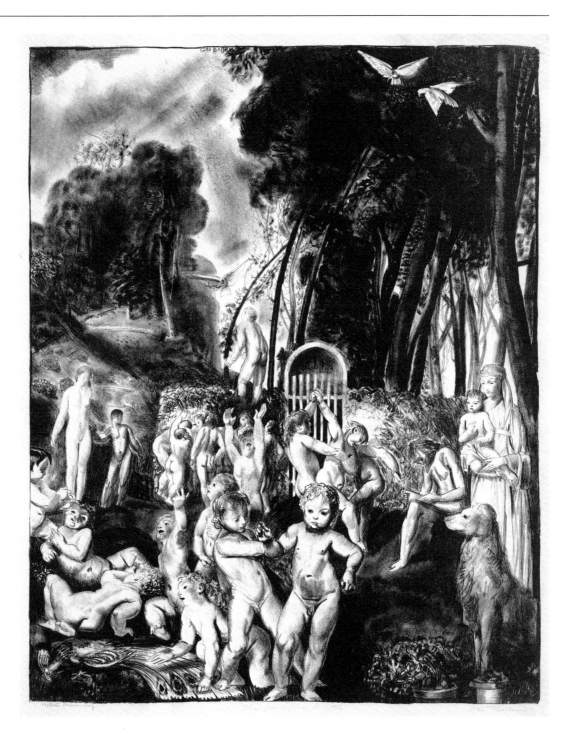

to their mutual love of caricature, draftsman-
ship, forcefulness, and "pungency."[49] Margaret
Breuning thought Bellows reminiscent of
Daumier in his "rich line, his fertility of in-
vention and his seizing upon the human body in
his fighting bouts as the theatre for terrific con-
tests between light and shadow that is played
with rapier thrusts of direction like flashes of
lightning." Another reviewer cited fleeting sug-
gestions of Daumier and Gavarni in *The Parlor
Critic* (fig. 60), Titian in *The Garden of Growth*
(fig. 123), and Goya in *Dance in a Madhouse*.
Rembrandt was also frequently cited as an influ-
ence on Bellows, especially in regard to the war
lithographs. *Edith Cavell* was comparable to
Rembrandt's work in subject and technique,
one critic wrote. A Boston writer found Bel-
lows reminiscent of the "greatest black-and-
white artists" who were similarly interested in
life's mysteries and tragedies, seeing Rembrandt
in *Edith Cavell* and *Gott Strafe*, and Goya—who
"never conjured up a more horrible night-
mare"—in *The Last Victim* (fig. 124). Marguerite
Williams, writing for the *Chicago Daily News*,
was reminded of Rembrandt's use of light
and shade when seeing *Edith Cavell, Prayer
Meeting*, and *Dance in a Madhouse*, among

others. Another Chicago critic, Lena McCauley,
mentioned *Edith Cavell*'s "Rembrandtesque
shadows."[50]

By the time of the Metropolitan Museum
of Art's memorial exhibition in 1925, Frank
Crowninshield proudly stated that Bellows'
prints were being sought as "if they bore the
name of Daumier or of Delacroix." And Helen
Appleton Read proclaimed that, with that ex-
hibition, Bellows could rightly take his place
as an American old master, a position he still
holds today.[51]

49. Mary Fanton Roberts, "George Bellows—An Ap-
preciation," *Arts & Decoration* 23 (October 1925): 39; "Stu-
dio and Gallery," *New York Sun*, May 14, 1921, p. 6;
W.H.D., "Huns Depicted Vividly," *Boston Evening Tran-
script*, January 13, 1919.
50. Margaret Breuning, "Two Shows by Bellows at the
Same Time," *New York Evening Post*, February 16, 1924,
p. 13; unidentified clipping, "Lithographs by Bellows and
Etchings by Rembrandt," New York Public Library artist
files (microfilm); "Lithographs and War Zone Graphics,"
Christian Science Monitor, November 18, 1918, p. 14;
W.H.D., "Huns Depicted Vividly"; Marguerite Williams,
"Horrors of the War Depicted by Artist," *Chicago Daily
News*, January 15, 1919, p. 13; Lena McCauley, "George
Bellows, N.A.," *Chicago Evening Post*, January 7, 1919, p. 4.
51. Crowninshield, Introduction to *Memorial Exhibi-
tion*, p. 11; Read, "The George Bellows Memorial Exhibi-
tion," p. 8c.

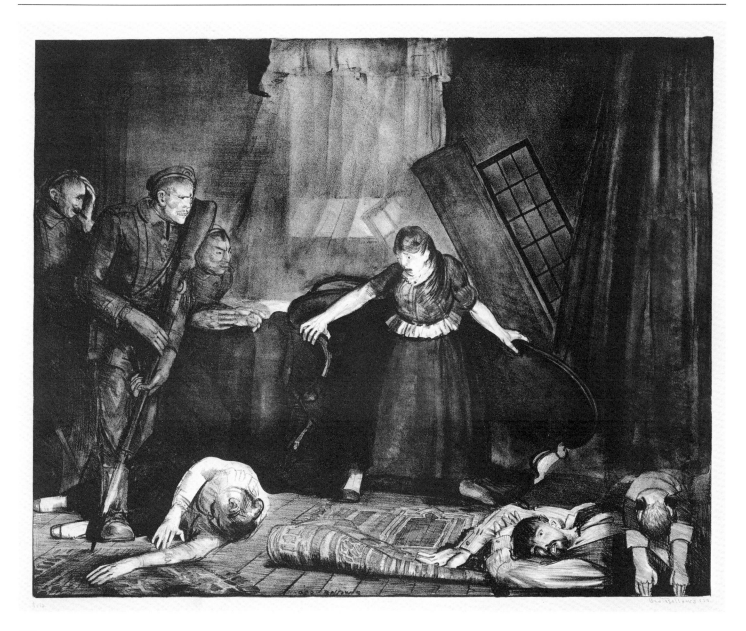

124.
The Last Victim, 1918
Lithograph
18¹³⁄₁₆ × 23¹¹⁄₁₆ in.
Amon Carter Museum

Additions to the Mason Catalogue Raisonné

Included in the Amon Carter Museum's collection of Bellows' prints are a group of previously unrecorded lithographs and variant states.[1] These are illustrated and described in this appendix, which also provides new information concerning edition size (the number of prints of a single image) and date for several prints, based on an examination of the prints and the artist's record books.[2] This information supplements that given by Lauris Mason and Joan Ludman in *The Lithographs of George Bellows: A Catalogue Raisonné* (Millwood, N.Y.: KTO Press, 1977), hereafter referred to as Mason. Except where there is evidence to the contrary, the information published in Mason is considered to be accurate.

With the exception of the lithographs in the 1918 war series and a few others, Bellows listed an edition size for his prints in his record books. Although there are some discrepancies between the edition size as listed in the record books and the actual edition size as gleaned from the numeration on the prints themselves, the artist's records are generally accurate. In some instances where no edition size is given in the record books, an estimate may now be made based on the number of prints remaining in the estate and the inscriptions appearing on the prints themselves. For those prints produced between 1916 and 1918, Bellows inscribed a number on each print, indicating the order in which they were pulled from the lithograph stone. These numbers generally appear beneath the lower left corner of the image, in graphite. For some early prints, Bellows' practice was to include variant states within a single edition (see, for example, *Mother and Children*).

An inventory (possession of Jean Bellows Booth) of Bellows' lithographs, compiled, according to the artist's daughter, shortly after his death, gives the number of impressions of each print then remaining in the estate. In some cases, the number of prints in the inventory exceeds the edition size given in the artist's record books. For a few of these prints a number of working proofs have been identified; these were in the possession of the estate and were counted in the inventory but had not been counted in the editions cited in the record books. For the other prints in this category (*Introducing John L. Sullivan, Tennis at Newport, Garden of Growth, Between Rounds No. 2,* and *Appeal to the People*), variant states may similarly exist but have not yet been identified. Especially among his early prints, Bellows produced a number of working proofs varying in minor details as he experimented with the medium, printing many lithographs himself.

The following list is not definitive; additional states, for example, are likely to be identified. The list is organized by year and then alphabetically by title.

1. The collection also includes one impression of Bellows' only known etching, *The Life Class.* In 1943, Emma Bellows donated the etching plate and five impressions of the print to the Boston Public Library. She retained a single impression for herself; this print was part of the Amon Carter Museum's acquisition of 220 Bellows prints in 1985.

2. Bellows inscribed these books "Book B Record of Pictures" and "Book C" (possession of Jean Bellows Booth; hereafter referred to as Record Book B and Record Book C). We are grateful to Jean Bellows Booth for allowing us to consult the original record books in order to obtain complete and accurate information on Bellows' lithographs.

Artists Judging Works of Art
1916

A number of working proofs (fig. 125) were made prior to the editioned print (Mason 18; fig. 126), to which Bellows added a glass to the foreground and hair to the head of the man in the center of the print. The inventory cited 75 impressions of this print remaining in the estate at the time of Bellows' death, while the edition size given in the record book is 52 (Record Book B, p. 106). The discrepancy between these two figures suggests that there were at least 23 working proofs of the lithograph. One working proof (David Tunick, Inc.), inscribed "No 24," bears crayon additions on the back of the central figure and to the still-life elements in the foreground.

Benediction in Georgia
1916
Illustrated fig. 46

Prior to the editioned print, Bellows produced at least one unnumbered impression (still in the artist's estate) lacking the lithographed signature in the lower right portion of the image.

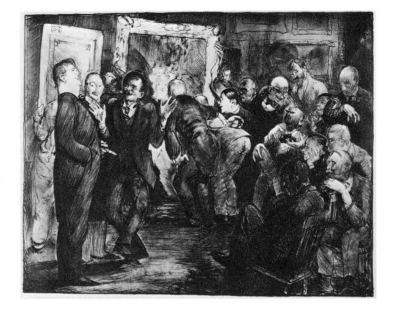

125.
Artists Judging Works of Art, first state, 1916
Lithograph
14¾ × 19¹⁄₁₆ in.
The Cleveland Museum of Art; Gift of Leonard C. Hanna, Jr.

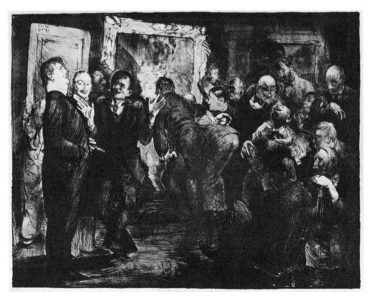

126.
Artists Judging Works of Art, second state, 1916
Lithograph
14¾ × 19¹⁄₁₆ in.
Amon Carter Museum

127.
Fantasy, first state, 1916
Lithograph
6¹⁵⁄₁₆ × 8¹⁵⁄₁₆ in.
Boston Public Library,
Print Department;
Gift of Albert Henry Wiggin

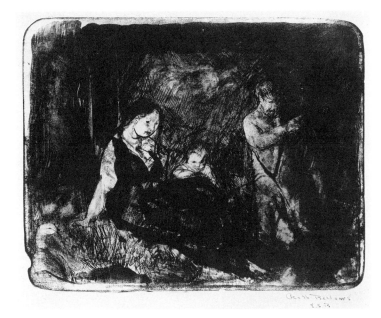

128.
Fantasy, second state, 1916
Lithograph
6¹⁵⁄₁₆ × 8⅞ in.
Amon Carter Museum

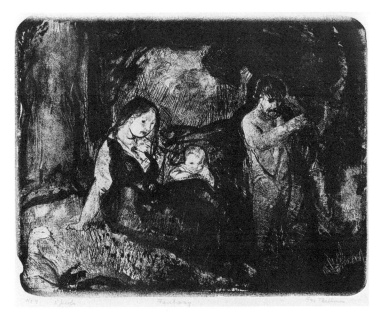

Fantasy
1916

A working proof of this print (fig. 127; Mason 9, first state) preceded the edition of 5 or 6. Bellows cited an edition of 6 in his Record Book B, p. 106, while the impression in the Amon Carter Museum is inscribed "5 proofs" (fig. 128). As noted by Mason, the editioned state bears alterations in the face of the male figure. Scratched lines were added to this figure and to the lower right portion of the print, and the top border was re-drawn. Mason also records a third state; this print, however, is not a variant state, but a darker impression of the second state.

Hungry Dogs No. 1
Hungry Dogs No. 2
1916

The first version of *Hungry Dogs* (fig. 129) was redrawn on a second stone (fig. 130). Bellows then altered this second version, adding lines throughout the composition, to create at least one additional state (fig. 131; Mason 1). The numeration of these prints suggests that Bellows editioned each version separately. If so, there are at least 11 impressions of the first version, 47 of the first state of the second version, and 41 of the second state (based on the numeration of prints in the Amon Carter Museum, the artist's estate, and the Boston Public Library, Print Department, respectively). The artist's Record Book B, p. 106, gives 41 as the edition size.

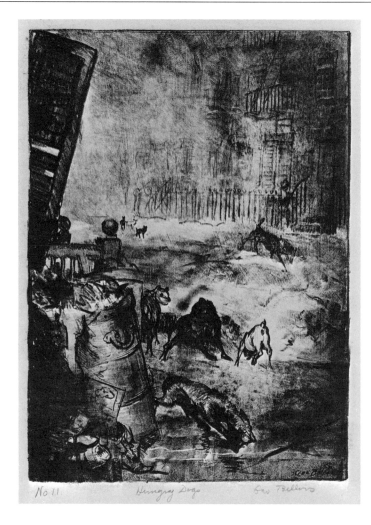

129.
Hungry Dogs No. 1, 1916
Lithograph
13⅛ × 9¹³⁄₁₆ in.
Amon Carter Museum

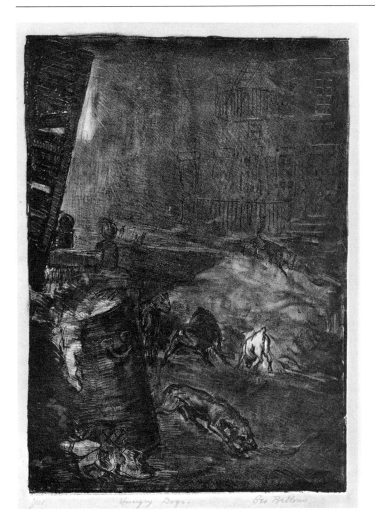

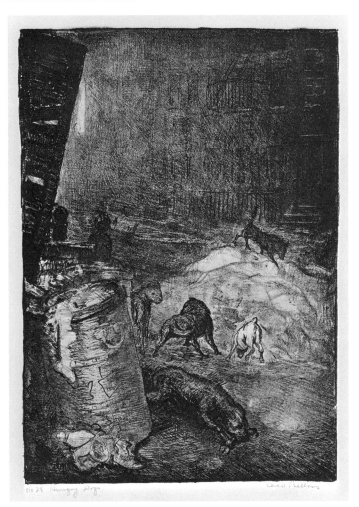

130.
Hungry Dogs No. 2,
first state, 1916
Lithograph
13⅜ × 9¾ in.
Amon Carter Museum

131.
Hungry Dogs No. 2,
second state, 1916
Lithograph
13⅜ × 9¾ in.
Amon Carter Museum

In the Park, Light
In the Park, Dark
1916

There has been some confusion about which of these lithographs (Mason 30 and 31) was printed first. An impression of *In the Park, Light* (fig. 132) in the Amon Carter Museum collection bears the inscription, in Bellows' hand, "second state." Mason concurs that the light version followed the dark. In his Record Book B, p. 106, Bellows lists an edition of 81 for "In the Park 1st State" and 59 for "In the Park 2nd State." The impression of *In the Park, Dark* in the Cleveland Museum of Art is inscribed "No. 70," confirming that the print with the largest edition (*Dark*) was the first state. If this is the case, Bellows may have printed the light version from a second stone, using the transfer process to copy the lower portion of the first version. The hypothesis that he regrained the upper portion of the stone after printing *Dark* is difficult to accept, because the middle ground of the image shows no evidence of such radical reworking.[3]

In the Park, Dark exists in several states, most of them bearing the inscription "X" beneath the image in the lower left corner, indicating that they were working proofs (figs. 133, 134). Two of the states (figs. 135, 136) were signed and numbered by the artist; both were probably included in the edition of 81. The variations among the states are in the drawing of the building, sky, and foliage in the upper portion of the image.

3. I am grateful to Linda Guy, Clinton Adams, and Garo Antreasian for their comments on the technical aspects of this print. For the hypothesis that the upper portion of the image was redrawn on the same stone, see, for example, Mason, p. 71.

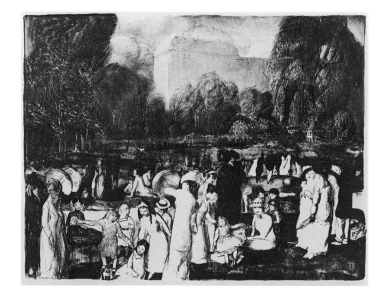

132.
In the Park, Light, 1916
Lithograph
16⅛ × 21⁵⁄₁₆ in.
Amon Carter Museum

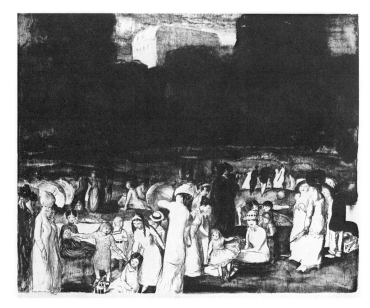

133.
In the Park, Dark,
working proof, 1916
Lithograph
17³⁄₁₆ × 21⁵⁄₁₆ in.
Amon Carter Museum

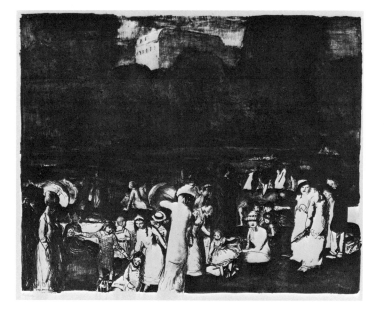

134.
In the Park, Dark,
working proof, 1916
Lithograph
17⅛ × 21⅜ in.
Amon Carter Museum

135.
In the Park, Dark,
variant state, 1916
Lithograph
17 1/16 × 21 3/8 in.
Amon Carter Museum

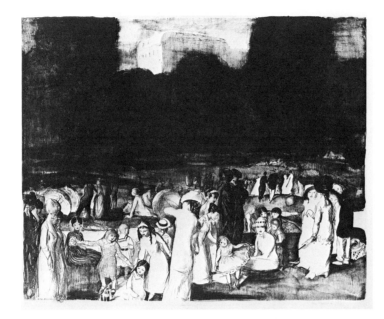

136.
In the Park, Dark,
variant state, 1916
Lithograph
16 3/4 × 21 1/8 in.
Print Collection,
Miriam and Ira D. Wallach
Division of Art, Prints
and Photographs,
The New York Public Library;
Astor, Lenox and Tilden
Foundations

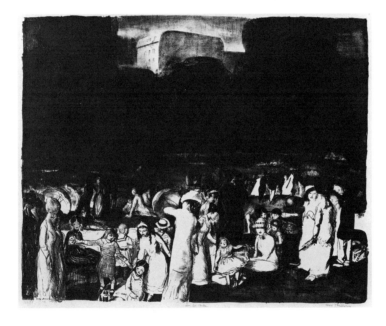

The Jury
1916

In the first state (fig. 137) the features of the third figure from the left are unfinished. In a second state (fig. 138) his features are more completely realized, and shading has been added to the display stand and to the wall behind the standing figures. In the final state (fig. 139; Mason 17), Bellows scraped away the shaded portion of the wall. The two "states" listed in Mason both appear to represent the final state, one of them printed more darkly than the other. All three states were numbered by the artist, whether in one or several editions. Record Book B, p. 106, lists an edition size of 35, while the impression in the Cleveland Museum of Art (the final state) is numbered 49.

Male Torso
1916 (Mason 2)
Not illustrated

Although Mason cites two states for the print based on the drawing of the feet, the rendering of the feet in these two prints appears to be identical. The edition size is at least 22 (given in Mason as "unknown, probably small"), based on the numeration of an impression in the artist's estate. The print was not listed by Bellows in his record books.

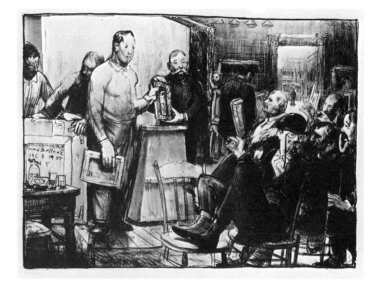

137.
The Jury, first state, 1916
Lithograph
12¹⁄₁₆ × 16⁵⁄₁₆ in.
Amon Carter Museum

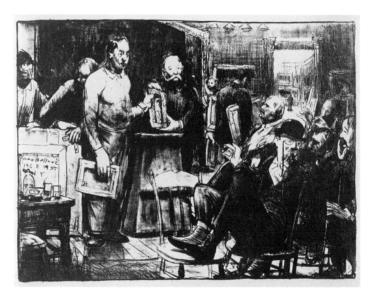

138.
The Jury, second state, 1916
Lithograph
12³⁄₁₆ × 16³⁄₈ in.
Boston Public Library,
Print Department;
Gift of Albert Henry Wiggin

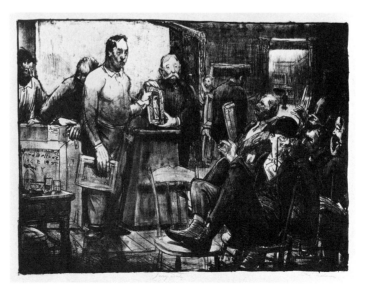

139.
The Jury, third state, 1916
Lithograph
12³⁄₁₆ × 16³⁄₈ in.
Amon Carter Museum

140.
Matinicus, first state, 1916
Lithograph
6¹⁵⁄₁₆ × 9⅛ in.
Boston Public Library,
Print Department;
Gift of Albert Henry Wiggin

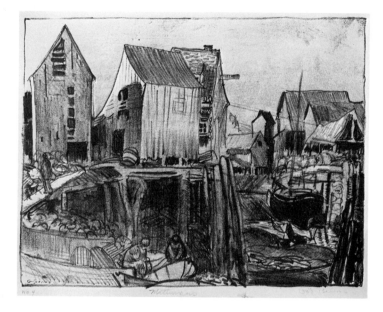

141.
Matinicus, second state, 1916
Lithograph
6⅞ × 9³⁄₁₆ in.
Amon Carter Museum

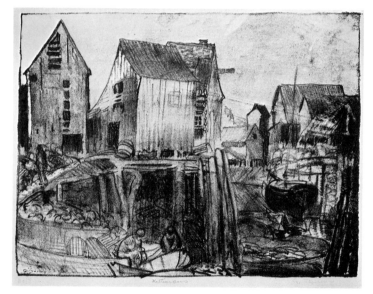

Man on His Back, Nude

1916 (Mason 3)
Illustrated fig. 4

The combined edition size for the two states of this print is at least 19 (given in Mason as "unknown, possibly 10"), based on the numeration of an impression in the estate. The print was not listed by Bellows in his record books.

Matinicus
1916

In an early state of this print (fig. 140; Mason 15, first state), Bellows scratched lines around the figure on the walkway at the left. In most of the prints in the edition, however, this detail has been eliminated, constituting a second state (fig. 141; Mason 15, "second" and "third" states). The prints became darker with multiple printings, which accounts for the variance in their appearance (as noted by Mason), but, like the dark round spot on the building to the left in the later state (an accidental mark made during the printing), these differences do not constitute additional states.

Mother and Children
1916

Bellows probably included the first (fig. 142) and second (fig. 143; Mason 16) states of this print depicting his wife and daughters in the edition of 68. In the second state, Bellows redrew the head of his elder daughter, Anne, facing it inward, and added tusche lines to Emma's skirt. Scratched lines have been added throughout the upper portion of the image.

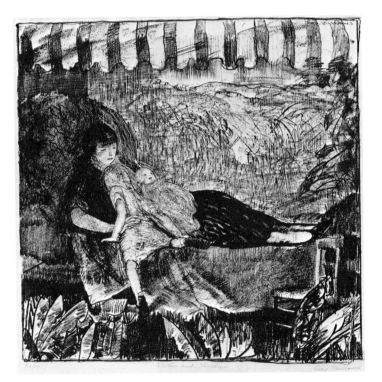

142.
Mother and Children,
first state, 1916
Lithograph
11³⁄₁₆ × 11³⁄₈ in.
Amon Carter Museum

143.
Mother and Children,
second state, 1916
Lithograph
11³⁄₁₆ × 11³⁄₈ in.
Amon Carter Museum;
Gift of H. V. Allison Galleries, Inc.,
New York

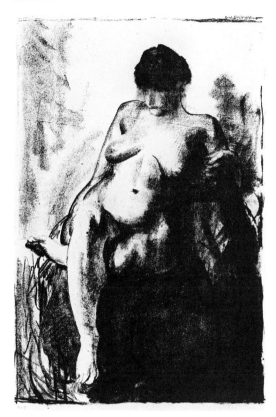

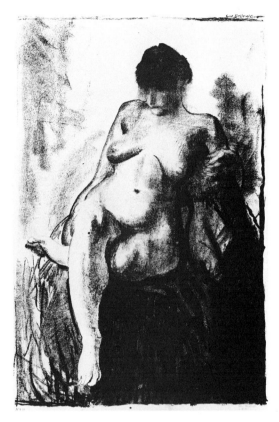

Nude Woman Seated
1916

The edition included at least two early states (figs. 144, 145), with tusche lines added in the lower right portion of the second variant. To a later version (fig. 146; Mason 7), the only state that bears Bellows' penciled signature, he added lines on and around the figure. The edition size for the three states combined is at least 11 (given in Mason as "unknown"), based on the numeration of one of the impressions in the Amon Carter Museum. (In the case of this print, Bellows does not seem to have numbered the impressions consecutively; the print representing the third state is inscribed "No. 1.") The print was not listed by Bellows in his record books.

144.
Nude Woman Seated,
first state, 1916
Lithograph
15 1/16 × 10 1/8 in.
Amon Carter Museum

145.
Nude Woman Seated,
second state, 1916
Lithograph
14 15/16 × 10 1/16 in.
Amon Carter Museum

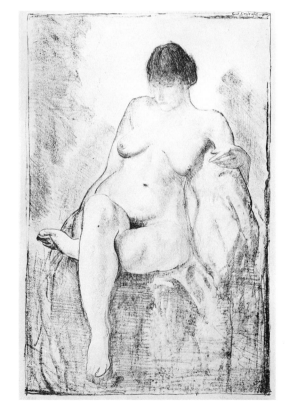

146.
Nude Woman Seated,
third state, 1916
Lithograph
15 × 10 3/16 in.
Amon Carter Museum

Nude Woman Standing, Side View
1916

Bellows numbered each print in the edition of 6, which included two states. After printing the first state (fig. 147), he added a border and additional shading (fig. 148; Mason 6).

Philosopher on the Rock
1916

To an early state of this print (fig. 149; Mason 29), Bellows added lines to the rocks at the right and to many of the figures, and changed details on some of the figures (fig. 150).

Prayer Meeting No. 1
1916 (Mason 13)
Illustrated fig. 39

Prayer Meeting No. 2
1916 (Mason 14)
Illustrated fig. 40

The edition size for *Prayer Meeting No. 2* is at least 47 (given in Mason as "unknown"), based on the numeration of an impression in the Albright-Knox Art Gallery. The edition size for *Prayer Meeting No. 1* of 77 (given in Mason) is based on the inscription on the Cleveland Museum of Art's print, "No 77 last print"; this edition size was listed in the artist's Record Book B, p. 106, for the print entitled "Prayer Meeting." It is possible (though somewhat unlikely) that Bellows included both versions of the print in a single edition, randomly assigning numbers to each version.

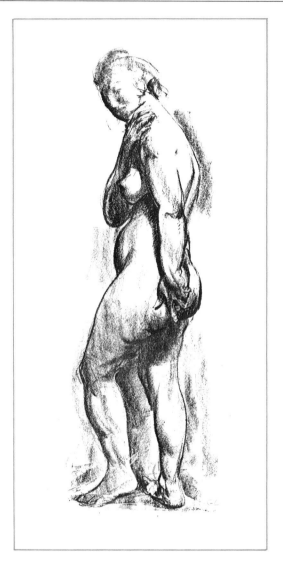

147.
Nude Woman Standing, Side View, first state, 1916
Lithograph
17½ × 6½ in.
Amon Carter Museum

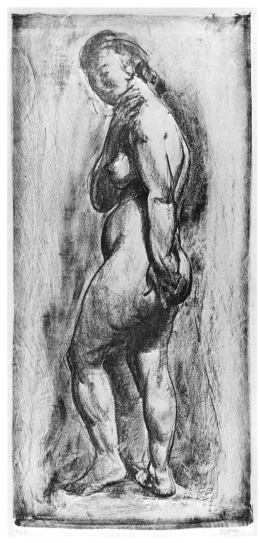

148.
Nude Woman Standing, Side View, second state, 1916
Lithograph
19 1/16 × 9¼ in.
Amon Carter Museum

149.
Philosopher on the Rock,
first state, 1916
Lithograph
19¹¹/₁₆ × 18⅞ in.
The Cleveland Museum of Art;
Gift of Leonard C. Hanna, Jr.

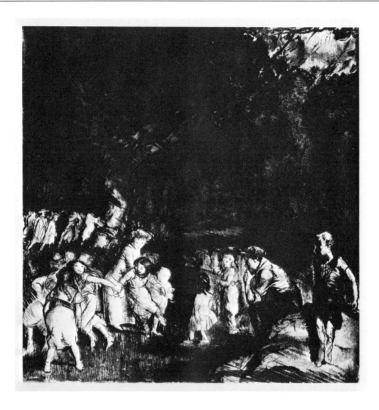

150.
Philosopher on the Rock,
second state, 1916
Lithograph
19¾ × 18⅞ in.
Amon Carter Museum

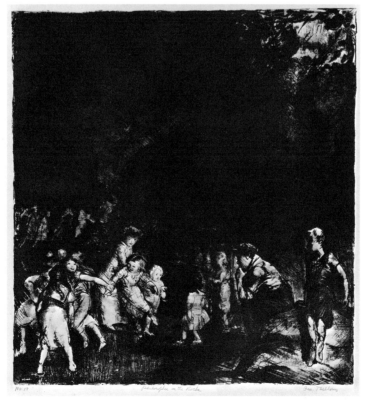

Preliminaries
1916 (Mason 24)
Illustrated fig. 36

On at least one impression of this print (Collection of Dr. and Mrs. Harold Rifkin), Bellows used a tint stone, adding brown shading to the black and white image.

"Prepare, America!"
1916 (Mason 34)
Not illustrated

The edition size for the print is at least 13 (given in the artist's Record Book B, p. 106, as "about 10" and in Mason as "10"), based on the numeration of an impression in the Boston Public Library, Print Department.

Reducing No. 1
1916 (Mason 21 as *Reducing, Large, First Stone*)
Illustrated fig. 16

Reducing No. 2
1916 (Mason 22 as *Reducing, Large, Second Stone*)
Illustrated fig. 17

Although the edition size of *Reducing No. 1* appears to have been quite small, the impression in the Boston Public Library, Print Department, is numbered "47," suggesting that Bellows may have arbitrarily numbered this print in the same edition as *Reducing No. 2.* Bellows listed only a single print with the title *Reducing* in his Record Book B (p. 106) for the year 1916, with an edition of 58.

Standing Nude Bending Forward
1916

After printing the first state of this print (fig. 151; Mason 4, first state), Bellows added contours around the figure, shaded passages, and his initials in the lower left corner of the stone (fig. 152). These two states constitute the working proofs for the print. Bellows then added a border and additional background shading (fig. 153; Mason "second" and "third" states). Mason's "third state" is actually a more darkly printed impression of her second state. The edition size for the print is at least 20 (given in Mason as "unknown"), based on the numeration of an impression in the estate. The print was not listed by Bellows in his record books.

The Studio
1916

Bellows' Christmas card (Mason 35) was also issued as a separate print in which the initials in the upper right corner were removed (fig. 119). The edition size for this print was not recorded in the artist's record book with the listing of the print (Record Book B, p. 106).

Training Quarters
1916 (Mason 23)
Illustrated fig. 35

The edition size for the print is at least 69 (given in Mason as "unknown"), based on the numeration of the impression in the Boston Public Library, Print Department. The edition size for the print was not recorded in the artist's record book with the listing of the print (Record Book B, p. 106).

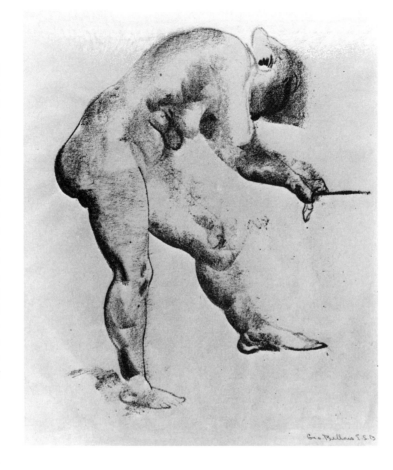

151.
Standing Nude Bending Forward, first state, 1916
Lithograph
11 1/16 × 9 7/16 in. (irreg.)
Boston Public Library,
Print Department;
Gift of Albert Henry Wiggin

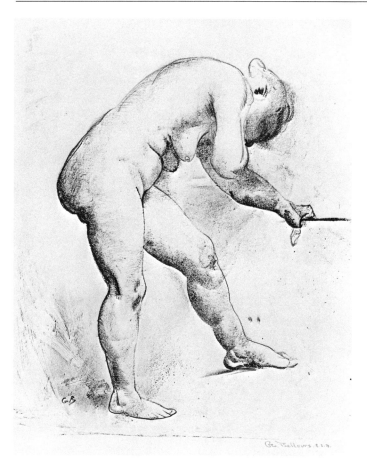

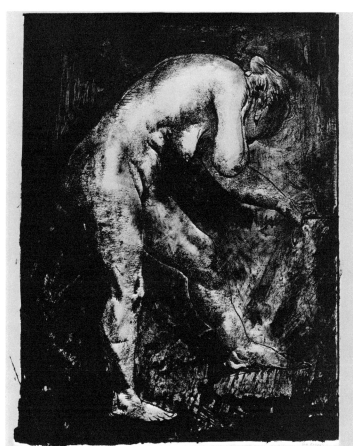

152.
*Standing Nude Bending
Forward*, second state, 1916
Lithograph
11⁷⁄₁₆ × 10¹¹⁄₁₆ in. (irreg.)
Amon Carter Museum

153.
*Standing Nude Bending
Forward*, third state, 1916
Lithograph
12¾ × 10⅛ in.
Amon Carter Museum

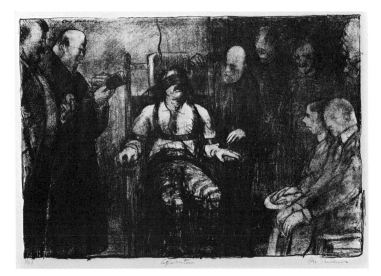

154.
Electrocution, first state, 1917
Lithograph
8⅛ × 11¹¹⁄₁₆ in.
Amon Carter Museum

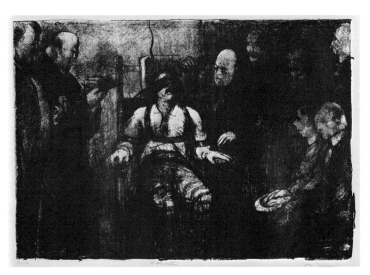

155.
Electrocution, second state,
1917
Lithograph
8³⁄₁₆ × 11¾ in.
Amon Carter Museum

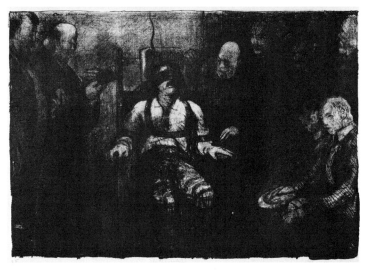

156.
Electrocution, third state,
1917
Lithograph
8³⁄₁₆ × 11¾ in.
Amon Carter Museum

157.
Electrocution, third state,
large detail, 1917
Lithograph
8⅛ × 7½ in.
Amon Carter Museum

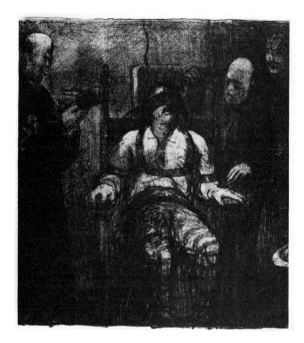

158.
Electrocution, third state,
small detail, 1917
Lithograph
8⅛ × 6 in.
Amon Carter Museum

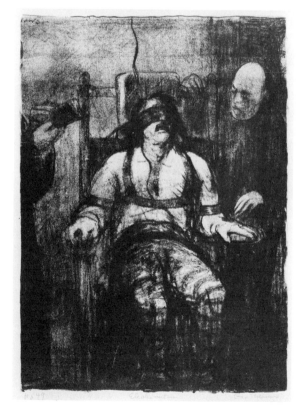

Dance in a Madhouse
1917 (Mason 49)
Illustrated fig. 27

The edition size for this print is
at least 77 (given as 69 in Mason
and in the artist's Record Book
B, p. 139), based on the numera-
tion of an impression in the col-
lection of Jean Bellows Booth.

Electrocution
1917

Five versions of this print com-
prise the edition of 51. To the
first state (fig. 154; Mason 42),
Bellows added lines to two
standing figures, second and
third from the right, to the
seated man lower right, and to
the man's head at the far left (fig.
155). In the third state, Bellows
added lines to the two seated fig-
ures on the right (fig. 156). The
print was then cut down to
create a detail of the third state
(fig. 157; given in Mason as "sec-
ond state"); this print was, in
turn, cut down to form yet a
smaller detail of the third state
(fig. 158).

The Life Class No. 1
1917

Previously thought to be Bellows' second lithographed version of the subject, this print was actually his first (see entry for *The Life Class No. 2,* 1919). Bellows lightened the first state of the print (fig. 159) by scraping away shaded areas on the nude figure (fig. 160; Mason 43). The first state was not part of the final edition of 49. The artist's inventory lists 69 impressions, suggesting that there were at least 20 impressions of the working proof or proofs.

The Model No. 1
1917 (Mason 39 as *The Model, First Stone*)
Not illustrated

The edition size for the print is at least 4 (given in Mason as "unknown"), based on the numeration of the impression in the Amon Carter Museum. No edition size is given with the listing for the print in the artist's Record Book B, p. 139.

Nude Woman Seated with Folded Hands
1917 (Mason 38)
Not illustrated

This is the print listed in the artist's Record Book B, p. 139, as *Life Study.* Bellows did not cite an edition size for this print. The Amon Carter Museum and the Boston Public Library, Print Department, have impressions of the print (nos. 6 and 2, respectively). The artist's inventory lists 10 impressions of "Life Study, Nude Woman Seated," of which five remain in the artist's estate.

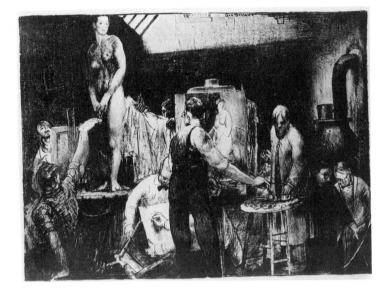

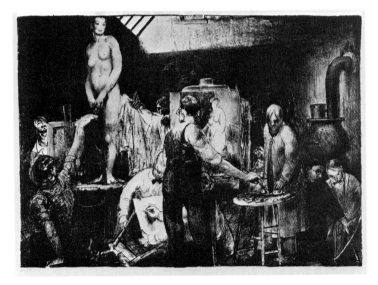

159.
The Life Class No. 1,
first state, 1917
Lithograph
13 15/16 × 19 7/16 in.
The Metropolitan Museum of Art;
Purchase, Gift of the Charles Z.
Offin Art Fund, 1978

160.
The Life Class No. 1,
second state, 1917
Lithograph
13 7/8 × 19 3/8 in.
Amon Carter Museum

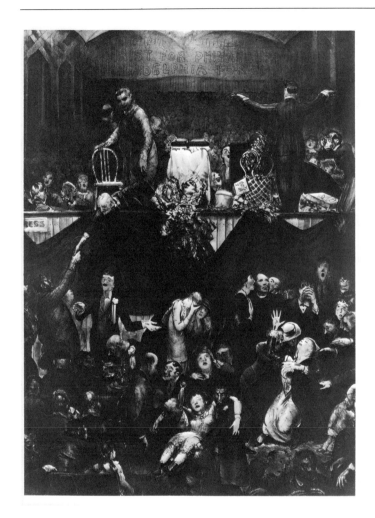

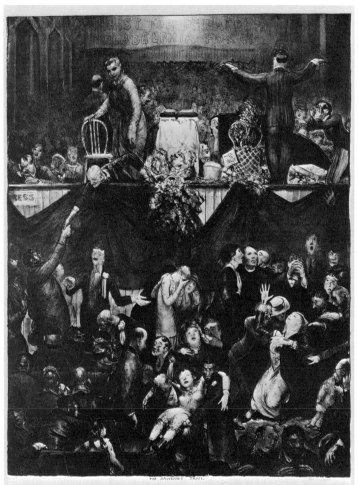

161.
The Sawdust Trail,
first state, 1917
Lithograph
26¾ × 19⅞ in.
Columbus Museum of Art,
Columbus, Ohio;
Gift of Jeffrey Shedd

162.
The Sawdust Trail,
second state, 1917
Lithograph
25½ × 20 in.
Amon Carter Museum

The Sawdust Trail
1917

The edition of 65 included two states of this print. The first state (fig. 161; Mason 48) was cut down, eliminating the ceiling elements at the top of the composition (fig. 162).

176

The Shower Bath
1917

The edition of 36 (as recorded in the artist's Record Book B, p. 139) included three states. The first state (fig. 163; Mason 45) may be identified by the black mustache of the central figure. In the second state (fig. 164), Bellows scraped away the ink in the area of the mustache. He then cut down the image, adding a border on the left edge and his signature in the upper left corner (fig. 165).

The Bacchanale
1918

At least two working proofs were made of this image. To the earlier proof (fig. 166), Bellows added shading throughout (fig. 167). He then redrew the image on a second stone (fig. 168), changing many of the details. The impression of this state in the Amon Carter Museum bears the numeration "No 67" and was not signed by the artist. In the final print (fig. 169; Mason 58), Bellows redrew the head of the soldier in the right middle ground, added a head to the left of the standing figure holding a bayonet, added lines to the sky and to the building at the left of the composition, and added shading throughout.

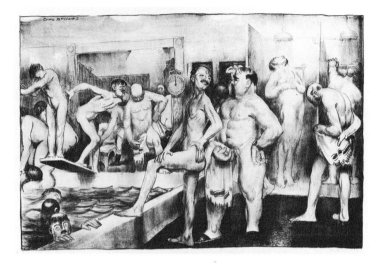

163.
The Shower Bath,
first state, 1917
Lithograph
16 1/16 × 23 7/8 in.
Amon Carter Museum

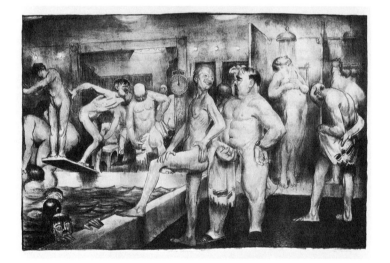

164.
The Shower Bath,
second state, 1917
Lithograph
16 1/16 × 23 7/8 in.
Amon Carter Museum

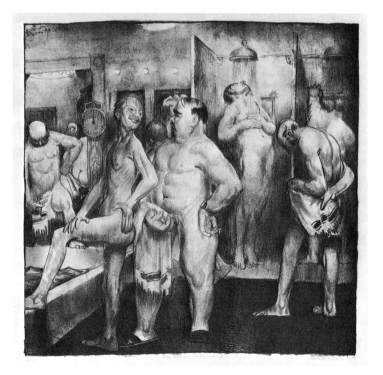

165.
The Shower Bath,
third state, 1917
Lithograph
15 7/8 × 16 3/8 in.
Amon Carter Museum

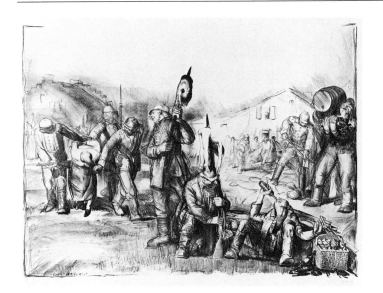

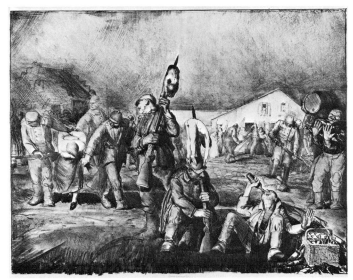

166.
The Bacchanale,
working proof, 1918
Lithograph
18¼ × 24⁷⁄₁₆ in.
Amon Carter Museum;
Gift of H. V. Allison Galleries, Inc.,
New York

167.
The Bacchanale,
working proof, 1918
Lithograph
18⅛ × 24½ in.
Amon Carter Museum;
Gift of H. V. Allison Galleries, Inc.,
New York

168.
The Bacchanale,
first state, 1918
Lithograph
18⅝ × 24⅛ in.
Amon Carter Museum;
Gift of H. V. Allison Galleries, Inc.,
New York

169.
The Bacchanale,
second state, 1918
Lithograph
18⅝ × 24⅜ in.
Amon Carter Museum

Gott Strafe
1918

The first state of this print (fig. 170) includes the title "Gott Strafe England" inscribed on the stone, lower center. In the second state (fig. 171; Mason 55), the title has been removed. The edition size for the print is at least 60 (given in Mason as "possibly 50"), based on the numeration of the impression in the Cleveland Museum of Art.

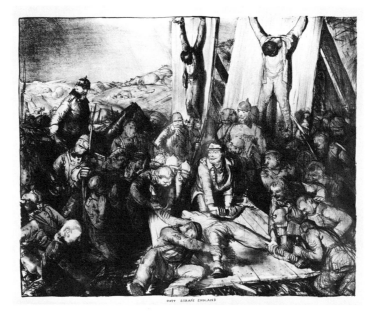

170.
Gott Strafe,
first state, 1918
Lithograph
16⁹⁄₁₆ × 18¹³⁄₁₆ in.
Amon Carter Museum

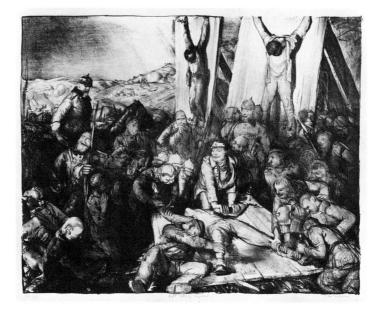

171.
Gott Strafe,
second state, 1918
Lithograph on chine collé,
15³⁄₁₆ × 19 in.
Amon Carter Museum

172.
Murder of Edith Cavell,
working proof, 1918
Lithograph
19 × 24 11/16 in.
Amon Carter Museum

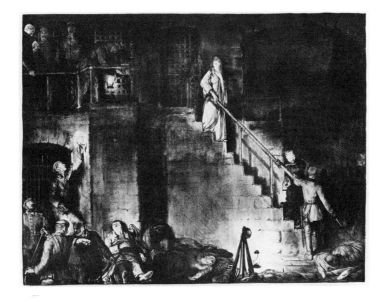

173.
Murder of Edith Cavell,
working proof, 1918
Lithograph
19 × 24 5/8 in.
Amon Carter Museum

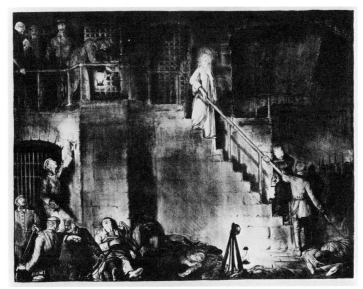

174.
Murder of Edith Cavell,
working proof, 1918
Lithograph
19 × 24 5/8 in.
Amon Carter Museum

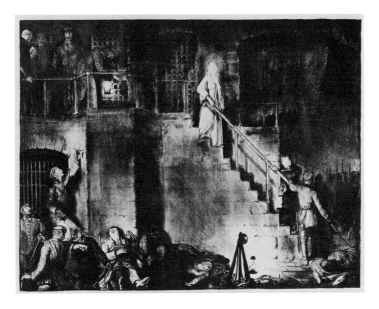

Murder of Edith Cavell
1918

Bellows made at least seven
states of this print, six of them
working proofs, each with a
slightly different rendering for
the head of Edith Cavell. The
states that preceded the edition,
for which the precise sequence is
uncertain (figs. 172–177), are
marked with an "X," Bellows'
designation for a working proof.
A single state was signed by the
artist (fig. 178; Mason 53) and
numbered. An impression in the
artist's estate bears the inscrip-
tion "no. 103 Last print" (edi-
tion size given by Mason as 99).

Return of the Useless
1918 (Mason 67)
Not illustrated

The edition size is larger than
that given by Mason ("possibly
50"). The Amon Carter Mu-
seum's impression is numbered
72, and there were 64 prints
remaining in the inventory of
the artist's prints following his
death.

Hail to Peace
1919 (Mason 68)
Not illustrated

This print is listed in the artist's
Record Book B, p. 195, under
"Lithographs for 1919" (given in
Mason as 1918) with an edition
size of 100.

The Life Class No. 2
1919 (Mason 8 as *The Life Class,
First Stone*)
Not illustrated

Dated c. 1916 by Mason, this
print, a unique proof, can now
be identified as the print Bel-
lows made with Bolton Brown
at a demonstration at Pratt In-
stitute in 1919. (See pp. 73–74.)

The Sand Team
1919 (Mason 69)
Not illustrated

This print is listed in the artist's Record Book B, p. 195, under "Lithographs for 1919" (given in Mason as c. 1919). Bellows noted the edition size as 3 or 4 and that the print was "destroyed."

Tennis
1920 (Mason 71)
Illustrated fig. 59

The Tournament
1920 (Mason 72)
Not illustrated

These prints are listed, each with an edition size of 63, in the artist's Record Book B, p. 195, under the heading "Lithographs 1920" (given in Mason as c. 1921). The entry notes that they were produced in March of that year.

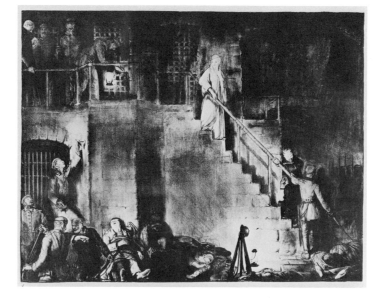

175.
Murder of Edith Cavell, working proof, 1918
Lithograph
19 × 24⅝ in.
Amon Carter Museum

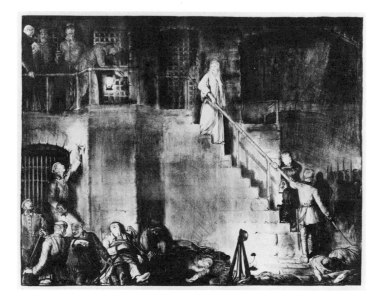

176.
Murder of Edith Cavell, working proof, 1918
Lithograph
19 × 24⅝ in.
Amon Carter Museum

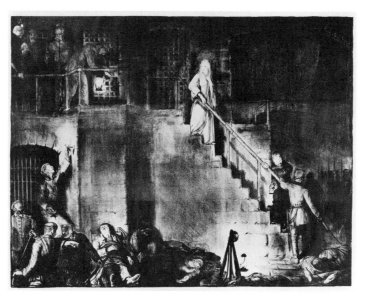

177.
Murder of Edith Cavell, working proof, 1918
Lithograph
19 × 24⅝ in.
Amon Carter Museum

178.
Murder of Edith Cavell,
final state, 1918
Lithograph
19 × 24 13/16 in.
Amon Carter Museum

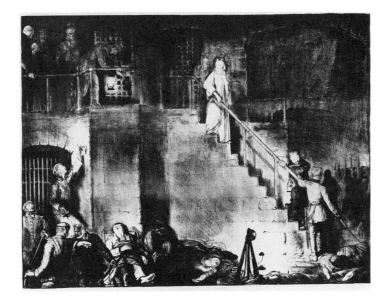

179.
The Case of
Sergeant Delaney No. 1, 1921
Lithograph
17 1/16 × 25 in.
Amon Carter Museum

180.
The Case of
Sergeant Delaney No. 2, 1921
Lithograph
17 5/16 × 25 1/16 in.
Amon Carter Museum

The Case of Sergeant
Delaney No. 1
The Case of Sergeant
Delaney No. 2
1921

Bellows produced two prints of
this subject, both listed in his
Record Book B, p. 253, with
lithographs produced in Janu-
ary–March 1921, as "The Inci-
dent of Delaney I for US Navy
large destroy" and "Delaney II
OK USN large." The latter
print is probably that signed by
Bolton Brown (fig. 180; Mason
99). The technical character of
the other print (fig. 179), which
includes a white cap in the right
foreground and other figural
differences, suggests that it was
not printed by Bolton Brown.[4]
There are 43 impressions of *The*
Case of Sergeant Delaney No. 1 re-
maining in the artist's estate.

4. I am grateful to Clinton
Adams for this observation.

Four Friends
1921

The state with the dark background (fig. 181, edition 17) precedes the state with the blank background (fig. 182, edition 13). (Mason switched the order; see pp. 142–143.) The artist's Record Book B, p. 252, establishes this sequence, listing the print "Four Artists" followed by "Four Artists same without background." Bellows cut around the figures, eliminating the background; the shadow of his initials in the lower right portion of the stone is still visible in the second state.

Introducing Georges Carpentier
1921 (Mason 98)
Illustrated fig. 80

Bellows listed this print in his Record Book B, p. 259, for July 1921 with an edition of "50 proofs" (given in Mason as "possibly 50").

Speicher Seated in a Chair
1921 (Mason 191)
Not illustrated

The dimensions of this lithograph correspond with those of a print Bellows listed in his Record Book B, p. 253, for January–March 1921 (given in Mason as 1923–24) as "Portrait of Eugene Speicher."

Portrait of Mrs. R.
1922 (Mason 131)
Not illustrated

Bellows recorded this print in his Record Book B, p. 270, for 1922 (given in Mason as c. 1923), with an edition of 40 (given in Mason as "unknown").

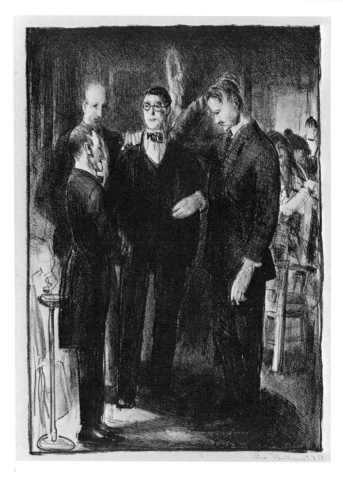

181.
Four Friends, first state, 1921
Lithograph
10 1/16 × 7 5/16 in.
Amon Carter Museum

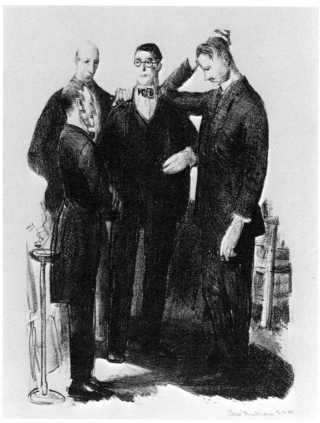

182.
Four Friends, second state, 1921
Lithograph
9 × 6 3/4 in.
Amon Carter Museum

183.
The Drunk No. 1, 1923–24
Lithograph
15¹⁵⁄₁₆ × 13¹⁄₁₆ in.
Amon Carter Museum

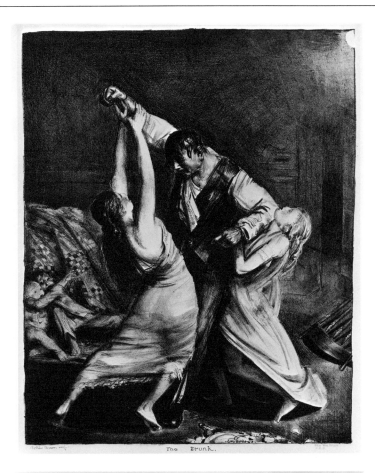

184.
The Drunk No. 2, 1923–24
Lithograph
15¾ × 13 in.
Amon Carter Museum

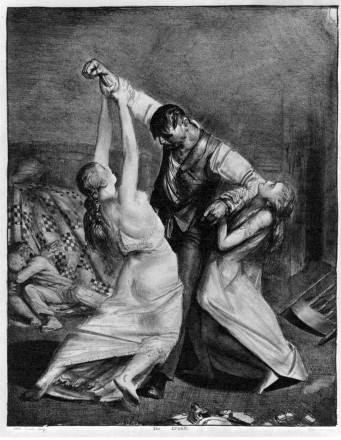

Study of B. P.

1923 (Mason 133)
Not illustrated

Bellows listed an edition of 49 (given in Mason as 41) for this print in his Record Book B, p. 294.

The Drunk No. 1
The Drunk No. 2
1923–24

Bellows executed two prints of this subject, listed in the artist's Record Book C, p. 9, as "The Drunk," with an edition of 35 (fig. 183), and "The Drunk (second stone)," with an edition of 50 (fig. 184; Mason 169). In redrawing the image, the artist made a number of alterations in the composition, most notably to the two children, the quilt, and the hair and clothing of the woman on the left.

Nude Study, Woman Lying Prone
1923–24 (Mason 174)
Not illustrated

The artist's Record Book C, p. 9, lists an edition size of 38 for this print (given in Mason as 39).

Head of Gregory

1924 (Mason 189)
Not illustrated

The artist recorded this print in his Record Book C, p. 10, as *Portrait of Master Gregory* under the year 1924 (given in Mason as 1923–24).

Portrait of Eugene Speicher No. 2

1924 (Mason 193 as *Portrait of Eugene Speicher, Second Stone*)
Not illustrated

Bellows lists "Portrait Eugene Speicher" [*Portrait of Eugene Speicher No. 1*] in his Record Book C, p. 9, under "WINTER 1923 1924" and "Eugene Speicher second stone" in Record Book C, p. 10, under 1924 (given by Mason as 1923–24).

Portrait of Mrs. Herb Roth

1924 (Mason 188)
Not illustrated

The artist recorded this print in his Record Book C, p. 10, under the year 1924 (given in Mason as 1923–24).

Exhibitions in which George Bellows' prints appeared, 1916–1925

The number of Bellows lithographs is listed for each exhibition, where known, along with reviews that mention Bellows.

Exhibition of Lithographs, Frederick Keppel & Company, New York, April 27–May 20, 1916: 7 lithographs

> "At the Art Galleries," *New York Evening Post Saturday Magazine*, May 6, 1916

> "Sketches and Prints in Many Exhibitions," *New York Times Magazine*, May 14, 1916

Paintings, Lithographs, Drawings and Etchings by George Bellows, Milch Gallery, New York, March 13–24, 1917: 27 lithographs

> "At the Art Galleries," *New York Evening Post Saturday Magazine*, March 17, 1917

> "News and Comment in the World of Art," *New York Sun*, March 18, 1917

> *New York Herald*, March 18, 1917

First Annual Exhibition of the Society of Painter-Gravers, 26 West 58th Street, New York, March 27–April 28, 1917: 6 lithographs

> "New Group of Artists to Uplift Print Art," *New York Evening Post*, March 21, 1917

> "Painter-Gravers' Aim Is to Cultivate American Taste for Graphic Art," *New York Times*, March 25, 1917

> "Painter-Gravers Hold Their First Annual Exhibition," *New York Herald*, March 27, 1917

> "At the Art Galleries," *New York Evening Post Saturday Magazine*, March 31, 1917

> "Painter-Gravers of America Exhibit Prints," *New York Times*, April 1, 1917

> "Painter-Gravers Display Their Art," *New York Sun*, April 2, 1917

> "Their First Exhibition," *The National Lithographer*, April 1917

> "The Show of the Painter-Gravers," *Vanity Fair*, May 1917

> "The Personal Accent in American Art Today," unidentified clipping by Royal Cortissoz, New York Public Library

Catalogue of Paintings by the Painter Friends, English and American Gardens by A.C. Wyatt, Paintings by Robert Spencer, Thumb-Box Sketches and Drawings by Oscar Fehrer and Lithographs by George Bellows, Memorial Art Gallery, Rochester, New York, April 1917: 32 lithographs

First Annual Exhibition, Print Club of Philadelphia, May 12–19, 1917: 6 lithographs

Second Annual Exhibition of the Society of Painter-Gravers, Milch Gallery, New York, December 10–31, 1917: 3 lithographs

> "Haskell Prints a Feature of Painter-Gravers Exhibition," *New York Herald*, December 15, 1916

> "News and Comment in the World of Art," *New York Sun*, December 16, 1917

> "Art Notes," *New York Evening Post*, December 19, 1917

New York in the Graphic Arts, Frederick Keppel & Company, New York, February 14–March 2, 1918: 3 lithographs

> "Galleries Display Great Variety of New Art," *New York Herald*, February 17, 1918

The Making of a Lithograph, New York Public Library, May–October 1918

> "Views and Reviews in the World of Art," *New York Sun*, April 28, 1918

Drawings and Lithographs of War Work by Vernon Howe Bailey and War Paintings and Lithographs by George Bellows, Art Association, Newport, Rhode Island, August 31–September 7, 1918

> "Newport (R.I.)," *American Art News*, September 14, 1918

Exhibition of Lithographs by George Bellows, Frederick Keppel & Company, New York, November 7–23, 1918: 54 lithographs

> "In and About the Art Galleries," *New York Evening Post Magazine*, October 26, 1918

> "George Bellows' Work on Exhibition," *New York Times*, November 10, 1918

> "Lithographs of War by George Bellows," *New York Herald*, November 17, 1918

> "Lithographs and War Zone Graphics," *Christian Science Monitor*, November 18, 1918

> "Art Notes," *Touchstone*, January 1919

Exhibition of War Prints, Philadelphia Print Club, 1919(?)

Exhibition of Original Lithographs by George Bellows, Albert Roullier Art Galleries, Chicago, January 6–20, 1919: 48 lithographs

"George Bellows, N.A.," *Chicago Evening Post*, January 7, 1919

"Among the Dealers," *Chicago Evening Post*, January 14, 1919

"Horrors of the War Depicted by Artist," *Chicago Daily News*, January 15, 1919

Exhibition of Original Lithographs by George Bellows, Doll & Richards Gallery, Boston, January 9–21, 1919

"Huns Depicted Vividly," *Boston Evening Transcript*, January 13, 1919

Third Annual Exhibition of the Society of Painter-Gravers, Art Alliance of America, New York, March 8–29, 1919: 3 lithographs

"Among the Art Galleries," *New York Evening Post Magazine*, March 15, 1919

"Art at Home and Abroad," *New York Times Magazine*, March 16, 1919

"Work of the Painter-Gravers of America," *New York Sun*, March 16, 1919

"Among the Art Galleries," *New York Evening Post Magazine*, March 22, 1919

"Painter-Gravers of America Have Excellent Show," *New York Herald*, March 24, 1919

Fourth Annual Exhibition of the Society of Painter-Gravers, Anderson Galleries, New York, April 1–17, 1920: 2 lithographs

Exhibition of Lithographs Made Between 1820 and 1920, M. Knoedler & Company, New York, September 17–October 17, 1920

"A Century of Lithography," *Christian Science Monitor*, October 4, 1920

"Studio and Gallery," *New York Sun*, October 9, 1920

First Retrospective Exhibition of American Art, Junior Art Patrons of America (Marie Sterner), Fine Arts Building, New York, May 8–21, 1921: 16 lithographs

"American Art," *Detroit News*, May 22, 1921

Exhibition of Original Lithographs by George Bellows, Frederick Keppel & Company, New York, May 5–June 4, 1921: 50 lithographs

"The World of Art," *New York Times Book Review and Magazine*, May 1, 1921

"Among the Art Galleries," *New York Evening Post*, May 7, 1921

"Notes and Activities in the World of Art," *New York Herald*, May 8, 1921

"Studio and Gallery," *New York Sun*, May 14, 1921

"Bellows's Progress in Lithography," *New York Herald*, May 15, 1921

Arts, May 1921

Paintings and Drawings by George Bellows, Montross Gallery, New York, December 3–31, 1921: 40 lithographs were later added to the exhibition

Arts, November 1921

"Studio and Gallery," *New York Sun*, December 10, 1921

"Recent Portraits and Landscapes by Bellows," *New York Herald*, December 11, 1921

"Among the Galleries," *New York Evening Post*, December 17, 1921

New York Sun, December 17, 1921

Lithographs by George W. Bellows, Corcoran Gallery of Art, Washington, D. C., November 1–22, 1922

Fourth Annual Exhibition of the New Society of Artists, Anderson Galleries, New York, January 2–27, 1923

"New Society of Artists Show Conservative Radical Elements in American Art," *Brooklyn Daily Eagle*, January 7, 1923

New York Evening Post, January 20, 1923

"Give Art Demonstration," *New York Times*, January 23, 1923

Arts, January 1923

Lithographs by George Bellows, White Gallery (Z.L. White Department Store), Columbus, Ohio, February 1923

"Palette and Brush," *Columbus Dispatch*, February 18, 1923

"Bellows Pictures His Jean," *Columbus Dispatch*, February 25, 1923

Fifth Annual Exhibition of the New Society of Artists, Anderson Galleries, New York, January 3 through the end of the month, 1924: 2 lithographs

"New Society Exhibitors Not a Clique, but Group of Personalities," *Brooklyn Daily Eagle*, January 6, 1924

"George Bellows's Crucifixion Is Sensation of the Exhibition," *New York Herald,* January 6, 1924

"Lithographs," *New York Times*, February 17, 1924

Exhibition of the Society of Illustrators, Art Center, New York, January 20–February 3, 1924: 2 lithographs

"Lithographs," *New York Times*, February 17, 1924

Exhibition of Lithographs and Paintings by George Bellows, Frank K.M. Rehn Gallery, New York, January 28–at least February 16, 1924

"Notes on Current Art Shows," *Sun and the Globe*, January 26, 1924

"Exhibition by George Bellows," *New York Evening Post*, February 2, 1924

"Bellows Shows His Paintings at Rehn's," *World*, February 3, 1924

"The Versatility of George Bellows," *Brooklyn Daily Eagle*, February 3, 1924

"Varied Attractions in the Art Galleries," *New York Herald*, February 3, 1924

"Art at the Dealers' Galleries," *Sun and the Globe*, February 8, 1924

"George Bellows' New York Show," *Christian Science Monitor*, February 11, 1924

"Two Shows by Bellows at the Same Time," *New York Evening Post*, February 16, 1924

Recent Lithographs by George Bellows, Marie Sterner Gallery, New York, February 1–March 1, 1924: 50 lithographs

"Two Shows by Bellows at the Same Time," *New York Evening Post*, February 16, 1924

"George Bellows' Lithographs," *Art News*, February 16, 1924

"Lithographs by George Bellows," *Brooklyn Daily Eagle*, February 17, 1924

"Dempsey-Firpo Lithograph Attracts Art Collectors," *New York Herald*, February 17, 1924

Sun and the Globe, February 25, 1924

"New Bellows Lithographs," *Christian Science Monitor*, February 27, 1924

Exhibition of American Art, Chambre Syndicale de la Curiosité et des Beaux Arts under the auspices of The Art Patrons of America, Paris, June 9–July 5, 1924: 12 lithographs

Exhibition of Lithographs and Drawings by George Bellows, Frederick Keppel & Company, New York, March 24–April 25, 1925: 159 lithographs

"Lithographs by George Bellows Grouped for Exhibition," *New York Evening Post*, March 28, 1925

"Bellows Lithographs on View," *New York Sun*, March 28, 1925

"Vivid Black and Whites by Bellows," *World*, March 29, 1925

"Bellows's Lithographs," *New York Times*, March 29, 1925

"Few but Diverse Exhibitions Mark Easter Season," *Brooklyn Daily Eagle*, March 29, 1925

"A Bellows Memorial," *Arts*, May 1925

Vanity Fair, July 1925 and August 1925

"Lithographs by Bellows and Etchings by Rembrandt," unidentified clipping from 1925, New York Public Library artist files

George Bellows Lithographs, Detroit Institute of Arts, April 1925: 50 lithographs

Detroit News, April 5, 1925

Special Exhibition of Lithographs, Wood Blocks and Linoleum Cuts, National Arts Club, New York, April 8–May 9, 1925: 14 lithographs

"Random Impressions in Current Exhibitions," *New York Herald Tribune*, April 12, 1925

"National Arts Club," *New York Evening Post*, April 18, 1925

Lithographs by George Bellows, Boston Art Club, October 1925

"Sermons, Ironies, Humors in Bellows's Lithograph," *Boston Evening Transcript*, October 10, 1925

Paintings and Lithographs by George Wesley Bellows, Marie Sterner Gallery, New York, October 1925: "an almost complete set of lithographs"

"Mrs. Sterner Has a Bellows Show," *Art News*, October 17, 1925

Woodblock Prints by Elizabeth Keith and Lithographs by George Bellows, Columbus (Ohio) Gallery of Fine Arts, October 4–28, 1925: 47 lithographs

"Gallery Reopens," *Columbus Dispatch*, October 4, 1925

"George Bellows, the Artist with a Punch," *Columbus Citizen*, October 7, 1925

"Bellows Lithographs to Stay Four Days," *Columbus Dispatch*, October 24, 1925

Memorial Exhibition of the Work of George Bellows, Metropolitan Museum of Art, New York, October 12–November 22, 1925: 59 lithographs

"Metropolitan Arranges Bellows Memorial," *New York Evening Post*, October 10, 1925

"The George Bellows Memorial Exhibition," *Brooklyn Daily Eagle*, October 11, 1925

"Paintings and Prints by George Bellows," *New York Herald Tribune*, October 11, 1925

"The World of Art: The Bellows Show," *New York Times Magazine*, October 11, 1925

"Exhibit Honors George Bellows, Native Painter," *New York Herald Tribune*, October 13, 1925

"Bellows Art Exhibit Opens," *New York Sun*, October 13, 1925

"Bellows Memorial Exhibit at Museum," *Art News*, October 17, 1925

"Art Season Starts Vigorously," *New York Sun*, October 17, 1925

"The Bellows Memorial Exhibition," *Christian Science Monitor*, October 19, 1925

"Youthful Admiration for Bellows," *New York Sun*, October 24, 1925

"George Bellows," *New Republic*, October 28, 1925

"George W. Bellows Takes His Place with the Old Masters," *American Art Student*, October 1925

"George Bellows—An Appreciation," *Arts & Decoration*, October 1925

"Bellows and His Critics," *Arts*, November 1925

"The Bellows Memorial Exhibition," *American Magazine of Art*, December 1925

The New Yorker, 1925, unidentified clipping

(Versions of this show traveled in 1925–27 to Rochester, Buffalo, Cleveland, San Diego, St. Louis, and Baltimore.)

Lithographs by George Bellows, Women's City Club, New York, November 1925

The checklist is arranged in chronological order. All dimensions are given in inches; height precedes width. All print dimensions represent the image size. Those prints not signed by the artist himself were generally signed and initialed by Emma Story Bellows ("E.S.B."). The "Mason" numbers are those given in Lauris Mason, assisted by Joan Ludman, *The Lithographs of George Bellows: A Catalogue Raisonné* (Millwood, N.Y.: KTO Press, 1977). All works in the exhibition are in the collection of the Amon Carter Museum.

1. *Artists' Evening*, 1916 (MASON 19)
Lithograph on wove paper
8¾ × 12³⁄₁₆ in. (22.2 × 31.0 cm.)
Signed beneath image, in graphite, l.r.: "Geo Bellows"
Inscribed beneath image, in graphite, l.l.: "No 44", l.c.: "Artists' Evening."
[fig. 51]

2. *Benediction in Georgia*, 1916 (M. 12)
Lithograph on wove paper
16⅛ × 19¹⁵⁄₁₆ in. (41.0 × 50.7 cm.)
Signed beneath image, in graphite, l.r.: "Geo Bellows"
Inscribed on stone, l.l.: "Geo[heavily inked]", l.r.: "GEO. Bellows"
Inscribed beneath image, in graphite, l.l.: "No 60", l.c.: "Benediction in Georgia."
[fig. 46]

3. *Between Rounds No. 1*, 1916 (M. 25)
Lithograph on wove paper
20⅝ × 16⁹⁄₁₆ in. (52.4 × 42.1 cm.)
Signed beneath image, in graphite, l.r.: "Geo Bellows"
Inscribed on stone, l.r.: "Geo. Bellows"
Inscribed beneath image, in graphite, l.l.: "No 39", l.c.: "Between Rounds 1"
[fig. 34]

4. *Business-Men's Class*, 1916 (M. 20)
Lithograph on wove paper
11½ × 17¼ in. (29.2 × 43.8 cm.)
Signed beneath image, in graphite, l.r.: "Geo Bellows."
Inscribed beneath image, in graphite, l.l.: "No 63", l.c.: "Business Men's Class."
[fig. 14]

5. *In the Park, Dark*, 1916 (M. 30)
Lithograph on wove paper
17¹⁄₁₆ × 21⅜ in. (43.3 × 51.8 cm.)
Signed beneath image, in graphite, l.r.: "Geo Bellows."
Inscribed on stone, l.l.: "Geo Bellows"
Inscribed beneath image, in graphite, l.l.: "No 11", l.c.: "In the Park"
[fig. 23]

6. *In the Park, Light*, 1916 (M. 31)
Lithograph on wove paper
16⅛ × 21⁵⁄₁₆ in. (41.0 × 54.1 cm.)
Signed beneath image, in graphite, l.r.: "Geo Bellows"
Inscribed on stone, l.l.: "Geo Bellows"
Inscribed beneath image, in graphite, l.l.: "No 37", l.c.: "In the Park"
[fig. 24]

7. *Introducing John L. Sullivan*, 1916 (M. 27)
Lithograph on wove paper
21⅝ × 20½ in. (54.9 × 52.1 cm.)
Signed beneath image, in graphite, l.r.: "Geo Bellows"
Inscribed on stone, l.r.: "Geo Bellows"
Inscribed beneath image, in graphite, l.l.: "No 18", l.c.: "Introducing John L. Sullivan."
[fig. 121]

8. *The Jury*, third state, 1916 (M. 17)
Lithograph on laid paper
12³⁄₁₆ × 16⅜ in. (31.0 × 41.6 cm.)
Signed beneath image, in graphite, l.r.: "Geo Bellows"
Inscribed on stone, c.l.: "Geo Bellows / 146 E 19 ST / NY"
Inscribed beneath image, in graphite, l.l.: "No 35", l.c.: "Jury Duty / The Jury"
[fig. 48]

9. *Mother and Children*, 1916 (M. 16)
Lithograph on wove paper
11³⁄₁₆ × 11⅜ in. (28.4 × 28.9 cm.)
Signed beneath image, in graphite, l.r.: "Geo Bellows"
Inscribed on stone, u.r.: "Geo Bellows"
Inscribed beneath image, in graphite, l.l.: "No 3", l.c.: "Mother and Children"
[fig. 90]

10. *The Old Rascal*, 1916 (M. 11)
Lithograph on wove paper
10⅛ × 8¹⁵⁄₁₆ in. (25.7 × 22.7 cm.)
Signed beneath image, in graphite, l.r.: "Geo Bellows"
Inscribed on stone, u.r.: "GB"
Inscribed beneath image, in graphite, l.l.: "No 9", l.c.: "The old rascal"
[fig. 5]

11. *Philosopher on the Rock*, 1916 (M. 29)
Lithograph on wove paper
19¾ × 18⅞ in. (50.2 × 47.9 cm.)
Signed beneath image, in graphite, l.r.: "Geo Bellows"
Inscribed on stone, l.r.: "Geo Bellows"
Inscribed beneath image, in graphite, l.l.: "No 19.", l.c.: "Philosopher on the Rock"
[fig. 21]

12. *Prayer Meeting No. 2*, 1916 (M. 14)
Lithograph on chine collé on wove paper
18⁵⁄₁₆ × 22¼ in. (46.5 × 56.5 cm.)
Signed beneath image, in graphite, l.r.: "Geo Bellows"
Inscribed on stone, l.r.: "Geo Bellows"
Inscribed beneath image, in graphite, l.l.: "No 40", l.c.: "Prayer Meeting"
[fig. 40]

13. *Preliminaries*, 1916 (M. 24)
Lithograph on wove paper
15 13/16 × 19 3/4 in. (40.2 × 50.2 cm.)
Signed beneath image, in graphite, l.r.:
"Geo Bellows"
Inscribed beneath image, in graphite, l.l.:
"No 16", l.c.: "Preliminaries"
[fig. 36]

14. *Splinter Beach*, 1916 (M. 28)
Lithograph on laid paper
15 1/16 × 19 7/8 in. (38.3 × 50.5 cm.)
Signed beneath image, in graphite, l.r.:
"Geo Bellows"
Inscribed on stone, on tugboat: "Geo Bellows"
Inscribed beneath image, in graphite, l.l.:
"No 45", l.c.: "Splinter Beach"
[fig. 29]

15. *The Studio*, 1916 (M. 35)
Lithograph on laid paper
5 1/2 × 4 5/16 in. (14.0 × 11.0 cm.)
Inscribed on stone, l.l.: "Geo Bellows"
Inscribed beneath image, in graphite, l.r.:
"Geo Bellows / ESB. 47"
[fig. 119]

16. *Dance in a Madhouse*, 1917 (M. 49)
Lithograph on chine collé on wove paper
18 3/8 × 24 7/16 in. (46.7 × 62.1 cm.)
Signed beneath image, in graphite, l.r.:
"Geo Bellows"
Inscribed on stone, l.c.: "Geo Bellows"
Inscribed beneath image, in graphite, l.l.:
"No 68", l.c.: "Dance in a Mad House"
[fig. 27]

17. *Electrocution*, first state, 1917 (M. 42)
Lithograph on wove paper
8 1/8 × 11 11/16 in. (20.6 × 29.7 cm.)
Signed beneath image, in graphite, l.r.:
"Geo Bellows"
Inscribed on stone, u.l.: "Geo Bellows"
Inscribed beneath image, in graphite, l.l.:
"No 1", l.c.: "Execution"; in graphite, l.l.:
"Only proof—will possibly get better ones of
this [crossed out]"
[fig. 47]

18. *Initiation in the Frat*, 1917 (M. 44)
Lithograph on wove paper
10 1/16 × 12 11/16 in. (25.6 × 32.2 cm.)
Signed beneath image, in graphite, l.r.:
"Geo Bellows"
Inscribed on stone, u.r.: "Geo Bellows"
Inscribed beneath image, in graphite, l.l.:
"No 14", l.c.: "Initiation in the Frat"
[fig. 62]

19. *The Life Class No. 1*, second state, 1917 (M. 43)
Lithograph on laid paper
13 7/8 × 19 3/8 in. (35.3 × 49.2 cm.)
Signed beneath image, in graphite, l.r.:
"Geo Bellows"
Inscribed on stone, u.c.: "Geo Bellows"
Inscribed beneath image, in graphite, l.l.:
"No 23", l.c.: "The Life Class"
[fig. 116]

20. *The Sawdust Trail*, 1917 (M. 48)
Lithograph on laid paper
25 1/2 × 20 in. (64.8 × 50.8 cm.)
Signed beneath image, in graphite, l.r.:
"Geo Bellows"
Inscribed on stone, l.c.: "THE SAWDUST TRAIL"
Inscribed beneath image, in graphite, l.l.:
"No 59"
[fig. 42]

21. *The Shower Bath*, third state, 1917 (M. 45)
Lithograph on wove paper
15 7/8 × 16 3/8 in. (40.3 × 41.6 cm.)
Inscribed on stone, u.l.: "Geo Bellows"
Inscribed beneath image, in graphite, l.l.:
"No 32", l.c.: "The Shower Bath, detail", l.r.:
"Geo. Bellows E.S.B."
[fig. 115]

22. *Solitude*, 1917 (M. 37)
Lithograph on chine collé on wove paper
17 1/16 × 15 3/8 in. (43.3 × 39.1 cm.)
Signed beneath image, in graphite, l.r.:
"Geo Bellows"
Inscribed beneath image, in graphite, l.l.:
"No 58", l.c.: "Solitude"
[fig. 19]

23. *A Stag at Sharkey's*, 1917 (M. 46)
Lithograph on wove paper
18 9/16 × 23 13/16 in. (47.1 × 60.5 cm.)
Inscribed on stone, l.c.: "Geo Bellows"
Inscribed beneath image, in graphite, l.l.:
"No 25", l.r.: "Geo Bellows E.S.B."
[fig. 38]

24. *The Street*, 1917 (M. 47)
Lithograph on wove paper
18 15/16 × 15 1/8 in. (48.1 × 38.4 cm.)
Signed beneath image, in graphite, l.r.:
"Geo Bellows"
Inscribed on stone, l.l.: "Geo Bellows"
Inscribed beneath image, in graphite, l.l.:
"No 3", l.c.: "Street—Spring Blossoms"
[fig. 11]

25. *Base Hospital No. 2*, 1918 (M. 52)
Lithograph on laid paper
17⁹⁄₁₆ × 13⅜ in. (44.6 × 34.0 cm.)
Signed beneath image, in graphite, l.r.:
 "Geo Bellows"
Inscribed beneath image, in graphite, l.l.:
 "No 9", l.c.: "Base Hospital"
[fig. 53]

26. *The Charge, Right Detail*, first state, 1918 (M. 65)
Lithograph on chine collé on wove paper
9⅞ × 8⅞ in. (25.1 × 22.5 cm.)
Inscribed on stone, l.c.: "Geo Bellows"
Inscribed beneath image, in graphite, l.l.:
 "No 4", l.c.: "The Charge, detail", l.r.:
 "Geo. Bellows E.S.B."
[fig. 58]

27. *The Last Victim*, 1918 (M. 56)
Lithograph on wove paper
18¹³⁄₁₆ × 23¹¹⁄₁₆ in. (47.8 × 60.2 cm.)
Inscribed on stone, l.c.: "Geo Bellows"
Inscribed beneath image, in graphite, l.l.:
 "No 12", l.r.: "Geo Bellows E.S.B."
[fig. 124]

28. *Murder of Edith Cavell*, final state, 1918 (M. 53)
Lithograph on wove paper
19 × 24¹³⁄₁₆ in. (48.3 × 63.0 cm.)
Signed beneath image, in graphite, l.r.:
 "Geo Bellows"
Inscribed beneath image, in graphite, l.l.:
 "No 9", l.c.: "Murder of Edith Cavell."
[fig. 56]

29. *Tennis*, 1920 (M. 71)
Lithograph on chine collé on wove paper
18³⁄₁₆ × 19⅞ in. (46.2 × 50.5 cm.)
Signed beneath image, in graphite, l.r.:
 "Geo Bellows"
Inscribed on stone, l.c.: "·Geo Bellows·"
Inscribed beneath image, in graphite, l.l.: "55
 Bolton Brown, imp.", l.c.: "Tennis"
[fig. 59]

30. *Bathing Beach*, 1921 (M. 86)
Lithograph on chine collé on wove paper
8⅜ × 7 in. (21.3 × 17.8 cm.)
Signed beneath image, in graphite, l.r.:
 "Geo Bellows"
Inscribed on stone, l.r.: "GB"
Inscribed beneath image, in graphite, l.l.:
 "Bolton Brown—imp—"
[fig. 71]

31. *Elsie*, 1921 (M. 110)
Lithograph on wove paper
10⁵⁄₁₆ × 7½ in. (26.2 × 19.1 cm.)
Signed beneath image, in graphite, l.r.:
 "Geo Bellows"
Inscribed on stone, l.r.: "GB"
Inscribed beneath image, in graphite, l.l.:
 "Bolton Brown. imp—"; in graphite, l.r.:
 "Elsie Speicher"
[fig. 86]

32. *Elsie, Emma and Marjorie No. 2*, 1921 (M. 104)
Lithograph on wove paper
11¼ × 13⅞ in. (28.6 × 35.2 cm.)
Signed beneath image, in graphite, l.r.:
 "Geo Bellows"
Inscribed on stone, l.r.: "GB"
Inscribed beneath image, in graphite, l.l.:
 "Bolton Brown—imp—"
[fig. 84]

33. *Emma, Elsie and Speicher*, 1921 (M. 107)
Lithograph on wove paper
11½ × 11⅝ in. (29.2 × 29.5 cm.)
Signed beneath image, in graphite, l.r.:
 "Geo Bellows"
Inscribed on stone, l.l.: "G.B."
Inscribed beneath image, in graphite, l.l.:
 "Bolton Brown—imp—"
[fig. 85]

34. *Evening, Nude on Bed*, 1921 (M. 78)
Lithograph on wove paper
12⅜ × 9⅝ in. (31.4 × 24.5 cm.)
Signed beneath image, in graphite, l.r.:
 "Geo Bellows"
Inscribed on stone, l.r.: "GB"
Inscribed beneath image, in graphite, l.l.:
 "Bolton Brown—imp—"
[fig. 110]

35. *Evening Snow*, 1921 (M. 91)
Lithograph on wove paper, mounted on wove
 paper
7³⁄₁₆ × 9⅞ in. (18.3 × 25.1 cm.)
Signed beneath image, in graphite, l.r.:
 "Geo Bellows"
Inscribed on stone, l.l.: "GB"
Inscribed beneath image, in graphite, l.l.:
 "Bolton Brown—imp—", l.c.: "Evening
 Snow"
[fig. 66]

36. *The Hold-Up*, first state, 1921 (M. 89)
Lithograph on laid paper
11 × 8½ in. (27.9 × 21.6 cm.)
Signed beneath image, in graphite, l.r.:
 "Geo Bellows"
Inscribed on stone, l.l.: "GB"
Inscribed beneath image, in graphite, l.l.:
 "Bolton Brown—imp—"
[fig. 120]

37. *Indoor Athlete No. 1*, 1921 (M. 81)
Lithograph on wove paper
6½ × 9¾ in. (16.5 × 24.8 cm.)
Signed beneath image, in graphite, l.r.:
 "Geo Bellows"
Inscribed on stone, l.l.: "GB"
Inscribed beneath image, in graphite, l.l.:
 "Bolton Brown—imp—"
[fig. 75]

38. *Indoor Athlete No. 2*, 1921 (M. 82)
Lithograph on wove paper
5¼ × 8¾ in. (13.3 × 22.2 cm.)
Signed beneath image, in graphite, l.r.:
 "Geo Bellows"
Inscribed on stone, c.l.: "GB"
Inscribed in graphite, l.l.: "1ˢᵗ Pull—"
[fig. 76]

39. *Jean 1921 No. 1*, 1921 (M. 120)
Lithograph on laid paper
5½ × 4⅜ in. (14.0 × 11.1 cm.)
Signed beneath image, in graphite, l.r.:
 "Geo Bellows"
Inscribed on stone, l.r.: "GB"
Inscribed beneath image, in graphite, l.l.:
 "Bolton Brown—imp—/ Jean"
[fig. 98]

40. *A Knock-Out*, second state, 1921 (M. 92)
Lithograph on chine collé on wove paper
15¼ × 21¾ in. (38.8 × 55.3 cm.)
Inscribed on stone, l.c.: ".G B."
Inscribed beneath image, in graphite, l.l.:
 "Bolton Brown—imp—", l.r.: "Geo W.
 Bellows E.S.B."; in graphite, l.c.: "A
 Knockout."
[fig. 79]

41. *Lady with a Fan*, 1921 (M. 111)
Lithograph on laid paper
11¼ × 8¼ in. (28.6 × 21.0 cm.)
Signed beneath image, in graphite, l.r.:
 "Geo Bellows"
Inscribed on stone, l.l.: "G B"
Inscribed beneath image, in graphite, l.l.:
 "Bolton Brown—imp.—"
[fig. 93]

42. *Legs of the Sea*, 1921 (M. 85)
Lithograph on wove paper
8⁹⁄₁₆ × 10¹¹⁄₁₆ in. (21.8 × 27.2 cm.)
Signed beneath image, in graphite, l.r.:
 "Geo Bellows"
Inscribed on stone, l.l.: "GB."
Inscribed beneath image, in graphite, l.l.:
 "Bolton Brown—imp—", l.c.: "Legs of the
 Sea—"
[fig. 72]

43. *My Family No. 2*, 1921 (M. 116)
Lithograph on laid paper
10³⁄₁₆ × 8 in. (25.9 × 20.3 cm.)
Signed beneath image, l.r.: "Geo Bellows"
Inscribed on stone, l.r.: "GB"
Inscribed beneath image, in graphite, l.l.:
 "Bolton Brown—imp—"
[fig. 91]

44. *Old Billiard Player*, 1921 (M. 84)
Lithograph on laid paper
9 × 7⁷⁄₁₆ in. (22.9 × 18.9 cm.)
Signed beneath image, in graphite, l.r.:
 "Geo Bellows"
Inscribed on stone, u.l.: "GB"
Inscribed beneath image, in graphite, l.l.:
 "Bolton Brown—imp—", l.c.: "Old Player"
[fig. 74]

45. *The Parlor Critic*, 1921 (M. 80)
Lithograph on laid paper
8⁷⁄₁₆ × 7 in. (21.4 × 17.8 cm.)
Signed beneath image, in graphite, l.r.:
 "Geo Bellows"
Inscribed on stone, l.l.: "GB"
Inscribed beneath image, in graphite, l.l.:
 "Bolton Brown, imp.", l.c.: "Parlor Critic"
[fig. 60]

46. *Polo Sketch*, 1921 (M. 87)
Lithograph on laid paper
8⁵⁄₁₆ × 10⅜ in. (21.1 × 26.4 cm.)
Signed beneath image, in graphite, l.r.:
 "Geo Bellows"
Inscribed on stone, l.l.: "GB"
Inscribed beneath image, in graphite, l.l.:
 "Bolton Brown—imp—", l.c.: "Polo"
[fig. 70]

47. *The Pool-Player*, 1921 (M. 83)
Lithograph on wove paper
5 × 10¹⁄₁₆ in. (12.7 × 25.6 cm.)
Signed beneath image, in graphite, l.r.:
 "Geo Bellows"
Inscribed on stone, l.r.: "G B"
Inscribed beneath image, in graphite, l.l.:
 "Bolton Brown—imp—"
[fig. 77]

48. *Portrait of Robert Aitken No. 1*, 1921 (M. 126)
Lithograph on wove paper
13⅝ × 11⁵⁄₁₆ in. (34.6 × 28.7 cm.)
Signed beneath image, in graphite, l.r.:
 "Geo Bellows"
Inscribed on stone, c.l.: "GB"
Inscribed beneath image, in graphite, l.l.:
 "Bolton Brown—imp—"
[fig. 89]